R. A. SCOTTI has wanted to write *Basili...* [since] seeing St. Peter's for the first time. [She has written several] books, including several espionage novels and, most recently, the best-selling *Sudden Sea: The Great Hurricane of 1938.* She lives in New York City with her family.

Praise for *Basilica*

"Astonishes. A sweeping account [of the] largest assemblage of artistic genius on any project in history."
—*The Wall Street Journal*

"Absorbing. A fascinating tale of genius, power, and money."
—*Publishers Weekly*

"With her vivid portrayals, Scotti turns a potentially dry architectural tale into a Vatican version of *Dynasty.*"
—*Entertainment Weekly*

"A fair and fascinating examination of splendorous and scandalous events. [Scotti] is a dramatic storyteller."
—*National Review*

"Fascinating history reveals how the world's most glorious house of worship emerged from decades of trial and scandal. A riveting portrait of the papacy, complete with its triumphs, intrigue, and excesses."
—*Kirkus Reviews*

"I have been to St. Peter's dozens of times but never really appreciated my favorite church until I read Scotti's beguiling account. *Basilica* is delicious history."
—Kenneth L. Woodward,
contributing editor to *Newsweek*; author of *Making Saints*

"*Basilica* tells the story of the building of St. Peter's—and the history of a turbulent century—in the most entertaining and enlightening way."
—Ross King, author of *Brunelleschi's Dome,*
Michelangelo and the Pope's Ceiling, and *The Judgment of Paris*

"A lovely book, filled with historical detail and lively depictions. Captures an extraordinary period in the Church's life."
—Richard John Neuhaus, editor in chief of *First Things*

ALSO BY R. A. SCOTTI

for Francesca,
a beauty inside and out

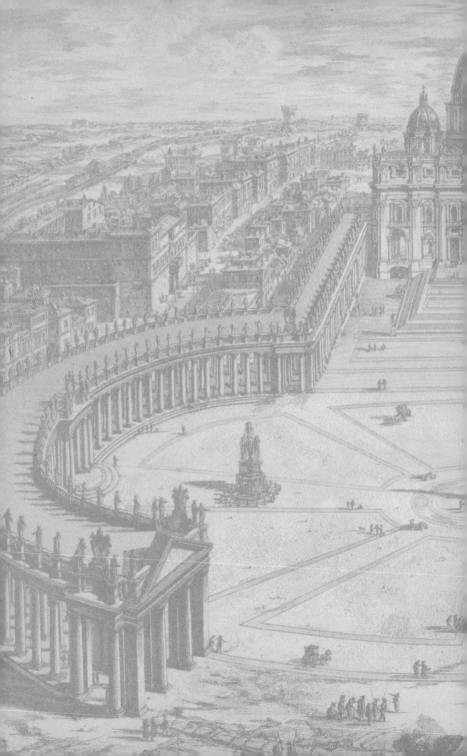

BASILICA

The Splendor and the Scandal:
Building St. Peter's

R. A. SCOTTI

A PLUME BOOK

PLUME
Published by Penguin Group
Penguin Group (USA) Inc., 375 Hudson Street, New York, New York 10014, U.S.A. • Penguin
Group (Canada), 90 Eglinton Avenue East, Suite 700, Toronto, Ontario, Canada M4P 2Y3 (a
division of Pearson Penguin Canada Inc.) • Penguin Books Ltd., 80 Strand, London WC2R
0RL, England • Penguin Ireland, 25 St. Stephen's Green, Dublin 2, Ireland (a division of Pen-
guin Books Ltd.) • Penguin Group (Australia), 250 Camberwell Road, Camberwell, Victoria
3124, Australia (a division of Pearson Australia Group Pty. Ltd.) • Penguin Books India Pvt.
Ltd., 11 Community Centre, Panchsheel Park, New Delhi – 110 017, India • Penguin Group
(NZ), 67 Apollo Drive, Rosedale, North Shore 0745, Auckland, New Zealand (a division of
Pearson New Zealand Ltd.) • Penguin Books (South Africa) (Pty.) Ltd., 24 Sturdee Avenue,
Rosebank, Johannesburg 2196, South Africa

Penguin Books Ltd., Registered Offices: 80 Strand, London WC2R 0RL, England

Published by Plume, a member of Penguin Group (USA) Inc. Previously published in a Viking
edition.

First Plume Printing, June 2007
10 9 8 7 6 5 4

Illustration credits appear on page 316.
Maps on pages 276, 280, 284, 286 by Jeffrey L. Ward, 2007.

Ⓟ REGISTERED TRADEMARK—MARCA REGISTRADA

CIP data is available

ISBN 0-670-03776-1 (hc.)
ISBN 978-0-452-28860-7 (pbk.)

Printed in the United States of America
Original hardcover design by Nancy Resnick

CONTENTS

❧

If they were great enough to invent such legends, we at least should be great enough to believe them.

—Goethe

BUILDING THE BASILICA

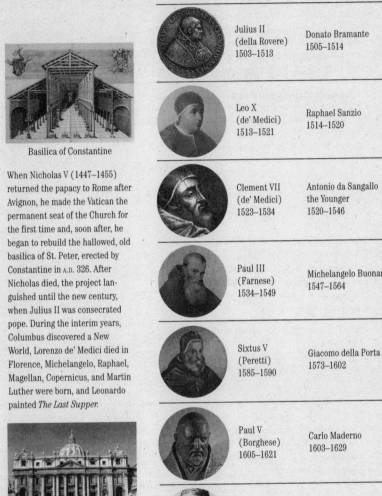

Basilica of Constantine

When Nicholas V (1447–1455) returned the papacy to Rome after Avignon, he made the Vatican the permanent seat of the Church for the first time and, soon after, he began to rebuild the hallowed, old basilica of St. Peter, erected by Constantine in A.D. 326. After Nicholas died, the project languished until the new century, when Julius II was consecrated pope. During the interim years, Columbus discovered a New World, Lorenzo de' Medici died in Florence, Michelangelo, Raphael, Magellan, Copernicus, and Martin Luther were born, and Leonardo painted *The Last Supper*.

Basilica of Julius

(For a complete list of the popes from Nicholas V to Alexander VII, see the appendix.)

POPES	CHIEF ARCHITECTS
Julius II (della Rovere) 1503–1513	Donato Bramante 1505–1514
Leo X (de' Medici) 1513–1521	Raphael Sanzio 1514–1520
Clement VII (de' Medici) 1523–1534	Antonio da Sangallo the Younger 1520–1546
Paul III (Farnese) 1534–1549	Michelangelo Buonarroti 1547–1564
Sixtus V (Peretti) 1585–1590	Giacomo della Porta 1573–1602
Paul V (Borghese) 1605–1621	Carlo Maderno 1603–1629
Urban VIII (Barberini) 1623–1644	Gianlorenzo Bernini 1629–1680
Alexander VII (Chigi) 1655–1667	

Construction Stages	World Events
1505: Michelangelo commissioned to sculpt papal tomb 1505: Julius II accepts Bramante's plan for new Basilica 1506: APRIL 18, FIRST STONE OF NEW BASILICA LAID 1507: Demolition of ancient basilica begins 1511: Antonio da Sangallo the Younger hired as carpenter	1506: Julius leads papal army vs. Bologna 1507: Raphael begins Stanze 1508: Michelangelo begins Sistina
1513: Bramante completes piers and most of east arm, builds altar house. Fra Giocondo named assistant 1514: Giuliano da Sangallo made assistant. Raphael succeeds Bramante 1516: Raphael proposes Latin-cross plan 1520: Antonio da Sangallo the Younger succeeds Raphael	1517: Luther posts 95 Theses 1519: Magellan sets sail 1521: Luther excommunicated
1523: Fabbrica di San Pietro formed 1530: Some progress on southern arm	1527: Sack of Rome 1534: Michelangelo to paint *Last Judgment*
1538: Paul III asks for definitive Basilica plan 1540: Sangallo raises Basilica floor, strengthens Bramante's piers 1543: Sangallo completes elaborate Basilica model 1547: Michelangelo succeeds Sangallo, rejects his model 1564: Michelangelo completes drum	1534: England breaks with Church of Rome 1542: New Inquisition begins 1545: Council of Trent convenes
1573: Della Porta becomes chief architect, completes Gregorian Chapel, begins west apse 1586: Domenico Fontana moves obelisk 1588: Sixtus approves della Porta's dome, gives him 30 months to complete it 1590: Dome vaulted	1588: England defeats Spanish Armada
1604: Basilica finished, except façade 1607: Maderno wins competition to change from Greek to Latin cross 1608: Last of old basilica razed 1612: Confessio begun 1614: Maderno completes façade	1605: World's first newspaper published in Antwerp 1613: Dutch establish trading post on Manhattan Island
1624: Bernini's Baldacchino commissioned 1626: Nov. 18, CONSECRATION OF NEW ST. PETER'S 1629: Bernini succeeds Maderno 1638: Bernini begins campanile on Maderno's façade 1648: Crumbling bell tower torn down 1656–1667: Bernini builds piazza and colonnade, Cathedra, and Scala Regia	1618–1648: Thirty Years' War 1620: *Mayflower* reaches Plymouth 1633: Galileo silenced

VISUAL GLOSSARIES

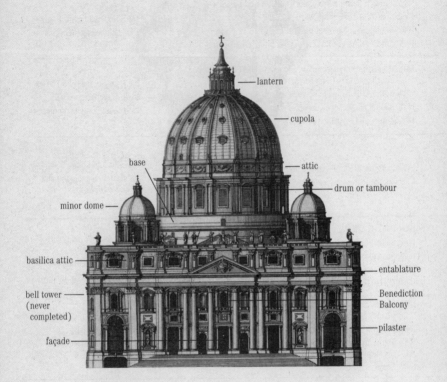

lantern

cupola

base

attic

drum or tambour

minor dome

basilica attic

entablature

bell tower
(never
completed)

Benediction
Balcony

pilaster

façade

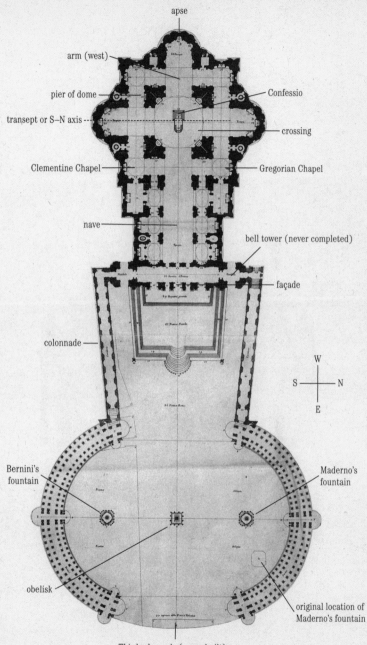

apse

arm (west)

pier of dome

transept or S–N axis

Clementine Chapel

nave

colonnade

Bernini's
fountain

obelisk

Confessio

crossing

Gregorian Chapel

bell tower (never completed)

façade

Maderno's
fountain

original location of
Maderno's fountain

Third colonnade (never built)

W
S N
E

AUTHOR'S NOTE

❧

I first saw St. Peter's Basilica on a scorching late September day of my first week in Rome. I was nineteen and spending a year in Italy. An Italian cousin picked me up in the morning in a green-and-black Roman cab and we rode out to the beach at Ostia, where, in my one-piece American bathing suit, I appeared ludicrously overdressed.

I was living at CIVIS, an international house for students, and I had to be back by three o'clock at the latest. My group had a papal audience at four. I couldn't miss it, not only because no one stands up the pope but also because he and my father had been friends for years. They had met when my father was studying medicine at the University of Rome and Paul VI, then the young Monsignor Giovanni Battista Montini, was chaplain of an anti-Fascist student group. In his pre-pontiff days, he would visit us whenever church business brought him to the States. Somewhere I still have the photograph of his cat, taken on the balcony of his Vatican apartment, that he sent to me when I was nine or ten. He had to give the cat away when he was elected pope, and I had written to say how sad it was that the pope could not keep a pet.

On that September day, the sun and the wine at lunch and the salty Mediterranean air made time irrelevant. When I finally tore

into CIVIS sunburned and sticky, it was well after three, and the group had left without me. CIVIS is a couple of miles north of the Vatican on the same side of the Tiber River, near Ponte Milvio, the bridge where Constantine, leading his army into the imperial city in A.D. 312, saw a cross in the sky and the words *In hoc signo vinces*—"By this sign you will conquer."

Constantine was a young general advancing on Rome to challenge Maxentius, the foremost contender to succeed the emperor Diocletian. With Christ so obviously on his side, Constantine defeated his rival easily and was crowned emperor. He mended his pagan ways and soon after built the first basilica of St. Peter.

Nothing happens quickly in Rome, but over the course of more than sixteen hundred years, a village grew up around Ponte Milvio. By the time I arrived, the old bridge still spanned the Tiber, but the road linking the village to the city proper had become a wide avenue with a bowling alley, a soccer stadium, and a half-mile stretch where prostitutes were allowed to solicit openly. (Only the bridge and the soccer stadium were mentioned in my guidebook.)

At three forty-five, I was standing at the bus stop just beyond the ancient bridge, in black dress, black heels, and black lace mantilla, prescribed attire for a papal audience but notably conspicuous for an average afternoon. The only vehicle in sight was a vintage pickup truck, one of those uniquely Italian three-wheeled contraptions. It appeared as ancient as the city as it hiccupped toward me. I stepped off the curb and waved. An immense workman with a very shiny, very black mustache sprouting beneath wide nostrils filled the cab. My father had warned me about Italian men. Being one himself, he knew the subject. But I was going to see the Holy Father—what could happen?—and the truck was going my way. Before the driver could protest, I edged in beside him. *"Il Papa,"* I said in my rudimentary Italian. *"Vaticano! Subito, per favore!"*

St. Peter's should be hard to miss, but as we putted along, I strained in vain for a glimpse of the Basilica. As I was trying to orient myself, the truck lurched to a stop. *"Ecco!"* The driver pointed. Directly ahead of us, a line of stone columns stretched horizontally in both directions as far as the eye could see. Too flustered to recognize what they were, I began again. *"Il Papa . . ."* By then, it was about two minutes to four, and I must have sounded frantic, because the driver, gesticulating broadly, shouted, *"Si, San Pietro in Vaticano. Eccolo!"*

"Ma, scusi," I ventured tentatively. *"Eccolo,"* he shouted louder, flailing his arms. *"Pazza Americana!"* His words chased me from the cab and trailed after me—"St. Peter's. Right there! Crazy American!" And so I entered the line of stone columns—Bernini's illusory colonnade. It is the first of the many illusions that compose St. Peter's.

Most visitors approach from Via della Conciliazione, the ostentatious avenue built by Mussolini to appease the papacy and trumpet the grandeur of the Church of Rome. Because I approached from the side, the colonnade concealed the Basilica until the precise moment when I stepped through the Doric columns into the sublime surprise of St. Peter's Square. No photograph, film, or book of art treasures had prepared me for the physical experience of that first encounter. Twin fountains sprayed into the vastness of the piazza. Between them, the obelisk brought by the emperor Caligula from Heliopolis ascended into heaven like a pagan convert. Ahead, spreading horizontally across the piazza and rising to the crescendo of the dome, appeared the first church of Christendom.

<div align="center">✆</div>

St. Peter's dominates the landscape of Rome. Its cold stones and immense size should make the human scale inconsequential. Yet

coming upon it from any angle—seen at dusk from the Pincio when the dome glows in the sunset, at dawn as a pale globe on the city skyline, or even from the cab of a sputtering three-wheeled truck—the pilgrim or the prodigal is overwhelmed with a feeling of coming home. This is its magnificence and its mystery.

Both a brilliant failure and an extraordinary feat of architecture and engineering, the Basilica of St. Peter was the most monumental undertaking of the High Renaissance, and the story of its construction is as convoluted and controversial as the Church it serves. It is a grand adventure. A clash of titans in cassocks and artists' smocks. A sprawling saga of glorious imagination, petty jealousy, magnanimous collaborations, and incalculable cost. Begun as a symbol of Christian unity, the Basilica would fracture the Church and ignite the Protestant Reformation.

∞

The landmarks of a city reveal its architects. From Windsor to Buckingham, London landmarks carry the names of peers of the realm. New York is a city of industrialists—Rockefeller Center, Carnegie Hall, the Chrysler Building. Roman landmarks bear the names of papal families—the Borghese Gardens, Palazzo Farnese, Piazza Barberini. There is a symbiotic relationship between the city and the Church. The popes who built St. Peter's also built Rome. They commissioned the fountains and gardens, palaces and piazzas, and from the rubble of a vanished empire created a new city that would be a worthy setting for a Christian imperium.

St. Peter's was a gauge of urban progress. When the Basilica grew, Rome grew. When construction lagged, the city lagged. But gradually, under the aegis of these discerning, liberal patrons, Rome once again became "the rendezvous of the world." The splendor of Rome and *la fabbrica di San Pietro*—"the building of St. Peter's"—are so entwined that the history of one cannot be told without the other.

Rome seems an eternal story. It began twenty-eight centuries ago in 753 B.C., when, according to legend, Romulus built a town on a hill by the Tiber River. The story stretches across civilizations to 49 B.C., when Julius Caesar, having conquered Gaul, returned home to invent a capital; to 27 B.C., when Augustus made the city of the Caesars the center of the known world, an imperial forum unparalleled in splendor and power. As Rome grew, successive emperors added to its beauty. Hadrian built the Pantheon, an astonishing circular temple to the gods; Nero finished his palace in gold; and in just five years, Vespasian and his son Titus built an amphitheater for gladiatorial games that was so huge it became known as the Colosseo*—the colossus. By the fourth century, Rome was a city of some eight hundred thousand, spreading across the fabled seven hills on the east bank of the Tiber.

A millennium later, the Christian popes would cart the stone of the pagan city across the river to build their Basilica, and this extraordinary merging of the sacred and the profane would become the centerpiece of a second Golden Age.

Conceived on a grand scale, constructed at an unimagined cost, created from a confusion of ideas, St. Peter's consumed the talents—and in some cases the genius—of the greatest artists of the age, among them Bramante, Michelangelo, Raphael, and Bernini. They built at the command or whim of a pontiff-patron, often tearing up one another's plans and imposing their own contending visions. Designs were added to, jettisoned, cobbled together.

The popes who commissioned them were not cast from a single mold. They included aesthetes and epicures, monks and militants, a pair of Medici princes, a burgher, a bastard, a bookworm, at least

*There is also a theory that a giant statue of Nero gave the amphitheater its name. Nero's figure was replaced in the Flavian era with a figure of the sun god.

two poets, a scholar, and a swineherd. If their morals were questionable, their taste was impeccable. They coaxed and commanded the greatest work from the largest number of master-artists ever engaged on a single project.

At times, the endeavor seemed more like the stone of Sisyphus than the rock of Peter. But over the course of two centuries, they shepherded the Basilica through intrigues and assassination attempts, through schism and the Sack of Rome, through the Reformation, the Counter-Reformation, and the Inquisition. Their passion for the arts created a world unsurpassed for the exuberance of its ideas and its freedom of expression.

Building St. Peter's spanned thirty papacies. The popes who contributed the most—the implacable della Rovere, Julius II; the suave Farnese, Paul III; the rough-edged Peretti, Sixtus V; and the brilliant Barberini, Urban VIII—were all old men: iron-willed, impatient, imperial pontiffs with much to accomplish and little time.

As building proceeded, the convulsions of history became a backdrop that changed like a series of stage sets. Over the decades of construction, the Church evolved, and the world evolved with it and sometimes because of it. Nationalism and religious revolution, one impossible without the other, reshaped Europe, and *la fabbrica di San Pietro* entered the Italian lexicon as a way of describing a project with no end in sight.

Motives are rarely pure or purely wicked, but a muddle of ambition, ambivalence, misperception, and sometimes desperation. If our own motives are often unclear, the motives of a pope or a painter five hundred years ago are at best conjecture. I have tried not to ascribe or assume motive and suggest it only when I can quote someone's own words. Since even these can be misleading, proceed with a generous mind.

PART ONE

THE CHRISTIAN CAESAR

1503–1513

The man who was capable of conceiving such a work of art as St. Peter's, and of beginning to execute it, deserves, by that fact alone, to live forever in the memory of mankind.

—Gregorovius

CHAPTER ONE

THE FIRST STONE

APRIL 1506

✣

Wrapped in a lavender cloak the color of dusk, riding headlong against a sharp north wind, Michelangelo Buonarroti made his escape. He had waited in his workshop behind Piazza Rusticucci for the cover of night, then, slipping through Porta San Pellegrino, the northern gate of the Leonine City,* he galloped along Via Cassia into the dangerous countryside beyond Rome. Thieves, cutthroats, and ravenous wolves scavenged in the *campagna*, but those terrors seemed less sinister than the ones he was fleeing.

"Sell all the furniture to the Jews," he had charged his servants, and, in his haste, left everything behind. He took only his chisels and hammer, the tools of his trade—some would say his genius. They clunked in his saddle pack as he rode. The only other sounds were the drumbeat of the hooves, the bay of a solitary wolf, and his own breath, sharp and quick.

The wind bit through his cloak, which was thin now and worn through in spots. It had been a gift from his first patron, Lorenzo

*In A.D. 849–52, after the attack of the Saracens, Pope Leo IV erected a fortified wall around the Vatican, which later popes strengthened and extended. The north wall runs from Castel Sant'Angelo to the foot of the hill behind St. Peter's; the south wall from the river to the hill.

de' Medici, truly "il Magnifico," dead fifteen years. Now in his place was a new patron, Giuliano della Rovere, His Holiness Pope Julius II—*il pontefice terribile*.

More than a singular individual, more than an ambitious man, although he was both, Julius II was a force of nature, restlessly moving from one grand enterprise to another. He did everything in a big way. He funded the arts, flayed his challengers, and sinned conspicuously. Romans called him "il Terribilis" with a mixture of awe and approbation. The incredulous Venetian ambassador to the Vatican summed him up this way: "No one has any influence over him, and he consults few or none. . . . It is almost impossible to describe how strong and violent and difficult to manage he is. . . . Everything about him is on a magnificent scale, both his undertakings and his passions."

In the final hours of April 17, the first Saturday after Easter in the year 1506, the moon was waning, and the glorious promise shattered. Work and future abandoned, Michelangelo raced through the night, stopping at wayside hostelries for a fresh horse, then galloping on, afraid to rest until he was beyond papal dominion.

Michelangelo was just thirty-one and already recognized as the most talented artist in Christendom, the sculptor of *David* and the *Pietà*. He had been the pope's favorite, commissioned to fashion an enormous funerary monument. It would be "the triumph of sculpture," he promised, two stories of milk-white marble, carved with forty statues, each one several times larger than life. But an even grander enterprise had eclipsed all thoughts of the tomb.

At daybreak, Pope Julius would lay the foundation stone of a new Basilica of St. Peter that in size and scale would exceed the most monumental temples of the emperors. Nothing comparable had been ventured since the imperial days of Rome when a limitless supply of slave labor had made the wonders of the ancient world feasible.

Michelangelo would have no part in it.

❧

In his *Lives of the Painters, Sculptors and Architects,* Michelangelo's friend and student Giorgio Vasari* wrote, "The most benign Ruler of Heaven in His clemency turned His eyes to the earth, and having perceived the presumptuous vanity of men which is even further removed from truth than is darkness from light, and desirous to deliver us from such great errors, sent down to earth" Michelangelo Buonarroti.

In the tight, fractious circle of Renaissance artists, where papal patronage was coveted and rivalry was intense, there was no fair way to compete successfully against such a talent, and no easy way to handle him.

Michelangelo already had the dimensions of myth and the disposition of a martyr. He was the patent for the artistic temperament— prickly, uncompromising, egotistical, immodest, self-absorbed, and slipping toward paranoia. "It is only your devotion to the great work to which you have given yourself that makes you seem terrible to others," a Florentine patron reassured him.

The sky was growing lighter when Michelangelo crossed into Tuscany, his home ground and beyond the jurisdiction of Julius. Still shaken by the anguished day, he stopped to sleep in a hostelry in the town of Poggibonsi, still twenty miles from Florence. He was slouched over a wooden refectory table, its surface scarred and stained, with a heel of bread and a flagon of wine, when he heard the stomp of boots and the clamor of demanding voices.

Like the Roman emperors, Pope Julius had eyes and ears everywhere, and Michelangelo had barely left the walls of the

*Unless otherwise noted, all the quotations pertaining to Michelangelo come from his own letters and poems or from biographies written by Giorgio Vasari and Ascanio Condivi, who were his pupils and friends. None of the three can be considered an objective source.

city behind when papal horsemen were in pursuit. With a sudden rush of wind and flash of light, the door of the inn burst open. Five papal couriers surrounded him, and in the name of Pope Julius II of Liguria, commanded him to return with them to the Vatican. They carried a personal message from "His Blessed Holiness."

Breaking the wax seals—the crossed keys of the Apostolic See and the della Rovere oak tree, the pope's family crest—the captain barked out the message: "From the Most Holy Father: Return to Rome under threat of punishment."

The words were as portentous as the snarl of Cerberus, but Michelangelo could disobey with impunity because he was on the soil of the Signoria of Florence. There were rude exchanges, some shoving, and more threats, before he agreed to an uneasy compromise. He would write an answer to Julius.

The innkeeper brought pen, ink, and parchment, a coarse sheet, not worthy of its recipient, but there was nothing else. The table was cleared, a fresh lamp lighted. Michelangelo loosened his cloak to free his arm, wiped his hands on his breeches to clean them of crumbs and sweat, and flexed his fingers, stiff from gripping the reins for so many hours. Bending over the parchment, he scratched out each word: "Most Blessed Father . . ."

For the sculptor of the giant *David*, almost seventeen feet tall and carved from a single marble block, his letters were small and cramped. After a perfunctory request for pardon, he wrote with indignation and wounded pride, in effect serving warning to Julius "that he would never again return to the sacred presence, since the pope had caused him to be driven away like a criminal, that his faithful service had not deserved such treatment, and that his Holiness should look elsewhere for someone to serve him."

Later, Michelangelo would hint of a nefarious plot against

him: "If I were to remain in Rome, my own tomb would have come before the pope's," he would write. "This is the reason for my sudden departure."

<center>❧</center>

Within the walls of the Vatican, boulders of abandoned marble loomed like snowy mountains in the shadowed piazza. Bonfires burned and torches flared in the windswept night. Pickaxes swung, cracking ancient stones. Shovels clanged against broken skulls. The laborers sweated in the chillness, enclosed in twenty-foot walls of earth, and digging deeper, through the gardens of Agrippina and the stones of her son Caligula's Circus, through the necropolis of ancient Rome and the killing fields of the emperor Nero.

The piers of the new Basilica of St. Peter would be so massive that each foundation trench had to be twenty-five feet deep. Huge baskets were lowered into the pit by a series of pulleys, filled with dirt, raised, emptied, lowered, and filled again. The laborers dug in a steady rhythm, displacing layer upon layer of history. Ager Vaticanus was not virgin soil.

Named for the *vati*, or "soothsayers," who augured there in classical times, the Vatican field lay on the west bank of the Tiber River, between the hills of Monte Mario to the north and the Gianicolo to the south. Since it was located across the river and well outside the main city, the Vatican had been a convenient place for Roman emperors to bury their dead and slaughter converts to the radical messianic cult of Jesus of Nazareth.

In the first, inky morning hours, the weary laborers drew up the last baskets of dirt and climbed out of the trench. Shovels slung over their shoulders, they filed home across the Ponte Sant'Angelo, their sweat polluting the air. The wisteria that spread in wild abandon over the seven hills of Rome should have been sending its

sweet perfume across the city, but this was a nasty April. The wind rushed south from the bony Apennines, churning the murky water of the Tiber. It flattened the tall grasses of the marshes, incubator for the malaria virus that swept through Rome every year or so, thinning the population, and blew away the fetid odors of garbage, fish bones, and offal that made the Vatican Borgo as malodorous as a cesspool.

Yards of canvas like the sails of a Roman galley billowed over the excavated earth. The wind slapped the canvas and swirled through the construction yard by the papal palace, raising a fine white dust that turned the site into a flour bowl. At first light, April 18, 1506, a ribbon of cardinals began snaking across the cluttered yard. Trailed by an entourage of secretaries and servants, they picked their way around the ancient stones, pilfered from the Colosseum on the pope's orders, around the mounds of travertine carted from quarries in Tivoli and Michelangelo's boulders of milk-white marble.

By dawn, every prominent figure in Rome had converged on the site. Cesare Borgia, the vicious bastard son of the previous pope, was in the audience, feigning goodwill. Rumor was that Julius held him hostage. There was a contingent from Florence: the ambassador and wit, Niccolò Machiavelli; and the heirs of Lorenzo il Magnifico, Cardinal Giovanni de' Medici and his bastard cousin Giulio. Both would become deplorable popes. A third future pope, the elegant young monsignor Alessandro Farnese, who would become Paul III, attended with his mistress. Julius's current favorites—the banker Agostino Chigi, on his way to becoming the richest man in Rome, and the architect Donato Bramante, who was designing the new Basilica—occupied places of honor beside members of the pope's family, his youngest daughter, Felice, and his cardinal-cousin Raffaele Riario, the chief financial officer of the Church.

To the blare of trumpets and the ring of applause, a line of

thirty-five cardinals processed to the lip of the excavation pit. The wind whipped their crimson cassocks and swirled through the crowd, carrying gossip with the dust. The renegade artist Buonarroti had absconded in the night like a criminal, his contract unfulfilled, his work in limbo. Pope Julius was in a fury, his day of glory spoiled by the sculptor's surreptitious flight.

Behind the cardinals, carried aloft in the *sedia gestatoria*, Julius towered above the crowd like a thunderhead and tossed commemorative coins into upstretched hands. He was sixty-three years old, an old man by Cinquecento standards, but he was built like a bull—powerful neck, powerful shoulders—and his tendency was to charge like a bull, trampling impediments and opponents alike. He never retreated except to regroup, to gain time and disarm his enemies. He charmed. He finessed. He even managed an occasional moment of humility, if it assured that his will would prevail. But he was never deterred.

As bearers lowered the chair by the lip of the pit, he stepped out, shrugging violently to shake the dust off his cope. The heavy brocade embroidered with gold thread was beginning to look like a baker's smock. Two masons descended first, followed by two cardinals, and then the pope, grim-faced. He climbed down the ladder carefully, his ringed fingers grasping the rungs, encumbered by the heavy clothing, the weighty tiara, descending lower, lower yet. The Ager Vaticanus was marshy, the earth in the pit damp, the air close.

As Julius disappeared into the trough, the crowd pressed forward for a better view. Dirt flew, striking his tiara. For a terrifying moment, he thought the sides would cave in and bury him. The foundation pit would become his tomb, not the magnificent sarcophagus abandoned without permission the night before by the impudent Buonarroti.

The trench was "like a chasm in the earth," the papal master of ceremonies, Paris de Grassis, recorded in his journal, "and as

there was much anxiety felt lest the ground should give way, Pope Julius thundered out to those above not to come too near the edge."

An urn holding a dozen commemorative medals, signifying the twelve apostles, was lowered into the pit. Cast of bronze and gilded, the medals featured on one side an image of the pope and on the other a picture of the new church. Julius placed them in an opening dug beneath the spot where the foundation stone would fit—a block of marble, "four palms wide, two broad, and three fingers thick"—the first stone of the new Basilica of St. Peter.

∞

Looking back across centuries of checkered history, across the lapses in Christianity and compassion, across the bloody crusades and Inquisition, it seems more than happenstance that, of his twelve apostles, Christ chose Peter to lead his new church.

Simon Peter, so clearly flawed, seemed to be the least among the disciples. He lacked the poetry of John, the curiosity of Thomas, even the boldness of Judas. He was ignorant, impulsive, unreliable, and boastful. He was one of us. He shared our ebullience and our errors. He was the first to swear his undying faith, and the first to fail. The first to volunteer to watch through the night with Christ, and the first to fall asleep. Even after he became the first pope, it was said that Jesus caught him on the Via Appia fleeing from Nero's dangerous city.

On the shoulders of this empathetic, eminently fallible man, Christ placed the future of the Church, and the humanity of Peter, that uneasy balance of sinner and saint, has sullied and sustained his Church ever since. A communion of sinners who would be saints, led by the most mortal of men—such is the enduring strength of the Roman Catholic Church. That boundless acceptance of a willing spirit foiled time and again by weak flesh has

confounded those who have prematurely prophesied its end, from the unforgiving Luther to the unyielding evangelicals.

As a historical entity, the Church of Rome is unparalleled. It has operated without interruption for more than two thousand years—no other institution is even a close second. Never a monolith that spoke with a single voice, it always had room for the beatific and the base. At no time in its often unedifying history has it seemed more wanton and wondrous, more earthy and existential than in the era of the Renaissance popes, and no pontiff has embodied those excesses more extravagantly than il Terribilis, Julius Secondo.

Giuliano della Rovere was elected supreme pontiff of the Church of Rome in a single ballot, having taken the prudent step of crossing the palms of key cardinals with silver. As pope he chose the name Julius, not for the sainted Pope Julius I, but for the original Julius, the conquering Caesar and empire builder who made Rome glorious.

Now, on the very spot where Peter was buried, the Christian Caesar was building a citadel of faith for God and eternity. The enterprise was audacious, but so were the times. Gutenberg had invented the printing press, Columbus had stumbled on a new continent, and the Renaissance was in full bloom. Before the new Basilica was finished, Magellan's fleet would sail around the world; Henry VIII would take six wives and dispose of four; Shakespeare would make all the world a stage, the *Mayflower* would drop anchor off Plymouth Rock, and Europeans would taste chocolate and coffee for the first time.

But from the foundation stone, Peter's new house was both a splendor and a scandal. One thousand two hundred years before, the emperor Constantine had raised a shrine to the apostle on the very same ground. To destroy Constantine's basilica—a hallowed site almost as old as the Church of Rome—was a desecration.

The scandal that his plan provoked only steeled the pope's resolve. Julius imagined the new Basilica as the centerpiece of a Christian Rome more magnificent and mighty than the city of the Caesars. And the fact that the original St. Peter's was the most revered shrine in Europe, the repository of a millennium of sacred history and art, be damned. He would rip it down and replace it with something more immense, immutable. A new edifice for a new age.

THE FIRST ST. PETER'S

⚭

According to the historian Tacitus, thirty years after Jesus of Nazareth was sentenced to death by crucifixion for inciting rebellion in the empire of the Caesars, his followers had spread to Rome and were attracting a devout group of converts. Although the messianic cult was not much bigger than a storefront church today, the emperor Nero viewed it with mistrust.

Nero was notorious for his public debauchery and lethal family squabbles. He had poisoned his half brother, assassinated his mother, and sentenced his wife to death. When a suspicious fire scorched Rome, blazing unchecked for nine days and nights in the summer of A.D. 64, angry Romans blamed him. Pliny the Elder charged, "Nero has burned Rome," torching the old city to build a new and grander one. The historian Suetonius described the emperor playing the lyre as he watched the distant fire from a tower: "Charmed by the beauty of the flames, he sang of the ruin ... in theatrical costume."

To quiet the outcry against him, the emperor needed to deflect blame for the controversial fire, and the Christians made a convenient scapegoat. On August 1, across the river from the charred city in Caligula's imperial Circus in the Vatican field, Nero slaughtered the alleged arsonists. It was history's first pogrom.

In the first century, the spectacle of surly slaves, clever rivals, or fickle wives tossed into an arena with hungry beasts was enjoyed with the unabashed enthusiasm that twenty-first-century Europeans lavish on soccer matches. But even to a populace for whom blood sport was an afternoon's diversion, the treatment of the Christians seemed sadistic.

Tacitus describes the scene in the fifteenth book of his *Annales*:

> Nero inflicted the most exquisite tortures on a class hated for their abominations, called Christians.... Covered with the skins of beasts, they were torn by dogs and perished, or were nailed to crosses, or were doomed to the flames and burnt, to serve as a nightly illumination, when daylight had expired.... Mockery of every sort was added to their deaths.

Although the disciples Peter and Paul may have been in Rome at the time, they escaped the first purge. Three years later, in another lethal Roman summer, the two old proselytizers were apprehended and killed. Paul, according to legend, was beheaded on his way to the port of Ostia. Peter was captured inside the city and forced to follow his own Via Dolorosa.

The old fisherman, his face tanned to leather by years of wind and sea, carried his cross through the Vatican field. His executioners walked behind him, and behind the soldiers, a jeering mob pressed forward. By the Circus of Caligula, beside the killing fields of Nero, he staggered. And it was there that the cross was raised, and Simon Peter was hung upside down, according to his wish, because at the end he knew, as he had always believed, that he was an unworthy proxy for Jesus.

Subsequent emperors continued the persecutions that Nero instigated with varying degrees of zeal. Suspected believers were tortured

and killed in an assortment of grisly ways—boiled in oil and roasted on spits. Christianity became an outlaw religion, practiced in tunnels or catacombs beneath the streets of the imperial city.

All that changed in A.D. 312 with the cross, the Milvian bridge, and the young general who would be emperor. Leading an army to Rome to claim the throne of the Caesars, Constantine saw the cross in the sky over Ponte Milvio: "By this sign you will conquer." With his rival's head on a pike, he entered the city and was crowned emperor. It was the answer to a mother's prayers.

∞

The Christian Church is usually viewed as a father-son narrative, yet at critical junctures in the Old and New Testaments and beyond, it is a tale of mothers and sons: Eve and her boys Abel and Cain, Jacob protected and warned by his mother, Mary standing by her accused son, Jesus, and Helena, whose faith moved an empire. Helena was Constantine's mother, and Christianity's most influential convert. Convinced that Christ had brought her son victory, she prevailed on him to accept the faith and make it legal.

Because Constantine's reign was unchallenged then, he could afford to humor his mother. He made Christianity respectable and built a basilica to honor Simon Peter, Christ's first apostle and first pope. The site he chose was both symbolic and pragmatic.

Ager Vaticanus was the very spot where Christians believed Peter had been crucified and buried. It was at the foot of the Vatican hill, opposite the main marketplace of the Foro Romano yet far enough away from the imperial city—outside the walls and across the Tiber—not to offend Rome's pagan aristocracy. Taking up a shovel, the emperor broke the ground himself. According to Roman lore, he filled twelve bags with soil, one for each of Christ's apostles.

Once Constantine gave it his imprimatur, Christianity spread across the empire. Against a pantheon of arbitrary deities who

hurled retribution from a distant mountaintop, loosed plagues on a whim, and never listened, Christ was a refreshing change. He was one deity in place of many, and he was a man—not aloof and authoritarian like the emperor, but a God-Man, who could sit down to supper with ignorant fishermen or hold his own against the smartest priests in the temple.

The new religion made God man and man God. "One day you will be with me in Paradise" was a giddy, radical notion. Every man could lift himself up from the exhausting slog of mortality and share a sweet slice of heaven. The path to paradise was straight and true. There were no more lambs to be slaughtered or virgins offered to humor the gods. Just a couple of simple rules that applied equally to all: "Love thy God and thy neighbor."

Christianity began as a simple faith for simple people. But once it was embraced by an emperor, it was only a matter of time before faith got mixed up with politics. When the Roman empire fell in A.D. 476, the Church that Constantine had legitimized filled the power vacuum. For centuries—through the invasions of Huns, Goths, and Vandals, and the Dark Ages of Europe—the Church preserved Western civilization. It trained the teachers and the scholars; built the universities; inspired and subsidized the arts; and anointed the kings and emperors, giving them a moral imperative through the divine authority it claimed. No European head of state could rule unless he paid obeisance to the pope in Rome.

As the Church became the dominant force in Europe, the simple message of faith grew more complicated, buried under the weight of excuses, exceptions, exemptions, clarifications, and amendments. An entire discipline, canon law, was formed to interpret them. The straight line from God to man became a circuitous road, obscure and obfuscated. The plot thickened, the main story line darkened.

By the Middle Ages, the shame of Good Friday had overshadowed the promise of paradise. The medieval Church became a dour

taskmaster, demanding atonement through piety, penance, and hair shirts. The temporal sway of the Church grew with its spiritual authority, and the temptations of power and pelf became as alluring as the snake in the Garden of Eden.

In 1309, the archbishop of Bordeaux was elected to the Holy See, and instead of moving to Rome, he brought the papacy to France. In their sojourn in Avignon, a period that became known as the Babylonian Captivity, the popes lived like kings, their cardinals like courtiers.

With court life, inevitably, came corruption, sloth, and all the other cardinal sins. Church wealth was counted not by the number of faithful Christians but by how much money they contributed. "Oh Rome, Rome," St. Bridget lamented, "now I can say of thee what the prophet said of Jerusalem! In your garden, the roses and lilies are choked with thistles; the ten commandments are compressed into a single maxim: give money!"

The papacy in Avignon was as far from the Church of Peter as hell from heaven. Prelates savored the high life and forgot about saving souls. Pomp and pageantry bred self-indulgence. Morals loosened. The Holy See luxuriated in Avignon, and, bereft of the papacy, Rome collapsed. No central authority governed the city. In the Quattrocento, while Florence was basking in the Renaissance, Rome, the city of the Caesars and cradle of Christianity, was a hellhole, the imperial relics overgrown, buried, or turned into animal lairs.

Wolf packs bayed on the Gianicolo and slunk down the slopes of the Vatican hill. They slipped through the broken walls that Pope Leo IV had built to keep the barbarian hordes at bay and pawed the broken earth, digging for the bones of the first Christians buried centuries before in the necropolis beneath Constantine's basilica of St. Peter. The stench of refuse—rotting fish heads, goats' hooves, excrement, and entrails—fouled the narrow streets, more alleys than imperial avenues now.

The city built on seven hills hunkered close to the riverbanks or clustered around the gates and basilicas, and nature reclaimed the famous hillsides. Vineyards sprawled across the Palatine, concealing the remains of the palaces that had given the area its name. The Roman Forum had become Campo Vaccino, the cow field, and goats grazed in such number on the Capitoline, once the center of government life, that it was called Monte Caprino.

A few farmhouses still dotted the hillsides, but little else remained. Pagan monuments and Christian churches crumbled. The yellowing hulk of the Colosseum gaped like a decayed molar on the landscape of the city. Writing in 1431, the humanist Poggio Bracciolini lamented that the imperial city "is now so ruined that not a shadow remains that can be identified as anything but wild wasteland."

The cramped neighborhoods were rimmed with watchtowers that guarded the strongholds of the landed families, chief among them the Colonna and Orsini—the Hatfields and McCoys of fifteenth-century Rome. They feuded among themselves and filled the power vacuum with turf battles fought by hired ruffians who tossed one another into the Tiber and terrorized at will, extorting what they could and decapitating whom they dared.

In the city once famous for its aqueducts, there was no clean water and little sanitation. Butchers, fishmongers, tailors, and skinners tossed their detritus into the streets. The piazzas were fetid garbage heaps. In the jerry-built neighborhoods, like the Borgo Vaticano, stairways and balconies stuck out from houses and shops at random angles, making the narrow streets almost impassable.

Rome, *caput mundi*—"center of the world"—had become a ghost town. But what ghosts.

❧

In 1447, the election of Nicholas V, an enthusiastic humanist and sincere Christian, brought a new spirit to the Church. The intellectual corollary to the artistic renaissance, humanism embraced the paganism of Greece and Rome. Long-forgotten classical texts offered a perspective on man and the universe dramatically different from the stern proscriptions of the medieval Church. The romantic ideals of man and nature, celebrated in ancient Athens, were an aphrodisiac after the absolute authority of a punitive, omnipotent God—the prime mover and first cause posited by the philosopher Thomas Aquinas almost two centuries before. The ideas of Aquinas and his Scholastics derived from the philosophy of Aristotle. Humanism embraced the thought of Plato. In essence a rebellion against the Church, it switched the focus from the divine to the human. Man, not God, became the measure of all things. Even the ideal architecture mirrored the proportions of the human body.

Glossing over the inherent contradictions, humanists welcomed Nicholas as Plato's philosopher-king. A bookworm, a bibliophile, and a scholar, once the librarian in Lorenzo de' Medici's palace, Nicholas was a slight, nondescript man. By some accounts, he was as small as St. Paul, who may have stood just fifty inches, but he had two passions: books and building.

Whether it was a naturally optimistic temperament, the profundity of his faith, or his zeal to build, after the sumptuousness of Avignon, Nicholas settled the papacy in the squalor of Rome. Previous popes had tried to return and been forced to retreat, but nothing would budge Nicholas. Because the Basilica of St. John Lateran, the traditional church of Rome and palace of the popes, was uninhabitable, Nicholas made the Vatican palace, once a guesthouse for visiting emperors and kings, the official seat of the Holy See. He resolved the Great Schism that had been threatening the

unity of the Church since 1377 (at one point, three popes, each backed by a rival political faction, claimed to be the legitimate heir to Peter and excommunicated the other two), and he proclaimed 1450 a Jubilee or Holy Year.

In spite of the desolation, pilgrims descended on Rome from all over Europe. Many journeyed for months. They came over land and sea, on foot, on horseback, by oxcart and river barge. They braved the Channel crossing, trudged over the Alps, and sailed down the Tiber to visit the five basilicas of Rome and earn a pardon from their sins.

The perils multiplied as they neared the city. Pirate ships lurked along the riverbanks and coastlines, and the only law in the *campagna*, the rough countryside north of the city, was the outlaw. Bandits and thieves terrorized at will, and the city offered no sanctuary. The walls enclosed as many terrors as they excluded.

For the pious travelers who survived the hazards, Rome was much more than its broken-down basilicas. It was the soul of Christendom, the rock on which Peter had founded his Church. The plot of earth marked by Constantine's basilica was the most sacred soil. In their eagerness to reach the shrine of Peter, pilgrims swarmed across the single narrow bridge, Ponte Sant'Angelo. Two hundred were killed in the crush, and in the summer heat, thousands more died of the plague.

In the Holy Year of 1450, the acts of God and man were terrible, yet the Jubilee was a success for Rome. As the Vatican treasury filled, Nicholas imagined an urban renaissance. "He had two soaring ideas," his secretary and biographer Giannozzo Manetti wrote, "the Renaissance of the world by learning and the turning of the eyes of Christendom to a Vatican which should outshine in magnificence the Palatine of the Emperors."

Nicholas brought the Renaissance to Rome and sparked one of the most brilliant—and most libertine—epochs in its history.

Out of the neglected city, which had shrunk to one tenth the size of imperial Rome, he envisioned the new Jerusalem of scripture— a papal Palatine* rising on the Vatican hill. At "the ideal center" would stand a reborn Basilica of St. Peter, "a temple, so glorious and beautiful that it seemed rather a divine than a human creation."

History overtook his plans. Political challengers conspired to assassinate him. Constantinople fell to the Turks, and the bishops of Byzantium sided against Rome. Nicholas V's papal Palatine remained just a paper city until Pope Julius II made it the defining event of the new century.

*As he lay dying, Nicholas V explained his building philosophy to his cardinals: "A popular faith, sustained only on doctrines, will never be anything but feeble and vacillating. But if the authority of the Holy See were visibly displayed in majestic buildings, imperishable memorials, and witnesses seemingly planted by the Hand of God Himself, belief would grow and strengthen like a tradition from one generation to another, and all the world would accept and revere it. Noble edifices, combining taste and beauty with imposing proportions, would immediately conduce to the exaltation of the Chair of St. Peter. . . ."

IL TERRIBILIS

❧

Julius II demands hyperbole. Everything about him—his personality, his ambitions, and his accomplishments, the art he commissioned and the Basilica he ordained—was outsized.

He enters history in a fresco by Melozzo da Forlì, called *The Founding of the Vatican Library by Sixtus IV.* A more apt title might be *Secularism and Nepotism in the Renaissance Papacy.* The word *nepotism* comes from the Italian *nipote,* meaning "nephew," and besides Pope Sixtus and his new librarian—the humanist and iconoclast Bartolomeo Sacchi, known as Platina—there are four figures in the painting. All are papal nephews.

Dressed in cardinal red, Giuliano della Rovere stands in the center of the painting, facing his pontiff-uncle and in profile to us, respectful, but with a hint of sangfroid. The young cardinal who will become Julius II appears ruggedly handsome, worldly, and sophisticated. He is a big man, powerfully built, square-shouldered and square-jawed.

At the right hand of the pope, avoiding direct eye contact with his cousin, stands Raffaele Riario. Elevated to cardinal at the ripe age of sixteen, Riario looks like a young version of Sixtus—same aquiline nose, same profile. Lurking in the background, turned away from the pope and appearing somewhat sinister, are two other

nephews: Giovanni della Rovere, whose son will rule the city-state of Urbino one day, and Girolamo Riario, who will implicate his uncle in a plot to unseat the Medici in Florence—the ill-conceived Pazzi conspiracy. The bad blood created between the della Rovere and the Medici families will infect the papacy and the future of the cardinal-nephews who are positioning themselves to lead the Church.

In Renaissance Rome, when many prelates owed their red hats to a papal connection, no cardinals were more colorful or more competitive than Giuliano della Rovere and Raffaele Riario. Cousins, rivals, and collaborators, passionate art collectors, shrewd gamblers, and extravagant builders, they were schooled in power by their uncle, a philosopher-friar who turned into a wily pontiff. Sixtus IV founded the Vatican Museum, built the Sistine Chapel that bears his name, and primed the ambitions of his cardinal-nephews.

The cousins chose complementary routes to power. Riario, a canny political operative, positioned himself to advance within the Curia. Della Rovere, more confrontational and charismatic, set his sights on the papacy. When Pope Sixtus died in 1484, della Rovere was poised to succeed his uncle, but another ambitious pretender, the charming, notoriously libertine Spaniard Rodrigo Borgia, a nephew of Calixtus III, challenged his claim. Deadlocked between the two contenders, the papal conclave settled on a compromise choice—the incompetent if amiable Innocent VIII.

By the next conclave in 1492, a nasty rivalry had developed between della Rovere and Borgia. Rather than trust in Divine Providence alone, the Spaniard secured the election by promising an influential fellow-cardinal a key position in the Curia and sweetening the offer with an ornate palace.

In 1492, Romans were not gossiping about the quixotic voyage of the Genoese sea captain Cristoforo Colombo, or the death of the Renaissance prince Lorenzo il Magnifico in Florence. The main

topic of conversation was the stunning upset that put the amoral Borgia cardinal on the throne of Peter. The new pope took the name Alexander VI and moved his mistress and his brood of unscrupulous children into the papal palace.

With the loathed Borgia ruling the Church, della Rovere feared for his life. The new pope hatched assassination plots to eliminate his rival, and della Rovere retaliated by escaping to France, where he incited war against the papacy. In 1494, at his urging, the French king Charles VIII rode into Rome. Alexander retreated to Castel Sant'Angelo, once the emperor Hadrian's mausoleum, now a redoubtable fortress for beleaguered pontiffs.* There, in a lavishly decorated suite, he lived as a virtual prisoner.

While della Rovere conspired in France, his cardinal-cousin Riario consorted with the enemy and accumulated power. He was apostolic chamberlain, the chief financial officer of the Church, a position he would hold for thirty-four years under six popes. He built a palace that was the talk of the city and an art collection that would have few rivals.

The years slipped by with della Rovere waiting impatiently in the wings and Alexander, the most licentious pope in history, leading the Church. Finally, in 1503, the long exile ended. The Borgia pope died, and Cardinal Giuliano della Rovere returned to Rome to claim the throne of Peter. He had left a vital man in the prime of life. He returned white-haired, but still with the energy of someone half his age. For the third time, he entered a conclave of cardinals, anticipating the papacy, and for the third time, he was denied.

A man of enormous passion for art and for the Church, della

*Originally built as a mausoleum for the emperor Hadrian, the cylinder of rock was christened the Castle of the Angel and turned into a fortress by a succession of beleaguered popes. *Il passetto,* a passageway, links the papal palace to the fortress so that a pope under siege could escape capture by retreating to Castel Sant'Angelo.

Rovere walked the streets of Rome furious to be passed over yet exhilarated to be back. After so many years, the city felt both familiar and fresh. Threading his way through the alleys of the Borgo Vaticano, each bend, the very paving stones beneath his feet, familiar, della Rovere approached Constantine's basilica, hemmed in now by pilgrims' hostels and convents. He crossed the square and approached the broad courtyard, avoiding the spray from the giant pinecone fountain that gushed in the center of the atrium and the hawkers peddling souvenirs and roasted *ceci* beans.

Inside the church, allowing a moment for his eyes to adjust, he saw in the crumbling vastness a serene white marble sculpture like a shaft of pure light. A young girl cradled her murdered son, a man now, larger than she, full grown and bearded. He is a dead weight in her arms. The years dissolve for her, and the reality is, as it always was, mother and child. The Virgin Mary, in her unutterable grief, holds her only son for the last time, with the resurrection three days away and unknown to her. The *Pietà** translated into marble the words that Dante wrote in the *Paradiso*, "Mary, daughter of your son." The sculpture was the work of the young Florentine Michelangelo Buonarroti, and della Rovere must have come out of the church determined to have the services of the man who could fashion stone into such serenity.

The cardinal's exile had ended and with it, he believed, his quest for the papacy, but in the blue clarity of late October, the sun hot but not scorching and the Mediterranean still warm enough to swim, he had discovered the artist who would assure his own greatness.

It was some consolation for his papal ambitions, thwarted for the third time by the shadow, if not the person, of his Borgia nemesis. After Alexander's decadent pontificate, the Church needed a clean-living

*Because they stir feelings of *pietà*, or pity, images of Mary holding the body of her crucified son are called pietàs.

leader, and the new pope Pius III was true to his name. A man of un-questioned piety but little luck, he died after twenty-eight days.

Inevitably, when a pope succumbs so quickly, there is talk of poison. No conclusive evidence turned up to confirm or quiet the gossip, and by prudence or advance knowledge, della Rovere entered his fourth conclave with his cardinals all in a row. There was no suspense this time. After three whisker-thin defeats, he had corrected the odds.

On November 1, All Saints' Day, Giuliano della Rovere was elected Julius II, supreme pontiff of the Church of Rome, in a single ballot. It had taken almost twenty years and involved bribery, war, assassination plots, and at least the suspicion of poisoning—all very much business as usual in the Renaissance Church.

ംഗ്

When Constantine picked up the shovel in the Vatican field to build his shrine to Peter, he blurred the distinction between Caesar and God. In architecture, in art, even in liturgical ceremonies and spiritual symbols, pagan and Christian became jumbled. Classical myths and Christian themes became chapters in the same unending story. The confusion was incised on the bronze doors that the Renaissance sculptor Filarete* made for Constantine's basilica. There, pagan nymphs played while Christian saints prayed.

The secular and the sacred borrowed so freely from each other that by the time the Renaissance reached Rome, the two were as inseparable as body and soul. Christ's dictum "Render unto Caesar the things that are Caesar's and to God the things that are God's" was moot. Caesar and God—or his human proxy, the Vicar of Christ—were now one and the same.

*Filarete's bronze doors were added to the first St. Peter's in 1455. One of the few artworks salvaged from the old church, they were made the central doors of the new Basilica.

The Renaissance papacy became a government more than a religion, led by statesmen and sometimes warriors who could rarely afford to be saints. More princes than pastors, they played one covetous state against another to maintain a balance of power.

There was no single road to the papacy, no character requirements or moral litmus test, and for the most part, the popes who followed Nicholas were worldly, pragmatic men concerned with consolidating temporal power. Behavior that had called for punishment and purification in the medieval Church was accepted with occasional concern but no censure.

The Renaissance popes were not distant spiritual figures. They were fighters in the center of the fray, sometimes captured, imprisoned, exiled, or poisoned. Within their ranks were pure souls and rascals, brilliant minds and bureaucrats, and this one indomitable warrior-patron.

∞

Julius II was the most momentous of pontiffs. In personality, a colossus. "All knew him to be a true Roman pontiff—full of fury and extravagant conceptions," a contemporary remarked. He dominated his age as he dominates the fresco by da Forlì. His goal was greatness—for the papacy, for the Church, and for the city. He expected it of himself, and he tolerated nothing less from others.

Modesty has never been a Roman virtue. If everything in moderation was the Socratic ideal, everything in excess was the Roman counterpoint. Pagan Rome was immoderate in its ambitions (its emperors were imperialists par excellence), immoderate in its treacheries (think of the bloodbaths of Nero and Caligula), and immoderate in its architecture (the Basilica of Maxentius covered half a city block.)

The papacy of Julius II aspired to the same imperial dimensions. From the ashes of empire would arise the glory of Christendom. Under Julius, Christian Rome would become more magnificent and

mighty than the city of the Caesars. Although he shared Nicholas V's aspirations for the city and the Church, Julius was no philosopher-king. It was said that he sat as easily in a saddle as he did in the Sedia di San Pietro. A battering ram of a man, he possessed a short temper, a powerful mind, and boundless ambition; he was irascible, irreverent, intractable.

Although it was Cosimo de' Medici who said, "We cannot govern a state with paternosters," the sentiment is pure Julius. He had no time for contemplation or the finer points of spirituality. He had waited twenty years for the papacy and he seized it absolutely, driving himself into battles and fighting them all—military, political, personal, and artistic—with ferocity.

The state of the Church was ambiguous at best. Upstart princes had usurped its temporal powers and dissolute clergy had made a mockery of its moral authority. Julius wanted no ambivalence in Christendom. His goals were sure and bold: to assert the authority of the Church by regaining control of the Papal States, lost during the sojourn in Avignon, and to display its power and prestige through art and architecture. To that end, he led an army of brawny Swiss mountaineers against recalcitrant princes and summoned an army of artists to create works that surpassed all other constructions.

His arsenal included unconventional weapons: papal bulls,* encyclicals, writs of excommunication, and indulgences. He rattled them as threats, and if his opponents resisted, he hurled them like javelins. When, for example, Bologna did not capitulate immediately to his will, Julius excommunicated the entire city, all who lived in it and their children, their grandchildren, and their great-grandchildren. He threatened the same against Venice, placing La

*The popes issued three types of missives: encyclicals, pastoral letters on a serious topic of concern; *brevi*, informal, "brief" announcements; and bulls, formal proclamations stamped with the official papal bull, or seal.

Serenissima under interdict and excommunicating the full Venetian Senate.

The contemporary historian Francesco Guicciardini described him as "a grand, indeed vast spirit, impatient, precipitous, open, liberal." And Guicciardini was a relentless critic. The Christian Caesar became the most formidable force in Europe—the preeminent power player and art patron.

There is no need to follow the twists and turns by which the papacy gradually reestablished its dominion. The treaties, battles, and plots are transitory beside the art and architecture that Julius commissioned. Like the Medici in the previous century, he was a one-man MoMA, underwriting the best contemporary artists. With charm, threats, bribes, and flattery, he wheedled work from them that they had never shown themselves capable of before. The art that he commissioned became the masterpieces of Western civilization. Although his papacy spanned only a decade, they were ten tumultuous years.

A TROJAN HORSE

❧

In the optimism of a new century, Julius II assumed the papacy and, early in his pontificate, called the sculptor of the *Pietà* to Rome, sending him one hundred ducats to cover traveling expenses.

Michelangelo di Ludovico Buonarroti-Simoni was born in Caprese, in the upper Arno valley just north of Florence, on March 6, 1475, one of five sons in a family with little money but pretensions to nobility. Those pretensions bred a defensive pride that could turn to insolence. Lorenzo il Magnifico brought the young artist into his palace for training. Michelangelo grew up with the Medici princes, the fatuous Giovanni and his more cerebral cousin Giulio, the future Medici popes.

His talent was precocious. By the age of twenty-nine, he had carved the *Pietà*, sculpted the giant *David*, and created the first art forgery on record. Although Julius was living in France when the fraud was perpetrated, he undoubtedly received a full account of the escapade from his cousin, who happened to be on the receiving end of the hoax.

The fake was a marble Cupid, and according to Michelangelo's pupil and biographer, Ascanio Condivi, a Medici patron instigated the deception. "If you were to prepare the cupid so that it should

appear to have been buried, I shall send it to Rome and it should pass for an antique, and you would sell it much more profitably," he told Michelangelo. Cardinal Riario, an astute collector, bought the pseudoantiquity for two hundred ducats. The dealer told Michelangelo that the payment was thirty ducats.

When Riario discovered the trickery, he dispatched an envoy to Florence to confront the forger. Instead of being apologetic or embarrassed, Michelangelo was indignant that the dealer had gypped him. Claiming he was the one who had been defrauded, he went to Rome to meet the cardinal and be recompensed. Michelangelo ended up living and working in Palazzo Riario for almost a year. Now, nine years later, he was recognized as the most talented sculptor in Christendom.

Michelangelo was an ardent young man when he met Pope Julius for the first time, single-minded in his faith and in his art. All of his disappointments were ahead of him. Their first meetings were probably models of decorum. Julius was an imposing figure, much bigger than the artist, and even without the papal panoply, he would have been intimidating. But seeing genius in the young man, Julius welcomed him kindly, like a father.

Michelangelo knelt and kissed the pope's foot, encased in a red silk slipper. In spite of his acclaim, the artist was still naïve and socially awkward. He would never be adroit at palace politics. He was too hot-tempered, too quick to take offense, feeling slights when none were intended, his ego as fragile as it was large. Michelangelo was slight but sinewy with a compact build, his arms and torso muscled from the physical labor of hauling and hewing stone. His forehead was broad, "his eyes the color of bone," Condivi wrote, his nose squashed, smashed by another artist in a fit of jealous pique.

Like Julius, Michelangelo belonged to the Renaissance in time but not in temperament. Patron and artist were not cool, serene souls. They were explosive personalities with epic ambitions and egos to match. Art was more than their passion. It was a life force, like air, water, or the Church of Rome. In agreement, they would be unassailable. At odds, volcanic.

Michelangelo could not help but be flattered by the pope's praise and excited by his words: "*Magari,* my son, if you could sculpt anything, what would it be?" Pope and artist met over several weeks and considered many ideas. Julius wanted a lasting memorial that would be a testament to his pontificate. He may have imagined a sculpture as serene and poignant as the *Pietà* or a monument-tomb as enduring as the pyramids of the pharaohs or the mausoleum of the emperor Hadrian.

After numerous sketches, Michelangelo drew a funerary monument worthy of a second Caesar. His excitement was so keen that, if he'd had the stone, he would have begun sculpting that very day. The sarcophagus he imagined would be a memorial for the ages— a colossal, freestanding monument, carved from the purest marble, with forty statues, each one several times larger than life. The central figure would be a mighty, seated Moses with the papal countenance. It was an apt allegory.

Although the exact design of the tomb is not known, Condivi and Vasari give similar dimensions in *braccia,* the equivalent of about two feet: "Because it would show the greatest magnificence, he directed that it should stand alone so that it could be seen from all four faces, which had two sides measuring 12 *braccia* and the other two 18 *braccia,* so that the proportion was a square and a half."

Michelangelo believed the tomb would be his masterwork. "If God assist me," he vowed to Julius, "I shall produce the finest thing that Italy has ever seen." The grandiose sculpture was more

triumph than tomb—a victory monument like the arch that Constantine had built to commemorate his glory at Ponte Milvio. It was a rash, brash exercise in hubris, and no design since the Trojan Horse has had such momentous consequences.

∞

In March 1505, an exultant Michelangelo departed Rome in search of the perfect marble. He disappeared for months in the quarries of Carrara "with two assistants and a mule," leaving the most basic question unresolved: Where would the tomb go? The obvious location was Constantine's basilica, but the enormous size of the sculpture posed a problem. The old St. Peter's was crowded with shrines, altars, oratories, and sarcophagi that had been added over the centuries. There was no room for such a huge memorial.

While Michelangelo hunted in the mountains for the perfect stone, Julius rummaged through the Vatican archives and dusted off Nicholas V's Basilica plan. Coincidentally, both pontiffs had been born in Liguria, Julius the son of a fisherman, Nicholas the son of a physician, and both had definite ideas about creating a papal palatine. In 1451, Nicholas had brought the architect Bernardo Rossellino from Florence and collaborated with him on a major renovation of Constantine's basilica. In his biography of Pope Nicholas, Manetti described the plan:

> All that the progress of art and science had achieved in the way of beauty and magnificence was to be displayed in the new St. Peter's. The plan of the church was that of a basilica with nave and double aisles, divided by pillars, and having a row of pillars along each of the outermost aisles. Its length was to be 640 feet, the breadth of the nave 320; this was to be richly decorated, and the up-

per part of the wall pierced with large circular windows, freely admitting the light. The high altar was to be placed at the intersection of the nave and transepts, and the Papal Throne and the stalls of the Cardinals and the Court within the apse. The roof was to be of lead, the pavement of colored marbles. . . .

Because the Rossellino-Nicholas design closely followed Constantine's, it is not clear whether it was a study for a new church similar to the original or a renovation project to enlarge the old basilica and fortify it with new exterior walls. In any event, in 1452, Rossellino, who had worked with Filippo Brunelleschi on the design of the lantern for the cathedral dome in Florence, began erecting a huge new tribune, or western apse (a half-circle at the end of a main arm). One hundred forty-three feet long and twenty-two feet thick, the new tribune was located beyond the exterior wall of the original apse and would have extended the basilica.

Shortly after construction started, Leone Battista Alberti, the foremost architectural theorist of the Renaissance, came from Florence to present Nicholas with his treatise on architecture *De re aedificatoria*. It was the perfect gift for a pope who wanted "to spend all that he possessed on books and buildings." While he was in Rome, Alberti inspected Constantine's basilica for Nicholas and found that the walls were seriously out of plumb.

Alberti's report was dire. "I am convinced," he wrote, "that very soon some slight shock or movement will cause the south wall to fall. The rafters of the roof have dragged the north wall inwards to a corresponding degree." Nicholas had already sunk 31,559 ducats, a significant expenditure, into the basilica.* But Alberti, a strict

*The money covered new windows, supplies of timber and beaten gold, and wages.

humanist, may have recoiled at the grandiosity of Nicholas's "glorious temple," because work on the tribune halted abruptly when the new wall was only seven and a half feet high.

In 1505, Rossellino's unfinished tribune was still standing behind the old basilica. If completed, it would be large enough to house the tomb. Julius studied the Rosellino-Nicholas plan and conferred with his architect Giuliano da Sangallo. Sangallo, the patriarch of a talented Tuscan family and a longtime friend of both Julius and Michelangelo, expressed reservations. He thought Michelangelo's tomb deserved something singular. Instead of enlarging the old church, Sangallo proposed building a separate chapel to "bring out all the perfection of the work."

Still undecided, Julius invited the opinion of a second architect, Donato Bramante. A newcomer to Rome full of enthusiasms and ideas, Bramante was beginning his first project for the pope— designing a courtyard and gardens in the Vatican.

Central to any discussion of enlarging or restoring the old St. Peter's were two basic issues: condition and cost. Some fifty years had elapsed since Alberti's warning, and Constantine's basilica was in dangerous disrepair. It was 1,200 years old, and although there had been some renovation work through the ages, there had been longer periods of neglect. The cost of renovating the venerable shrine would be prohibitive.

As Julius and his architects discussed the issues, Bramante may have thrown out a novel notion: Instead of tampering with an ancient edifice, for the same amount of time and money, he could tear down the old St. Peter's and build a new one. Although it may have been an offhand remark, the very thought was blasphemy.

∞

Constantine's shrine to St. Peter was based on the design of the secular basilicas of imperial Rome—enormous rectangular indoor forums used as meeting places, tribunals, and money markets. The original St. Peter's was a simple structure in the shape of the cross that had brought martyrdom to Christ and Peter and victory to Constantine at Ponte Milvio. The cross became the symbol of the empire's new, official faith.

Consecrated in A.D. 326, the original St. Peter's was four hundred feet long by two hundred feet wide, with a large atrium, five columned aisles, and a timber roof, which was later covered with gilded bronze plates filched from the Basilica of Maxentius. The penchant for stealing from a predecessor's monument was a bad habit of the emperors, and the popes continued the architectural plundering to rebuild Rome.

Constantine placed the main altar over the bones of Peter. A protective wall surrounded the grave, and over it, he raised a solid gold cross, fulfilling the scripture: *"Tu es Petrus et super hanc petram aedificabo ecclesiam meam"*—"Thou art Peter and upon this rock I shall build my church." Weighing more than 150 pounds, the cross was inscribed with the legend: "Constantine Augustus and Helen Augusta built this royal chamber, surrounded by the Basilica shining with a similar splendor."

Although the oldest church in Rome and the official seat of its bishop was St. John Lateran, the shrine to St. Peter was the theater where the drama of the Roman Church had been staged throughout its first millennium.

Thirty generations of pilgrims had come from every corner of Christendom to worship in the old St. Peter's. Many of the pilgrimages were as quixotic as the journey of the three kings to Bethlehem. Caedwalla, a barbarian king, traveled all the way from West Saxony by sea and land to Rome. On Easter Saturday,

A.D. 689, dressed in a white baptismal gown, he was christened Peter by the pope. Caedwalla-Peter seems to have started a trend, because ten years later, two more British warlords made the hazardous trip from Britain to Rome. Since recognition by the pope conferred legitimacy to civil authorities, it was a journey of political expediency as much as faith. Not to be outdone by Caedwalla, they not only submitted to baptism, they became monks, shearing off their warlocks and dedicating their lives to St. Peter.

One hundred eleven years later, on Christmas Day A.D. 800, Charlemagne knelt on a slab of red porphyry before Pope Leo III and was anointed the first Holy Roman Emperor. The papal librarian Anastasius described the scene:

> The gracious and venerable Pontiff did with his own hands crown Charles with a very precious crown. Then all the faithful people of Rome, seeing the defense he gave and the love that he bore to the Holy Roman Church and her Vicar, did by the will of God and the Blessed Peter, the Keeper of the Keys of the Kingdom of Heaven, cry with one accord: "To Charles, the Most Pious Augustus, crowned of God, the Great and peacekeeping Emperor, be life and victory."

Every successive Holy Roman Emperor knelt on the same stone to be crowned. Ethelwulf of Britain went to Rome for his coronation, too, and brought his six-year-old son, who would become the great English king Alfred. For what he called "the welfare of his soul," Ethelwulf ever after sent an annual donation of 300 marks to Rome from his personal horde: 100 marks for oil to light the lamps of St. Peter's on Easter weekend; 100 to do the same at St. Paul's Outside the Walls, and 100 for the pope's personal use.

Ethelwulf's donation was the beginning of Peter's Pence, the annual drive of the Roman Catholic Church to this day.

Over the centuries, the encrustations of history had grown around the original church like barnacles on the rock of Peter. The old church had been looted, embellished, desecrated, and ornamented with mosaics, frescoes, statues, precious gems, gold, and silver. Chapels and memorials had been tacked on haphazardly. Constantine's basilica came to symbolize the resilience and continuity of the Church.

One hundred eighty-four popes had been consecrated in the first St. Peter's, and dozens of martyrs and saints were buried within its walls. The history of the faith could be read in its timbers, in its aisles and altars, and its proposed destruction caused a furor. Christians were outraged. The scholar-monk Desiderius Erasmus of Rotterdam condemned the new Basilica as a sacrilege and a grandiose waste of money. The new Julius, with pretensions to be the Christian Caesar, was displacing layers of history, disturbing the bones of pagan Romans and Christian martyrs and despoiling a hallowed shrine to satisfy his own megalomania.

To the della Rovere pope, the idea of replacing Constantine's church was unthinkable, dangerous—and irresistible. Michelangelo's tomb would glorify the man. A new Basilica, more splendid than any imperial construction, would glorify God and confer honor and renown on its architects for all time.

Although there is no way to know absolutely who had the idea to build a new Basilica, or what passed among the pope and his architects, Vasari suggests that once the idea was aired and Bramante saw "the powers and desires of the Pope rise to the level of his own," he began to work on "an endless number of designs."

Over the objections of cardinals, kings, and true believers, Julius forged ahead. In the newness of his papacy and in his supreme

arrogance, less than two years after virtually buying the throne of
Peter, he decreed that the original basilica, built by the emperor
Constantine over the tomb of the apostle, would be razed and a
new, more magnificent and monumental church constructed on the
site.

CHAPTER FIVE

A SURPRISE WINNER

❧

P ope Julius II's eagerness to build was so great, Vasari writes, that he "would have liked to see the edifice sprung up from the ground, without needing to be built." Rejecting the Nicholas-Rossellino plan as clunky and old-fashioned, he called for new designs. Two architects* were in contention. The first was Giuliano da Sangallo, who assumed that the commission would be his.

No name is found in the account books of the building of St. Peter's with more frequency than Sangallo. It is not a true surname but the name of a district of Florence, which was home to Giuliano and Antonio di Francesco Giamberti. The brothers "from Sangallo" were Tuscan guild artisans (members of l'Arte dei Legnaiuoli, the guild of sculptors, architects, bricklayers, masons, and carpenters). Because artists traveled from job to job, they were frequently identified by their home area—Leonardo da Vinci or Giuliano da Sangallo. The Sangallo brothers began as cabinetmakers and carvers, working in both wood and stone, and, like most Renaissance artists, they mastered many crafts.

*There is some indication that Julius also consulted Fra Giovanni Giocondo da Verona, reputedly the finest architectural engineer of the day, who was working in Paris in 1505. A sketch in the Uffizi is annotated "Fra Giocondo's opinion."

Giuliano had probably worked on St. Peter's for Rossellino, be-
cause he is first noted in the Vatican records between 1467 and 1472
as a wood-carver. His name does not appear again for some thirty
years. Returning to Florence, he became architect to Lorenzo de'
Medici and gained a reputation for building military fortifications.

After Lorenzo's death in 1492, Sangallo became personal archi-
tect to Julius and a close friend, even going into exile with him. The
years spent scheming a comeback in France had been long and
frustrating, but now his patron was primate of the Church and first
prince of Europe. It was a time of jubilance and creative expecta-
tions. The new pope was known to be a generous and discriminat-
ing patron, and every day more artists, musicians, and scholars
came to Rome, hoping to work for him.

Art was an integral part of the political game. From triumphal
arches incised with an emperor's heroics to Renaissance frescoes,
art was a measure of refinement and wealth, a conspicuous display
of position and power, and a means of conveying a message. Today,
we have the media blitz, a barrage of television, print, advertising,
and the Internet. Renaissance popes and cardinals had sculpture,
frescoes, churches, and palaces. Since the vast majority of ordinary
Christians were illiterate, art was the only mass medium, and pon-
tiffs and princes lavished money on it. The popes who built St. Pe-
ter's were the Morgans and Rockefellers of their day, and many
artists became wealthy working for them.

Renaissance artists used medals like business cards, with their
portrait on one side and a favorite work on the other. A coin of
Giuliano da Sangallo shows the artist in profile, his head wrapped
in a turban, a flowing beard reaching to his chest. Prominent cheek-
bones jut like stony outcrops, and nostrils flare. His expression sug-
gests an impatient stallion of a man, proud and assured. Sangallo
fully expected to be named *magister operae*—master of all Vatican
works. He had coffered the ceiling of the Basilica of Santa Maria

Maggiore, using the first gold from the New World, and built the della Rovere palace. More significantly, he was thoroughly trained in Roman architecture and had employed imperial forms in a number of his best buildings. Although Sangallo was a gifted architect, his design fell short of the pope's expectations. The reason may be discerned from the judgment of Vasari: Sangallo represented the Tuscan style "better than any other architect and applied Doric order more correctly than Vitruvius."

Julius wanted much more. The Cinquecento must have seemed like a miraculous time. The world was embarking on the Age of Discovery. Unimagined lands were being mapped, conquered, and claimed, and oceans of gold and silver would soon wash across the seas from the Americas.

Julius wanted his own miracle in stone—a Basilica that would "embody the greatness of the present and the future," that would dwarf the epic constructions of the Caesars and proclaim the power and the glory of Christ and his Church. For this— the enterprise of the century—he turned to his new architect, Donato Bramante, an amiable, middle-aged man of no soaring accomplishments. Bramante's only notable building in Rome was the Tempietto, the "little temple" still under construction on the Gianicolo in the shadow of San Pietro di Montorio. It was a flawless miniature—nothing as perfect had been built in Rome since the Temple of Venus—and it had captivated Julius.

The art world of 1505 was a whorl of internecine rivalries, and within those fiercely competitive circles, the pope's choice was stunning. Bramante was an outsider, not part of any clique. He had come from the court of Urbino, by way of Milan, where he had been a friend and collaborator of another notable outsider, the unpredictable Leonardo da Vinci.* The selection of Bramante put

*Although Leonardo was a Tuscan, he was never part of the Florentine faction.

Sangallo, Michelangelo, and the other Florentine artists on guard. The sides were drawn before the first stone of the Basilica had been laid.

Julius had a keen understanding of the artistic psyche. Although history portrays him as a ferocious character, the man who built a palace to shelter a broken torso of Apollo and ordered all the church bells of Rome to ring when the Laocoön was unearthed could not have been soulless. He tried to let Sangallo down kindly, but after so many faithful years, the rejection carried the sting of betrayal. Sangallo had been so confident of the appointment that he had made plans to move his family to Rome, and he felt "put to shame" by the pope.

Sangallo returned to Florence an angry and bitter man, and Bramante began to build a new Rome.

<center>∞</center>

Though often overlooked today, Donato di Pascuccio d'Antonio, known as Bramante, was the fourth giant of the High Renaissance— together with his nemesis Michelangelo, his protégé Raphael, and his friend Leonardo. Bramante was a maverick. No artistic ties bound him to a particular school. He was not a Lombard, or a Tuscan like Sangallo.

In the self-portrait we have of Bramante, a fleshy lower lip juts from a shrewd, lined face. Small alert eyes appear ever vigilant. He was bald and ugly, a jovial, earthy man, a teacher, a mentor, an artful power player—and something of a surprise. How did he come so late in life and so unexpectedly to design St. Peter's and claim the title preeminent architect of the High Renaissance?

Although his early life is sketchy, there are a few clues. First, Bramante had the good fortune to be born in the duchy of Urbino, an enclave of Renaissance culture. Born to a farming family in 1444, two years before the death of Brunelleschi, he was named Donato—"the little gift." After seven daughters, the arrival of a son who could work

on the farm seemed like a gift from God. To the dismay of his family, Bramante showed no interest in farming. Instead, he trained as a painter in the palace of Urbino's ruler, Duke Federigo di Montefeltro.

An amateur architect and a man of exquisite refinement, Duke Federigo embodied humanism at its purest. When asked what was required to rule a kingdom, he answered, "*Essere umano*"—"To be human." It was said that "no one of his age, high or low, knew architecture so well." Among the painters in his court in Urbino were Andrea Mantegna, Piero della Francesca, and Giovanni Santi, who was more blessed as a father than an artist. His young son's name was Raphael.

Bramante was equally fortunate to leave the serene duchy for the sinister court of Ludovico Sforza. The condottiere prince of Milan known as "il Moro"—"the Moor"—because of his dark complexion and brooding disposition, Ludovico also prized paintings and buildings, but for different reasons. To Duke Federigo they were objects of beauty. To il Moro, they were displays of power. If Urbino embodied the harmonious Renaissance, Milan was its evil twin. In the menacing atmosphere of il Moro's court, Bramante mastered the political arts.

He was earning five ducats a month as painter and architect in Milan, when a thirty-year-old artist arrived from the Republic of Florence, bringing with him a silver flute that he had fashioned in the shape of a horse's head. The newcomer's name was Leonardo da Vinci, and the horse was one of his many preoccupations. Leonardo's official title in the Sforza court was *ingeniarius ducalis*—"the duke's inventor."

Since Bramante played the lyre and sang, the two young men may have accompanied each other. Both were illiterate, according to the humanist standards of the day—they didn't speak or read Latin, and neither attempted Greek. But they tried their hand at just about everything else. Bramante loved drama, and they designed stage sets together and sketched out various solutions to engineering questions.

During this period, probably in the late 1480s, il Moro was thinking of building a new palace. Instead of using his own artists-in-residence, he asked Lorenzo de' Medici to send an architect from Florence. Lorenzo dispatched Sangallo. Leonardo and Sangallo probably knew each other, but this was Bramante's first encounter with the architect against whom he would compete two decades later for the Basilica commission.

Sangallo had spent several years in Rome, and at the time he visited Milan, he knew the monuments of the emperors more thoroughly than any other artist. We can only guess how Bramante and Leonardo reacted to his arrival, or whether the three discussed the building methods of the Romans. We do know that il Moro "was filled with astonishment and marvel" when he saw Sangallo's model palace.

For close to twenty years Bramante and Leonardo worked together in Milan, exchanging ideas, experimenting, and studying the principles of the Roman architect Vitruvius. The only classical book on architecture that had survived the ages, the Vitruvian text had become the bible of Renaissance builders. Vitruvius saw architecture as analogous to the human body, "each limb belonging to the whole" and proportional to it. The image of a male figure, arms extended and legs akimbo within a circle, symbolized man as the ultimate measure. In his architectural drawings, Leonardo experimented with the concept. Although he never built anything himself, his drawings of centrally planned churches* clearly influenced his friend's design for St. Peter's.

In 1499, Milan fell to the French, and Bramante moved to Rome, where he experienced an epiphany. Rome was a cemetery of history, and the ghosts of its imperial past were its ruins. Even in rubble, the architecture of the emperors was a revelation.

*In a central plan, whether designed as a Greek cross or as a circular Roman temple, the main altar is placed at the central point of the church.

Bramante stopped working, lived as cheaply as he could on the money he had saved in Milan—which couldn't have been much given his five-ducat salary—and spent the next several years measuring the enormous edifices: the Pantheon with its simple geometry and massive saucer dome, the vast aisles of the Basilica of Maxentius, the immense vaults of the Baths of Caracalla.

His tools were the same ones the ancients had used: a level, compass, and straight edge, an astrolabe for determining slope, and a Jacob's rod for estimating depth and distance. To figure the height of an edifice, Bramante probably used a quadrant, a graduated arc of 90 degrees with an attached plumb line for fixing the vertical direction. Or he may have used a simple mirror. Laying a mirror on the ground so that the top of the building was reflected in its center and measuring the distance from the base of the building to the mirror, he could then calculate the height of the building.

Until he arrived in Rome, Bramante had never encountered volume, space, and mass on such a monumental scale. He studied the ruined antiquities closely both as works of art and as lessons in engineering. In Rome, Bramante encountered the heroic dimensions of the imperial city and the heroic dimensions of Julius II.

In October 1505, imagination, opportunity, and enterprise converged. Julius officially accepted Bramante's design for the new Basilica of St. Peter, saying that it showed "the finest judgment, the best intelligence, and the greatest invention." The architect's ambition was as vaulting as his own. Bramante wanted to build a Basilica that would "surpass in beauty, invention, art, and design, as well as in grandeur, richness, and adornment, all the buildings that had been erected in that city."

CHAPTER SIX

IMPERIAL DIMENSIONS

෨෬

If a grain of sand can show us the world, then Bramante's Tempietto can show us his Basilica. Alberti defined architectural perfection as a geometric construction in which all elements are proportioned exactly. He called it *concinnitas:* "I shall define Beauty to be a harmony of all the parts, in whatever subject it appears, fitted together with such proportion and connection, that nothing could be added, diminished, or altered but for the worse. . . ."

Begun around 1502 and celebrated ever since, the Tempietto exemplified that Renaissance ideal in microcosm. It is impossible to imagine the slightest modification. Just fifteen feet in diameter, it was commissioned by Spain's royal couple, Ferdinand and Isabella, a decade after they had sponsored another aging Italian's quixotic adventure.

Bramante's "little temple" turned the circular temple of antiquity into a Christian martyrium. Sebastiano Serlio, whose sixteenth-century book on architecture stands with the works of Vitruvius and Alberti, calls the Tempietto "a model of balance and harmony, without a superfluous detail. The circle of the ground plan, the height of the drum, and the radius of the dome are in exact ratio one to the other."

The Tempietto and the Basilica are Bramante's foremost achievements. Both are dedicated to St. Peter, and they are the smallest and the grandest constructions in Rome.

∞

For many years, in the Uffizi Gallery in Florence, in a small room with a view of the Arno, ochre colored and meandering, within the Gabinetto Disegni e Stampe Architettura, inside an imposing armoire that appeared as old as the building, a cloth-covered box, eighteen by twenty-four inches or so, held an architectural study, labeled Uffizi No. 1A. It is one among scores of drawings, nine hundred in all, dating from the same few years, 1503–13, the papacy of Julius II. Most of the studies were executed for Bramante by his pupils and assistants.

Uffizi No. 1A is different from the others. The paper, though now too brittle to touch, was more expensive and of a higher quality than the typical drawing paper from the same period. It was folded over several times, and each crease is worn thin and cracked. When opened the plan measures more than three feet by twenty inches and is drawn on a scale of 1:150. In spite of its large size, it is only one half of a blueprint known as the Parchment Plan. The missing half was presumably a mirror image.

The study was drawn in brown ink, then traced over in watercolor. Though faded now, the wash is still a warm umber tone, a few shades softer than the roof tiles of Tuscany. On the back, scrawled in ink, is a note saying, "*di mano di Bramante, non ebbe effetto*," in effect, a plan "by the hand of Bramante, never executed."

The Parchment Plan may be the very paper that Bramante presented to Pope Julius, and later showed to the workers when he was explaining his design for the new Basilica. Together with the commemorative medal coined for the foundation-stone ceremony, it

gives the best visual clue to his original design. The one shows the interior, the other the exterior.

For the first church of Christendom, Bramante imagined the dome of the Pantheon raised on the shoulders of the Basilica of Maxentius, the last and largest basilica built by the Roman emperors. On the commemorative medal, the Basilica appears as a vast horizontal structure, with a hemispherical dome rising above a colonnaded drum. There is a bell tower on each end and four secondary towers.

Like the original St. Peter's, Bramante's design fused the Christian shrine to a martyr and saint with the pagan basilica. Placed directly over the apostle's grave, the martyrium was the essence of the new St. Peter's. It was also Bramante's boldest concept and greatest challenge. Like the Tempietto, his St. Peter's was a central plan—round because the circle, without beginning or end, is the perfect symbol of God, and domed. An immense basilica extended from the central shrine.

Bramante's design was both true to the Renaissance ideal and a radical departure from it. He composed an exercise in geometry, made up of perfectly proportioned parts within parts. It was a symmetrical Greek cross with four arms of equal length. The interior was a series of identical shapes in ever-diminishing size. Within each arm were smaller crosses, and within their arms still smaller crosses forming chapels, each exactly half the size of the next largest. The four corner chapels were as big as most conventional churches. By making them replicas on a 1:2:4 ratio, Bramante drew attention to the enormous central space.

Although the Renaissance ideal was Greek in spirit, shape, and scale, Bramante's Basilica was Roman. He was inspired by two of the monuments that he had studied so closely, yet he departed dramatically from imperial architecture. Ancient Roman basilicas were

rectangular roofed constructions, Roman temples were domed. By uniting these two distinct imperial forms—the basilica and the temple—he imagined a new Christian Basilica.

Bramante's first inspiration, the Basilica of Maxentius, also known as the Temple of Peace, opens onto the Forum and was reputedly the last, the largest, and the most magnificent basilica built in Rome. It was begun by Maxentius in A.D. 308 and finished by his rival and challenger Constantine five years later, no mean feat considering its massive size—115 feet high by 262.4 feet long. Like the typical Roman basilica, it was a rectilinear construction, but it rose to a distinctive three-dormered roof. Two stories of tall arched windows filled the interior with light. Within the basilica, marble colonnades divided the vast space into a high wide nave flanked by narrower aisles. The nave ended in an apse, which Constantine filled with a heroic-size statue of himself.

Bramante's second inspiration is an architectural wonder. The Pantheon is a large circular edifice, built as a pagan temple to the multiple gods of Rome and some time later rededicated to the Blessed Virgin. Each element of it astounds: the brilliant lighting achieved by a single eye in the sky—a 27-foot-wide oculus in the center of the dome; the solid walls 15 feet thick bearing the weight of the dome; and the massive dome itself. A marvel of construction and engineering, it is a 143-foot hemisphere, equal in diameter and height, constructed of cement faced with brick.

Monumentality was a distinctly Roman conceit, and Bramante embraced it. His Basilica covered 28,700 square yards—a third again (11,350 square yards) as large as

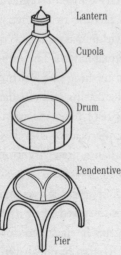

Lantern
Cupola
Drum
Pendentive
Pier

The parts of a dome.

St. Peter's is today. Like the Pantheon's dome, his was as smooth and shallow as a porcelain saucer. Yet there were radical differences. Ancient temple domes sprang directly from the circular outer wall.

Bramante's cupola rested on a drum—a ring of uniform columns, each one 60 feet in circumference—and was held aloft by four massive piers. Arched by coffered barrel vaults, it towered 300 feet in the air. Its width was almost twice that of the nave and its diameter of 142 feet was equal to the Pantheon's and just shy of the Duomo's in Florence. Like the dome of the Pantheon, it was planned as a single shell constructed of cemented masonry. Bramante carried through the same 1:2:4 ratio in the proportion of the crossing arches to the dome. Their height was twice their span, and the total height of the dome was four times the arch span. For the exterior, he imagined a crescendo of smaller domes of increasing size over the apses and corner chapels culminating in the immense central dome.

By the norms of Renaissance architecture, Bramante's Basilica was revolutionary. In its titanic scale, in its use of space as an architectural force, and in its shape (the divine circle inscribed within a square), Bramante abandoned the serenity that was Greece for the drama that was Rome. The new St. Peter's has been called the boldest experiment in religious architecture ever conceived. Nothing comparable had been attempted since the days of imperial Rome when Constantine raised the first basilica.

∞

The Roman architects were extraordinary engineers. But somewhere on the long, rutted road from antiquity to the Renaissance, the techniques they devised to erect massive arches and vault vast spaces were forgotten. Even the material that made their feats of engineering possible was lost. To build his church, Bramante had to rediscover their methods.

Building on such a scale and with techniques not attempted for more than a millennium made much of the construction trial and error.

Bramante coaxed the secrets of the ancient architects from the ruined city and welded Roman forms to Renaissance principles. The papal goldsmith and memoirist Benvenuto Cellini described his skill: "Bramante began the great church of St. Peter entirely in the beautiful manner of the ancients. He had the power to do so because he was an artist, and because he was able to see and to understand the beautiful buildings of antiquity that still remain to us, though they are in ruins."

Centuries of architectural history and tradition came together in Bramante's plan—the arch, vault, and dome introduced by the elusive Etruscans; the harmonious proportion and unity of the Athenians; and the Romans' remarkable use of brick and concrete, which formed the structural basis for the domes, piers, and arches of their massive constructions.

❦

Concrete is one of those dull, unsung inventions that make extraordinary achievements possible. When the architects of the Caesars had the inspired notion to mix sand and volcanic gravel, they came up with a substance that was handy, plastic, and extremely durable. If they used bricks and poured concrete, they didn't need beams. They could support massive weights on piers alone and vault vast spaces, creating buildings on a heroic scale with immense open floors and soaring ceilings.

By the second century, Romans were building both infrastructures and architectural marvels with concrete masonry. They could produce it cheaply and easily by combining pozzuolana, a volcanic gravel, with lime, broken stones, bricks, and tufa, a porous deposit found in streams and riverbeds. The ingredients were mixed with a

small amount of water and beaten vigorously. The small proportion of water allowed the cement to set quickly, and a thorough beating ensured a durable substance.

Roman concrete not only built the Pantheon, the baths, the aqueducts, and other engineering works, remnants of which still mark the landscape of Europe, it also paved all the roads that led to Rome.

To rediscover the brick-and-cement building skills of the emperors, Bramante studied the antiquities and consulted the Vitruvian text that Alberti had tried to interpret for Renaissance builders. As Alberti noted, Vitruvius was the only architectural writer to survive "that great shipwreck of antiquity," and he was such a poor stylist "that the Latins thought he wrote Greek and the Greeks believed he spoke Latin." From Vitruvius, Alberti drew attention to the giant pilasters, the colossal orders, and the massive barrel vaults that were essential elements in imperial architecture. Bramante would make them essential elements in the new Basilica, combining them in ways the Romans had never attempted.

In essence, barrel vaults are tunnels formed by a series of abutting arches. Because rigid concrete vaults exert no lateral thrust, the Romans could span expanses of vast height and width, creating a monumental architecture. For the concrete vaults in his new Basilica, Bramante had to train artisans in the "new" masonry and establish an on-site operation at St. Peter's to form, shape, and cut the bricks.

Writing some twenty years after Bramante's death, Serlio called him "a man of such gifts in architecture that, with the aid and authority given to him by the Pope, one may say that he revived true architecture, which had been buried from the ancients down to that time."

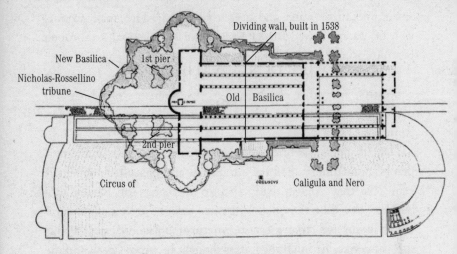

The plan of St. Peter's (drawn in gray) is shown in relation to Constantine's basilica (broken black line) and the imperial Circus of Caligula and Nero (solid black line). The small square to the left of the words "Caligula and Nero" indicates the original location of the obelisk.

VAULTING AMBITION

ॐ

I f Julius had chosen a more circumspect personality to be his architect, he might have had second thoughts about replacing Constantine's church, but the two men shared an exuberance, a rashness, and a rush to glory. Julius and Bramante were the same age, and they were conspiring in the most glorious escapade of the century.

In late fall of 1505, Bramante went to work, Vasari says, "with various extraordinary methods of his own and with his fantastic ideas." He started excavating the foundation for the northwest pier, known today as St. Veronica's. It was the first of the four massive piers that would support the Basilica dome. Digging started behind the old church, just west of the abandoned tribune of Rossellino and Nicholas.

In place of the planes and boxes that characterize Renaissance buildings, Bramante was constructing an architecture of cylinders and hemispheres. His interest was in the space itself, not the walls that enclosed it. The dynamic central space he devised gives the illusion of a centrifugal force pushing an ever-expanding space out into the arms of the church and beyond. In his architecture, solid geometry replaces plane geometry. Space and volume seem to come

to life, becoming active dimensions on a scale so awesome that they suggest an omnipotent agent.

Even a perfect miniature like the Tempietto cannot compete with a flawed but colossal construction. Heroic size is itself a claim to divinity, the ultimate chest-pounding. Modest men don't attempt the Colosseum or the Basilica of St. Peter, and if Bramante's Basilica had been built, it would have been the marvel of the High Renaissance. No wonder Michelangelo's tomb seemed diminished by comparison.

∞

Returning to Rome after eight months in the quarries of Carrara, the sculptor found a noisy, boisterous construction yard in St. Peter's Square. Oxen dragged broken arches and columns from the Palatine to recycle in the new church. Although much of the interior would be sheathed in the marble of the classical city, travertine was becoming the building stone of papal Rome.

So much of the honey-toned limestone was needed for its churches, fountains, and palaces that the Holy See leased an entire quarry in nearby Tivoli. Transporting the stone the twenty-mile distance to the work yard was a logistical enterprise, requiring a complete transportation system. Landing docks and convoys moved the stone by barge from Tivoli down the narrow Anio tributary that flows into the Tiber. Then mule trains and oxcarts carried the stone overland from the river to the Vatican.

Michelangelo was excited by the pope's plans for a new basilica and proud to be the cause of the hectic, busy scene. "*Venner ad esser a cagione di me*," he boasted—"It is happening on account of me." The new St. Peter's would be a magnificent home for his extravagant tomb, and he added happily to the chaos, dumping his own marble boulders in the piazza. The first load was probably "34 *carrate*, including two pieces that are 15 *carrate*." Michelangelo

had signed a contract on November 12 to have the stone sent to Rome. With one *carrata* equaling about 1,875 pounds, 34 *carrate* was more than 30 tons.

"So great was the quantity of marble that spread out on the square, it aroused wonder among all and joy in the Pope, and Julius showered such boundless favors on Michelangelo that after he started work, many and many a time the pope went right to his house in order to find him, discussing with him the tomb and other matters just as if they were brothers."

Michelangelo's studio was located behind the church of Santa Caterina della Cavellerotte,* close by the elevated stone passageway leading to Castel Sant'Angelo. The *passetto* was the popes' escape route in times of turmoil, and Julius ordered a bridge slung from it so that he could visit Michelangelo's atelier at any time.

In the first months of 1506, the pope visited often. Michelangelo didn't like to be interrupted when he was working, and even more, he didn't like someone looking over his shoulder. Julius barged in anyway at unexpected hours, unannounced and uninvited. Then in early spring, he promoted Bramante to *magister operae*, and soon after, his visits to Michelangelo stopped.

Michelangelo didn't complain. He worked without interruption through the forty days of Lent, too engrossed in sculpting the tomb to be anything but relieved that the pope wasn't banging down his door. Work in the construction yard quickened. At daybreak on *domenica in albis*,** the first Sunday after Easter, the pope was planning to lay the foundation stone of the new St. Peter's.

*The church would be torn down in the next century to make room for Bernini's colonnade.

**The first Sunday after Easter was called *domenica in albis*—"Sunday in white"—because the newly baptized wore white tunics for the week after their baptism on Easter morning.

In the beginning of April, Michelangelo received the bill of lading for an additional shipment of marble, probably another 56 tons, that had arrived at Ripa, a port on the Tiber. Just before leaving Carràra, on December 10, he had signed a second contract for "the extraction of the last 60 *carrate*, comprising four large stones—two of eight *carrate* and two of five *carrate*—with the remainder each weighing two *carrate* or less."

When he brought the bill to the papal palace for payment, he was told that the pope was too busy to see him—be patient, and try again tomorrow. He returned to the Vatican the next day, and the next. Each time, he was turned away, the bill unpaid, the door barred. Michelangelo did not doubt that the pope was occupied with the liturgies of Holy Week, and he paid the freight charges of 150 to 200 ducats himself. "I found myself very frustrated by lack of money," he wrote later. But more than Holy Week had intervened.

Michelangelo's grandiose sculpture had impelled Julius to replace Constantine's church. Now, building the new St. Peter's was consuming his attention.

On Saturday morning, April 17, a bishop from Lucca, who happened to be going into the palace, saw Michelangelo denied entry. "Don't you know who this is?" he said to the man.

"Forgive me, sir," the sentry replied, "but I have been ordered to do this."

Michelangelo was stunned. "No curtain had ever been drawn nor door bolted" against him before. "You tell the Pope," he shouted at the sentry, "that from now on if he wants me, he can seek me elsewhere."

Michelangelo suspected that Bramante was behind his banishment, and he scribbled an angry note to Julius: "This morning I was turned out of the palace by your orders; therefore, I give you notice that from now on, if you want me, you will have to look for me elsewhere than in Rome." In spite of his renown, he was still a naïf, and this was his first taste of treachery. With the lessons of

Holy Week fresh in his mind, he saw it not as one artist outmaneuvering another but as a dark plot by the architect and a personal betrayal by the pope.

By superior skill, duplicity, or an amalgam of the two, Bramante had displaced Sangallo. Now he had sidelined Michelangelo. The Basilica had eclipsed the tomb. Julius was pouring all his enthusiasm and funds into Bramante's masterwork. There was nothing left for Michelangelo's.

In pique and paranoia, believing that Bramante had "deprived him of the pope's favor" and "the glory and honor he deserved," Michelangelo fled from Rome under cover of night, just hours before Julius would lay the first stone of the new Basilica.

∞

The Renaissance art world was intimate, intensely suspicious, and covetous. To survive and thrive required craft as well as creative talent. Bramante possessed both. Free of provincial allegiances, open to new ideas, he reinvented himself in Rome. He was at the right place at the right time, and he was canny and congenial enough to exploit his good fortune. With the young sculptor back home in Florence, sulky and sore, the over-the-hill upstart installed himself in the Vatican.

As chief architect of all Vatican projects, Bramante became, ipso facto, the preeminent architect of the High Renaissance. His strengths were his enthusiasm, his curious, open mind, and a willingness, even eagerness, to experiment. In the beginning, he may have felt unsure. He was the newcomer, and beneath the bravura, the quick, often cutting, wit, and the sudden enthusiasms, he was always on his own, always unsatisfied and second-guessing himself. But as Vasari suggests, when Bramante saw a chance to upstage the Florentine artists, he "threw everything into confusion to persuade the pope to accept his proposal for a total rebuilding of the church."

He won over Julius and consolidated his new position by control-ling operations, dispensing assignments, and dividing the opposi-tion. Undercutting the papal favorites Sangallo and Michelangelo, he formed his own circle of loyal artists.

⬥

Although Leonardo is the most celebrated Renaissance man, he wasn't the only one. St. Peter's was designed in an age when archi-tects were more than engineers. They were artists, which explains why their works are so enduring, and to be an artist often meant being a painter, sculptor, poet, set designer, stonecutter, actor, musi-cian, administrator, and bill collector.

Today, when specialization has been cut so fine, the notion that someone might have so many talents may seem, at the least, an exaggeration. But what sounds incredible now was the norm in the Cinquecento. Most Renaissance artists were polymaths. Bramante, Raphael, and Baldassare Peruzzi were painters. Fi-lippo Brunelleschi, Michelangelo, and Gianlorenzo Bernini were sculptors.

Renaissance artists were traveling salesmen, brushes and chisels for hire, traveling from city-state to city-state, competing for com-missions. No longer bound to a specific guild as they had been in the Middle Ages, artists became independent contractors. Packing their pigments and saddling their horses, they shuttled from prince to prelate. Painting on canvas was just coming into vogue. (Michelangelo dismissed it as a pastime for dilettantes.) Since most paintings were murals of one kind or another, artists had to go wherever the work was, moving from town to town, from Florence to Pescara, Perugia to Milan, Urbino to Rome, and beyond.

The best were sought after and liberally paid. Their reputation was spread by envoys, ambassadors, and warring princes who came to Italy for conquest and found culture and the new art.

Among the seasoned artists who came from the north to work in the Vatican were Pietro Perugino and Bernardino "Pinturicchio" di Betto from Perugia and Luca Signorelli from Cortona. As long as Bramante was the unchallenged *numero uno*, he was magnanimous. He was genial and generous to his circle of artists, supporting them, not only for their talents, which were considerable, but also as a counterforce to the Florentines.

Bramante was equally generous and wily with the young artists whom he hired to work on the Basilica. He advanced the Sienese architect Baldassare Peruzzi, at least in part because he was the protégé of Julius's favorite banker, Agostino Chigi, and he employed at least three of Giuliano da Sangallo's nephews, possibly as a wedge to further divide the Florentine clique. Although his motives were not always pure, Bramante was such a fine teacher that his pupils became the leading architects of the next generation.

∞

While Bramante consolidated his position, Michelangelo sulked in Florence, protected by the Signoria and comforted by his aggrieved friend Sangallo.

Michelangelo believed that he had escaped from the imputations of an incorrigible patron, from the press of his own reputation, and from the architect-assassin scheming against him. Even as an old man, he never forgave or forgot. Some forty years later, he was still blaming Bramante to justify his flight from Rome: "If I fly into a passion, it is sometimes necessary, as you know, when defending yourself against evil people."

Julius bombarded the Signoria with missives, demanding the return of the sculptor "by force or favor." But urged on by Sangallo, Michelangelo rejected every overture, even the gentler ones.

Although the pope enticed Sangallo back to Rome in May, the two Florentines continued to seethe and commiserate in an exchange

of letters. While Sangallo certainly fed his friend's fears, Michelangelo was not without guile. Knowing that Sangallo would show the letter to Julius, he wrote to Sangallo in Rome:

> Giuliano—I have heard from one of your people how the Pope took my departure badly . . . and that I should return and not worry about anything. . . . I was sent away, or rather driven out, and the person who sent me packing said that he knew me but that he was under orders. So, when I heard those words that Saturday, and then saw what followed, I fell into deep despair. But by itself, that was not entirely the reason for my departure; there was something else again, but I don't want to write about it. Enough then that it made me wonder whether if I stayed in Rome my own tomb would not be finished and ready before the Pope's. And that was the reason for my sudden departure.

Julius certainly read Michelangelo's letter, because he renewed his efforts at conciliation. He sent the Signoria another brief that was paternalistic and forgiving:

> Michelangelo, the sculptor, who left us without reason, and in mere caprice, is afraid, we are informed, of returning, though we, for our part, are not angry with him, knowing the humors of such men of genius. In order then that we may lay aside all anxiety, we rely on your loyalty to convince him in our name, that if he returns to us, he shall be uninjured and unhurt, retaining our Apostolic favor in the same measure as he formerly enjoyed.

Caught between two towering tempers, Piero Soderini, the leader of the Signoria, tried to soothe them both. While urging Julius to "show the artist love and treat him gently," he warned Michelangelo that his insolence was on a scale that "not even the King of France would dare against the Vicar of Christ." Negotiations between the two camps continued with no resolution. By the end of summer, the soldier-pope was on the warpath.

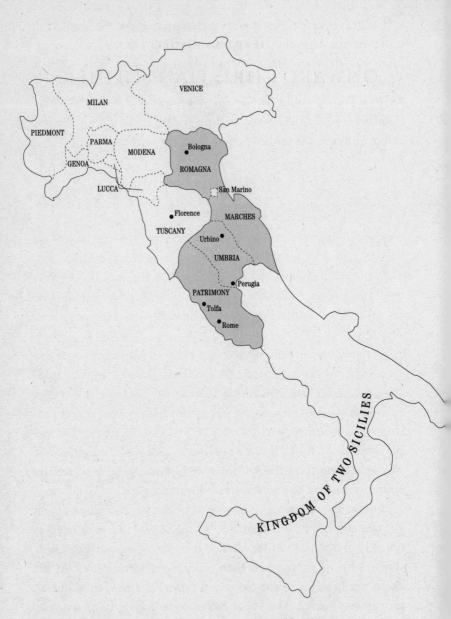

The highlighted areas show the territory claimed by the papacy.

ONWARD CHRISTIAN SOLDIERS

◆

In August 1507, *il pontefice terribile* strapped on his armor and led an army north into the Papal States of Umbria and Romagna, lost when the popes were in Avignon. Local princes and condottieri had taken advantage of the power vacuum to usurp control, and Julius was determined to retake the pivotal territory.

Although the unholy sight of the Vicar of Christ leading a battle charge appalled many devout believers, Julius's military campaigns were not motivated solely by a warlike disposition. While he relished every battle, military, political, and personal, it was prudence of a sort that drove him to war. The Papal States were strategic territory on the land route between Europe and the East, and if he could bring them to heel, they would once again be a lucrative source of income to replenish the Vatican treasury.

Julius had inherited a bankrupt Church. His predecessor, Alexander VI, the most carnal of all the popes, had lived in open adultery and plundered the Vatican treasury, squandering an inordinate sum of money and time on his profligate brood. At his death, the behavior of the clergy was raising alarms even in liberal, humanistic circles. The Papal States were going their own way. Only one of the ancient aqueducts was still functioning, which

meant that most Romans were drinking dirty river water, and there wasn't enough money in the treasury to meet even half the basic administrative costs of the Church and the city.

In contrast with his often impulsive behavior, Julius was a fiscal conservative. He needed to balance the budget and create a firm financial basis for the future.

The Church of Rome was the first huge international enterprise. It was a global company centuries before the word *globalization* was coined, and like any global organization today, it had multiple sources of revenue. While money flowed in from so many directions that one English king complained, "The successor of the Apostles was commissioned to lead the Lord's sheep to pasture not to fleece them," the prime revenue sources were real estate, religion, and natural resources.

As far back as Gregory the Great, popes had invested in property throughout Europe. By the sixteenth century, they also controlled a sizable chunk of the Italian peninsula. This included an area known as the Patrimony of Peter, which encompassed the city of Rome and the surrounding region, and also the Papal States— Umbria, the Marches, and the Romagna. The Holy See had acquired the Papal States in two gifts—one in the eighth century, from Pepin the Short, the conquering king of the Franks and father of Charlemagne, the other in the eleventh century, from Countess Matilda of Tuscany.*

At some point between receiving these two generous gifts, a document known as the Donation of Constantine turned up, purportedly signed by the emperor and confirming the pope's dominion over Rome. Once Constantine moved the capital of his empire to Byzantium in A.D. 326 and built Constantinople (now Istanbul),

*Countess Matilda was such a devoted benefactor of the Church that there is a memorial to her in St. Peter's.

he never returned to Rome. The Church claimed that he had ceded the city and the surrounding countryside to the popes. Although the humanist Lorenzo Valla proved the Donation of Constantine a forgery in the pontificate of Nicholas V, the region remained firmly under Vatican jurisdiction.

The status of the Papal States was more complex and somewhat contradictory. Machiavelli, the Renaissance's most acerbic political commentator, explained it slyly:

> Only these princes [popes] have dominions and do not defend them, have subjects and do not govern them, and although their dominions are undefended, they are not taken from them, and their subjects, although they are not governed, pay no attention to the fact and do not, nor can they, quit the papal dominion.

The Papal States cut a broad swath across the middle of the Italian boot from the Mediterranean to the Adriatic. The Church imposed customs on goods transported by land through its territories and by sea through the ports it controlled. It also levied taxes on just about everything imaginable: wine, grain, livestock, timber, and firewood from the *campagna*.

Substantial revenue also accrued from the accoutrements of religion. Besides the payment of annates and tithes, every dispensation or "grace" granted to a petitioner and every benefice (cardinal's hats, bishoprics, abbeys, monasteries, and convents) came with a price tag. Indulgences and Peter's Pence, the annual collection, were additional and long-standing sources of income. And most Vatican jobs, from apostolic secretary to librarian, were venal offices, meaning they were for sale. The higher the office, the dearer the price.

Jubilees, traditionally the first year of a new century, also brought money pouring into Rome. In the first Jubilee, in 1300,

Rome, then a city of fifty thousand, was overrun by two hundred thousand eager Christians, one of them the poet Dante Alighieri. The Holy Year of 1300 was such a success that Boniface VIII made it a centenary event. His successors, recognizing a prime opportunity, shortened the span between jubilees to fifty, then to twenty-five, years.

The third substantial revenue source was natural resources. The Church enjoyed a monopoly on two vital commodities, salt and alum.

Although the Vatican had its own mint, it needed moneymen to juggle its complex finances. Its chief financial officer, the apostolic chamberlain, contracted with a bank or countinghouse to "farm" the salt and alum mines, cover a shortfall with advances against expected revenue, collect taxes, transfer money to and from every part of Europe, and float papal loans, known as *monti.*

During the pontificate of Julius, Rome became one of the busiest money markets in Europe. Like artists vying for papal patronage, international bankers competed fiercely to win papal contracts. As many as fifty banking houses had offices in Rome, including the House of the Medici of Florence and Fugger Bank of Augsburg. But no "farmer" operated with greater success than Agostino Chigi.

Born in Siena in 1466 to a banking family, Chigi moved to Rome when he was a young man with one ambition: to become the pope's banker, and the first among equals. Early on, he adopted a pattern that never varied. He ingratiated himself with each pope by extending a substantial personal loan.

As brilliant in finance as the Renaissance masters were in art, Chigi was wily, devout, and social climbing. A man of legendary charm, diplomacy, and ambition, he maneuvered adroitly through the Vatican labyrinth. At one time or another, he was treasurer of

the Patrimony of Peter, collected taxes on salt and grazing, and floated loans for a succession of popes. But he made the bulk of his fortune as the Church's alum farmer.

Alum was the oil of the fifteenth and sixteenth centuries. From Byzantium to Britain, and notably in Flanders and the Low Countries, the leading industry was cloth. Alum was an essential mineral in the dyeing process. Since the largest mines were in Asia Minor, the fall of Constantinople to the Ottoman Turks in 1453 had an effect on Christian wool merchants comparable to the OPEC oil shortage of the 1970s.

By the end of the century, when Christian merchants had become desperate to find new sources of alum, mirabile dictu, rich veins were discovered in Tolfa, a mountainous area north of Rome that happened to lie within the Patrimony of Peter. Smaller deposits were also discovered in Naples and Tuscany. And so, by luck or Divine Providence, the Church became the leading alum exporter in Europe.

Agostino Chigi won the contract to farm alum under Alexander VI and assured that it would be renewed with the strategic loan that secured the papacy for Julius. It was the beginning of an intense and fruitful friendship. Although the alum mines had always been profitable, Chigi enriched the Church and himself by turning them into a monopoly. In this, he was aided and abetted by the incorrigible pope. Julius forbade any Christian from buying infidel alum on pain of excommunication.

This was a man who once excommunicated the entire Republic of Venice, and threatened to do the same with the king of England. His threats were never idle, but they occasionally backfired. One trader, Francesco Tommasi, who incurred the pope's wrath by breaking the alum monopoly, turned out to be Chigi's agent. Tommasi was running a little scam for his boss. He was buying alum from the Turks, then Chigi was reselling it in Europe at an inflated price.

The pope and his banker were pragmatists, unconcerned with ethical niceties. They delighted in a vision of a supreme Christian imperium with themselves in the roles of Julius and Augustus Caesar. Now in the summer of 1507, the two were charging into battle.

∞

When Julius II rode to war, the papal court rode with him. It was a huge and colorful cavalcade. His personal army comprised six hundred Swiss Guards, gorgeously outfitted in uniforms of purple and gold striped velvet.* Augmenting the fighting force were his cohorts Bramante and Chigi, and a cadre of cardinals. Most were reluctant warriors, more at ease in a salon than a saddle, whom Julius coerced into joining the fray. Waging war was often less dangerous than incurring his wrath.

In the rear guard were secretaries and servants from the papal household. It was an astounding spectacle and a logistical challenge. Transporting and feeding the army of guards, clerics, and clerks was the equivalent of moving an entire town.

The pope's expeditions were for show, not carnage. In the city-states of Italy, war was more a jousting for the political upper hand than a duel to the death. Since most battles were fought by condottieri, mercenaries who needed to keep their troops intact to fight again tomorrow, warfare was more often a fight to the last ducat than a fight to the last man.

Riding behind the red star-spangled flag** of the papacy, brandishing his weapons of eternal terror—writs of excommunication and papal interdictions—Julius advanced on the principal towns of

*During the pontificate of Paul III, Michelangelo designed new uniforms for the Swiss Guard. Still worn today, the red, blue, and gold striped uniforms were sewn from 154 individual strips of cloth.

**The yellow-and-white papal flag did not become official until 1824.

Umbria and Romagna. Perugia capitulated first, then Bologna, both without bloodshed.

ⓧ

In Florence, the Signoria watched the papal advance with apprehension. Unless Michelangelo turned himself in, the Florentines feared that il Terribilis would march on Tuscany to retake the stubborn sculptor. First Bologna, next Buonarroti.

"The pope will no longer wait to be asked," Solderini told Michelangelo. "We don't want to wage war with him over you and put our State at risk, so prepare to go back."

No longer guaranteed sanctuary, Michelangelo threatened to leave Italy and sell his services to the enemy—and not to some two-bit Lombard upstart, but to the devil himself, the invidious sultan of Islam. Bayezid II wanted Michelangelo to build a bridge at Constantinople.

"Choose to die going to Julius," Solderini cautioned, "rather than live going to the Turk."

Finally relenting, however grudgingly, Michelangelo consented to meet Julius on neutral ground. In the winter of 1507, accompanied by a bishop to assure that he was "safe from bodily harm," Michelangelo rode to Bologna. He went "with a rope around my neck," as he put it, and "had scarcely drawn off his riding boots" when he was conducted to a papal audience.

Flush with victory and forgiveness, Julius welcomed him like the prodigal son. We have the details of the audience from Condivi, and it was a meeting of sincere warmth and cordiality.

"We have come to you, son, and you know that is not as it should be," Julius said. It was a gentle reproach after so many months of impudence.

Begging forgiveness, Michelangelo answered that he had acted in anger, "not being able to endure being driven away so abruptly,

but that if he had erred, His Holiness should once more forgive him."

The bishop-bodyguard, trying to mediate, interjected, "Your Holiness, pay no regard to his error, because he has erred from ignorance. Painters, except for their art, are all just as ignorant."

Julius turned on the priest. "You are abusing him, and we are not. It is you who are ignorant, and you are a miserable wretch, not him." Pummeling the stunned bishop with a hail of blows, the pope shouted, "Get out of my sight, and bad luck to you."

A chastened Michelangelo knelt in contrition, kissed the "Blessed foot," and made his peace. For his penance, he received a new commission. Julius ordered a life-size equestrian statue of himself cast in bronze to commemorate his victory in Bologna. Michelangelo fashioned a clay model of the pope astride a horse, one hand raised in triumph.

When Julius saw the model, he asked, "This statue of yours, is it giving a benediction or a malediction?"

As arrogant as ever, Michelangelo answered, "It is a warning to the people here, Holy Father, to be prudent."

By the end of the year, Julius was preparing to withdraw his troops from Bologna. Leaving one thousand ducats for Michelangelo to cast the triumphal bronze, the warrior-pope set out on the long, slow trek back to Rome. Chigi and Bramante rode with him, their thoughts filled with the grand enterprise that lay ahead.

Invigorated by his victorious sally to return the Papal States to the fold, Julius was eager to take on another campaign. The clash of armies was won. The clash of genius was just beginning.

A CHRISTIAN IMPERIUM

The year 1507 was pivotal in the building of the new St. Peter's. By the time the papal calvacade rode into Rome to a triumphant welcome, the first pier of the new Basilica was rising behind Constantine's church. It was an astounding sight. The titanic northwest pier stood 90 feet high and was almost 30 feet thick, with a circumference of some 232 feet. Work was already under way on the corresponding southwest pier. Since neither impinged on the existing structure, the old basilica was still intact. By April, though, the inevitable could no longer be delayed.

Bramante began to raze the millennium-old church. In his enthusiasm, he ripped the roof off the Confessio, the main altar area, and tore down the walls, destroying priceless art, altars, votive chapels, and mosaics. His reckless bravado provoked widespread fury. Romans jeeringly named him "the wrecker," and Paris de Grassis noted in his journal, "The name *il Ruinante* has been added to the vocabulary to describe Architect Bramante."

Perhaps because his heedless demolition was raising such an outcry, Bramante adopted a novel approach. Instead of leveling the old church entirely and laying a new foundation, he worked in sections, building the new Basilica piece by piece and continuing to demolish the old one as needed.

Although the roof was gone, he preserved the main altar. Unfazed by either the construction going on around him or the weather, Julius continued to hold ceremonies there. As long as he was pontiff, he celebrated the papal mass al fresco to the distress and vexation of many of his cardinals. Paris de Grassis complained ceaselessly of the trouble he had organizing papal functions amid the scaffolding and boards in the *maledetta fabbrica*—"the accursed construction."

❧

Destruction and construction became an ongoing process that would stretch over the course of the century. At the same time, Bramante continued to draft new plans. His methods were unorthodox. In his rush to build, he seemed to try out each new idea as it came to him. He began work while his own architectural plans were still jelling, returning to Julius repeatedly with revisions and changes.

The Basilica that was rising in 1507 was not the design that Julius had accepted originally. There is no way to know why Bramante went back to the drawing board, beyond the ferment of his endlessly fertile mind. Vasari wrote that he bombarded Julius with hundreds of designs. Although his sketches include both cruciforms—the T-shaped Latin cross and the equi-armed Greek cross—Bramante's preference was the central plan. It was a truer reflection of the Renaissance ideal and a truer spiritual metaphor.

The metaphysical core of the Basilica was Peter's grave, the "rock" of the Roman Church. In the Greek cross, it was located at the very center of the building. The dome rose over it, symbolizing the transcendent Christ, and the arms of the Basilica stretched out in equal length from it, representing the Church reaching to the four corners of the world.

The Basilica that Bramante probably adopted is a variation of

the Parchment Plan. A sketch of the new design was drawn by one of his assistants, Domenico Antonio de Chiarellis, known as Menicantonio, a diminutive of the first and middle names. Only discovered in the 1950s and now in the Mellon Collection of the J. Pierpont Morgan Library in New York City, the Menicantonio Sketchbook is crudely made, with cardboard covers, the front one strengthened with a sheet of parchment, and measures roughly eight inches by seven inches. There are eighty-one folios on strong drawing paper, and the signatures and covers are bound with double strings.

In the Mellon Codex plan, the essence of Bramante's Greek cross remains "the dome of the Pantheon raised on the shoulders of the Basilica of Maxentius." Only the details changed. Once again, Bramante began with the Renaissance ideal, and then went beyond it—establishing an exact geometry before deviating from it. In that, he was truer to Vitruvius than architects who hewed more closely to the Renaissance conventions. Vitruvius never encouraged the slavish adherence to ratio and proportion that became the rule of the Renaissance. "The architect's skill must be brought in," he wrote. "He will introduce those corrections into the general symmetry, increased in some places and reduced in others, which will make the building seem to have no fault."

Although the "corrections" Bramante introduced seem small, they created striking architectural illusions. The towering height of the apses introduced a vertical drama that was lacking in the more horizontal church pictured on the commemorative medal.

While his massive dome was still set on discrete piers rather than on a solid cylindrical base, Bramante turned the piers on the diagonal. Instead of making four corners, the angled piers form an octagon. He turned the piers in the corner chapels on the diagonal as well. What may seem like a simple deviation had an exhilarating effect. By eliminating the ponderous square corners, he

created a dynamic central crossing. Bramante, who has been fa-
mously criticized for cutting corners in his rush to build enor-
mous structures in the shortest possible time, here cut them to
brilliant effect.

Although the body of Bramante's Basilica seems to have changed
many times, its essence remained the enormous central dome. His
enthusiasm for it was so great that he began building St. Peter's
from the center out. By the end of the year, the foundation stones
of all four piers had been blessed and laid, and work was proceed-
ing at a furious speed.

Julius visited the construction site often and showed it off to
visiting dignitaries. One envoy wrote, "His Holiness shows every
happiness and frequently goes to the building of St. Peter's demon-
strating that he doesn't have any greater concern than finishing the building."

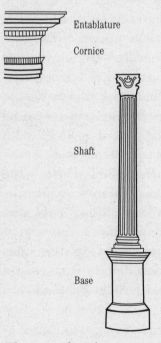

Another reported, "The pope
went today to visit the church of
St. Peter and inspect the work. I
was there also. The pope had Bra-
mante with him, and he said to me
smiling, 'Bramante tells me that
2,500 men are at work here. One
might review them. It is an army!'"

Bramante raised the ninety-
foot piers and crowned them with
Corinthian capitals, twelve palms
high, or about six feet, carved with
olive leaves. All the double pi-
lasters and columns throughout
St. Peter's repeat the same colossal
Corinthian order. In an intense

Entablature

Cornice

Shaft

Base

The parts of a column.

surge of construction that continued through 1510, he joined the piers with coffered barrel vaults that soar one hundred and fifty feet, higher than the dome of the Pantheon.

Bramante's heroic crossing arches established the height of the transept and nave,* as well as the diameter of the dome. His unorthodox strategy—building from the center out—fixed the nucleus of St. Peter's immutably. By concentrating construction on the Basilica crossing, he ensured that the monumental scale could not be diminished no matter who succeeded him, and he kept his options open. Until the crossing was finished, he could continue experimenting with the shape of the surrounding Basilica.

❧

The cost of building the Basilica was commensurate with the astonishing progress. In the Middle Ages, construction of the Gothic cathedrals had been consigned to an independent organization. Often called a chapter or an opera, it handled all building issues, mediated disputes among the various craftsmen, paid the bills, secured the material, and generally took care of details, large and small.

But Julius didn't delegate. In spite of his impetuous rush to build and his scandalous disregard for history, he was a conscientious manager, and he signed off personally on every detail—aesthetic, practical, and financial. As long as he was pope, there was only one authority. While his accountant Girolamo de Francesco, his bankers Stefano Ghinucci and Agostino Chigi, and his cousin and cardinal-chamberlain Raffaele Riario advised him, the pope held the purse strings himself. Julius allocated

*The transept is the north-south axis of the Basilica. The nave is the east arm that forms the large center aisle.

funds from the Camera Apostolica and the Tesoreria Segreta, his personal expense accounts, and paid his architect directly. Bramante, in turn, paid his assistants out of his own pocket. Ghinucci disbursed payment to suppliers, laborers, and craftsmen.

Artisans were paid by the piece—so many ducats for a square foot of flooring, wall, roofing, or pavement; so many for a cornice or capital. Each expenditure was noted in a *liber mandatorum*. Still filed in the archives of St. Peter's, this slim, eighty-page "book of commissions" is a concise record of the cost of the new Basilica and the pace of construction during Julius's pontificate.

In 1506, the first year of building, total expenses were 12,500 ducats. The papal ducat was comparable to the euro today. It was an international coin—three and a half grams of pure gold. Although it is difficult to make an accurate comparison with today's dollar, in 1506 a laborer worked for 15 to 20 ducats a year, a teacher or clerk earned 25 to 30 ducats, and a skilled craftsman brought home on average about 50 ducats. On the other end of the social scale, lifestyles were so lush that a nobleman with an income of 1,000 ducats was just making ends meet. Two thousand ducats relieved financial headaches.

Depending on how you liked to spend your money, for 2,000 ducats you could buy twenty translations of Homer, hand-lettered; muster your own army for a couple of months; hire an artist to fresco your house; or buy your way into the Curia, the main governing body of the Church.

In 1507, building expenditures more than doubled from the first year, and Julius saw no end in sight. The new St. Peter's would be an enormous expense for the Church for years to come. Much as nonprofit institutions do today, he appealed to the conscience of wealthy donors, in effect launching a capital campaign to underwrite

construction. In a papal bull, signed on February 13, 1507, he asked the crowned heads of Europe for donations.

"The New Basilica, which is to take the place of one teeming with venerable memories, will embody the greatness of the present and the future. In proportions and splendor we believe it will surpass all other Churches of the Universe," he wrote.

Henry VII of England sent tin for the Basilica roof and was rewarded with wheels of Parmesan cheese, globes of provolone, and barrels of wine. In spite of the generous response, much more was needed. Operating costs were soaring, and in April, Julius imposed a tribute on all apostolic properties, with 10 percent of the revenue earmarked for the Basilica.

If the monies flowing into the Vatican treasury were enormous, so too were the outlays. The Church was a religious institution, a charitable and humanitarian enterprise, a civil authority, an educator, and a patron. It operated in many countries, had a large payroll, administered the city of Rome, maintained an army, ran numerous charities, social services, and universities, and funded the arts and sciences.

Total annual expenses were always substantial, but the pope's military campaigns, lavish patronage, and ambitious building projects made 1507 especially costly. Over time, the revenue returning from the Papal States, the increased income from the alum monopoly, and a lucrative new source—gold and silver from the New World—would ensure the financial stability of the Church. But Julius faced an immediate cash-flow problem, and so his operating budget was strained.

With expenditures on the Basilica escalating from 12,500 ducats in 1506 to 27,200 in 1507 and facing years of building, he looked for a way to underwrite future construction, and he called on Agostino Chigi for advice. Among the many bankers who attended to the

Church business, only Chigi was the pope's confidant and friend as well as his financier.

At a time when 2,000 ducats was a comfortable annual income for a noble, Chigi had paid 3,000 to purchase the coveted position of apostolic secretary, which assured him full access to Julius. Apostolic secretaries numbered only thirty and worked directly for the pope. Chigi continued to improve his portfolio, buying a position as notary of the Apostolic Chamber in 1507, and later, gilding his venal offices with the purchase of a noble title, court palatine.

The Apostolic Chamber was the finance department of the Curia. A classical Roman term referring to the Senate, the Curia of the early 1500s was small and informal—much different than it is today. Governance was divided among an administrative arm called the Apostolic Chancellery, a judiciary called the Rota, or wheel, and the Apostolic Chamber, the finance department, which was headed by a cardinal-chamberlain.

The pope's cousin Raffaele Riario served as cardinal-chamberlain. It was a position of substantial power. He hired the papal bankers, let out contracts, and oversaw a network of notaries, scribes, and clerks. Since Chigi's tax concessions and alum monopoly came under the jurisdiction of the Apostolic Chamber, becoming a notary was comparable to buying a seat on the board of directors of the corporation that owned your company. To Chigi, it was insurance. If the papacy changed hands, his leases would be renewed and his operations continue without interruption.

Because the Renaissance Church was both a marketplace and a meritocracy, a man like Agostino Chigi, a merchant, a banker, and a moneylender, through sagacity, shrewdness, and a dearth of scruples, could make himself not just a man of means but a man of position. Chigi pursued power so adroitly and gained the pope's trust so absolutely that Julius adopted him, actually and

metaphorically, grafting a new branch onto the della Rovere oak, the symbol on his papal crest.* It was the ultimate noblesse oblige.

The scheme that Chigi proposed to underwrite St. Peter's was a centuries-old custom—the granting of indulgences. If allowed by the pope, a penitent who in good faith had confessed his sins with a sincere heart could earn an indulgence, or redemption, by performing a specific charitable or selfless deed.

Chigi advised Julius to set up a separate building fund for the Basilica and grant an indulgence to anyone who made an annual contribution to it. The idea was similar to a pledge drive today, except that instead of an immediate thank-you gift, say a logo tote bag, donors received a reduced sentence in purgatory—the inherent presumption being that if you could afford to contribute, you were probably not on the fast track to heaven.

Julius did not act immediately to implement Chigi's proposal, but neither did he reject it out of hand. It is not clear why he hesitated, since indulgences were an accepted way to raise money for capital projects and charitable causes. Instead, Julius continued cutting costs.

In the interest of economy, he limited the use of expensive material, particularly travertine, which was costly to quarry and transport. Bricks and breccia, a form of crushed tufa that was cheap and plentiful, were used as much as possible to build the walls. Bramante had applied a fake travertine finish on an earlier project, and he planned to use it for the Basilica walls as well. He was casting the vaults and the shafts of the giant columns and using travertine for only the bases, capitals, and cornices.

*The distinctions between merchant and prince would be obliterated by time, merit, and money 150 years later, when a Chigi grandnephew became pope and finished the work that Julius and Agostino began.

At the same time that Julius was practicing fiscal restraint, he was pursuing his imperial ambitions. It was a precarious balancing act. Urged on by his brash *magister operae,* Julius began to imagine the new St. Peter's not just as a grand enterprise but as the centerpiece of a papal Palatine, modeled on the Forum of ancient Rome. At the start of his papacy, much of the city was still a ramshackle medieval town. A traveler visiting Rome in 1500 wrote: "There are parts within the walls which look like thick woods and wild beasts, hares, foxes, deer, and even porcupines, so it is said, breed in the caves."

All that was changing. Under the patronage of Julius, Rome replaced Florence as the capital of art and imagination. Humanists rambled through the imperial wilderness, reading poetry, philosophizing, and more than likely gossiping about their Curial employers. Rome was the site, the very dust and stones, the overgrown forums and crumbled baths, of one of the classical civilizations that they revered. The romantic imagination could wander freely among the mossy ruins where Ovid once recited his odes and Seneca tutored the young Nero in his pre-despotic puberty. The lolling cattle on the imperial hillsides and the meandering goats added to the picturesque scene.

But papal Rome was more than broken cornices and fallen columns. It was also the place to land a plum job. The Church was the best career opportunity for young intellectuals. If you were intelligent and played your cards right, you could gain fame, wealth, even the papal tiara. Francesco Petrarch, the original humanist, set the tone when he said, "The true noble is not born but made."

The best and the brightest—painters, architects, Greek scholars, scientists, historians, poets, and musicians—flocked to Rome and found employment and advancement in the *famiglia,* or household, of the pope and his cardinals. The Vatican had the first Arabic printing press and produced the first cookbook as well as works

on historical criticism, gardening, and fishing, one of the pope's favorite pastimes.

In a papal bull issued in 1507, Julius gave tax concessions to those who built, spurring a boom. Across the Tiber, cardinals, Curial bankers, and ambassadors to the papal court were building palaces, and much of the city became a construction site.

The pope and his architect set the pace. They planned their Palatine together, poring over classical texts in the papal library to learn more about the imperial buildings. The descriptions of Nero's Golden House, the Domus Aurea, in Tacitus and Suetonius, and Pliny the Younger's descriptions of his own villas became their guides.

Bramante designed a three-level complex in the Vatican to rival the imperial palaces. Covering more than five acres and called the Belvedere Court, it connected an enlarged and refurbished papal palace with a villa that Nicholas V had built on the north slope of the Vatican hill about three hundred yards away, called the Belvedere—"beautiful view."

The Belvedere Court would have lush terraced gardens and fountains, a permanent open-air arena with tiered seats for dramatic performances and bullfights, and a courtyard museum to display the pope's collection of antiquities, including his prized sculpture now known as the Apollo Belvedere. Buildings and gardens would flow from each other as parts of the same architectural landscape. A wider bridge and broad new avenues leading from the Vatican would create easy access to the center of Rome. It was a plan fit for the Christian imperium of the second Julius.

❧

Although Raphael painted him as Euclid holding a pair of compasses and demonstrating the principles of geometry so integral to the Renaissance architectural ideal, Bramante was an experimenter.

According to Vasari, he invented a kind of flying scaffold to use in casting vaults and devised a way to cast using wooden molds so that patterns would seem to be carved in the plaster. Bramante was constantly looking for new and better ways to build. To some contemporaries, he was "a capricious genius," impulsive and often inattentive to detail, but Julius gave him more commissions than anyone could carry through with care and competence.

As *magister operae*, Bramante was charged not only with building the Basilica, in itself the work of many lifetimes, but also with executing all the works throughout the city and the Papal States. With an enthusiasm that matched the pope's own, he accepted every assignment that fired Julius's restless mind: naval fortifications in the port of Civitavecchia, hydraulic machines, an apostolic palace in Loreto, a staircase in the Palazzo Communale in Bologna, a choir in the Roman church of Santa Maria del Popolo, even a machine for printing papal bulls "with a very beautiful screw."

To carry out the commissions, Bramante oversaw an operation so vast that a contemporary dubbed it "Bramante & Co." He employed a huge construction force: his surveyor Riniero da Pisa, his chief carpenter Venttura da Pistoia, his overseer Giuliano Leno, and scores of artisans and laborers, including draftsmen, foremen, two types of masons to hew and lay stones, bricklayers, carpenters, wood-carvers, and unskilled workers. They drew the plans, quarried the stones, split the timber, drove the mule carts and oxen, raised the scaffolding, and dug the foundations. They fired the furnaces, mixed the cement, cut the bricks, and moved mountains of earth and stone. A virtual army of suppliers provided tons of lime and sand, miles of rope, and forests of timber.

The first architectural firm in Rome and very likely in the world, Bramante & Co. also employed five sub-architects and the most gifted fresco painters in Italy.

Julius wanted every great artist in his service, which he equated with the service of the Church and the glory of God—and what he wanted, Bramante usually gave him. But one giant of the Renaissance eluded his reach. Oddly enough, he was Bramante's old friend, Leonardo.

Why not da Vinci? It is tantalizing to speculate. Why didn't Julius call him to the Vatican after the Sforzas lost power in Milan? Leonardo was looking for a new patron then. If by some improbable fluke he had escaped the pope's notice, why didn't Bramante introduce them?

When he wanted to impress Julius and diminish the influence of Michelangelo, Bramante turned instead to an inexperienced young painter from his hometown of Urbino.

CHAPTER TEN

A VIPER'S NEST

∽∾

Raphael Sanzio arrived in Rome in 1508 when some of the finest painters in Italy were at work in the papal palace frescoing the walls of a new second-floor apartment for the pope. Julius refused to live in the Borgia Apartment on the first floor because his hated predecessor had decorated it with images of his mistress, Giulia "la Bella" Farnese, displayed as the Madonna.* On a bright autumnal day, Bramante brought his eager young protégé upstairs to the new papal apartment.

What did they think—Pinturicchio and Luca Signorelli; Giovanni Antonio Bazzi, known as Sodoma; Bartolomeo Suardi, nicknamed Bramantino ("Little Bramante") for his teacher; the Venetian Lorenzo Lotto, the Dutchman Johannes Ruysch, and Perugino, an old man now? They were painters of rich experience and enviable talent, accustomed to respect.

They must have been tired of making the circuit from Florence to Perugia, Milan to Urbino to Venice—tired of the road, the capricious patrons, the never-ending contest for commissions. They had landed a cushy assignment in the Vatican of Julius, employed

*Julius ordered every trace of the Borgia pope Alexander VI expunged from the Vatican, even opening his tomb and shipping his remains back to Spain.

by the best. Accommodations were plush, and there was plenty of work, until Bramante brought in the boy, a stripling of twenty-five.

Arm thrown across the young man's shoulder, Bramante introduced him as a friend and protégé—Raffaello Sanzio, son of Giovanni. Some of the older artists must have remembered Giovanni Santi, the court painter in Urbino in the exalted days of Duke Federigo, and the little boy with the face of an angel and a crown of golden ringlets who painted beside his father.

Perugino, eyes moist, rushed forward and embraced Raphael like a son. It was an emotional moment for the old painter. He pinched the boy's cheek affectionately, marveling at how he had grown. After Giovanni died, Perugino had taken the boy into his studio and taught him to paint, replacing the father and teacher that Raphael had lost. Perugino took pride in the youngster who learned so well that "his copies could not be distinguished from his master's."

Seeing Perugino embrace the boy, the other artists welcomed him. They probably looked on Raphael as an assistant more than an equal. They may have heard of him from the brief time he spent in Florence, but Raphael had never frescoed a large space or composed a complex dramatic painting. On Bramante's word, the pope was giving him a chance to "show his worth." There is no reason to suppose that they felt threatened by him—at least not at first. Unlike Leonardo or Michelangelo, Raphael did not provoke fear.

Most artists have "a certain element of savagery and madness," Vasari writes. "Raphael had no fight neither against men nor against his own heart. He was not obliged like so many other geniuses to give birth to his works by suffering; he produced them as a fine tree produces fruit. The sap was abundant and the cultivation perfect." He had the face of an innocent and manners to match, respectful toward the older painters, deferential to his teacher Perugino. But his amiable character concealed intense ambition.

When he arrived at the Vatican, most of the rooms were already frescoed. Piero della Francesca had finished one scene. Signorelli was completing another wall, and Bramantino, the Milanese, had painted many figures. Raphael began in the Stanza della Segnatura. Although he was the greenest of the pope's painters, he quickly outshone all the other artists, stunning them with his unexpected skill.

When Julius saw Raphael's first fresco, he recognized a special gift. Overnight, Perugino and the rest found themselves unemployed, their paintings obliterated, and the entire work of frescoing the papal apartments given to the boy-genius "so that he alone might have the glory."

The more seasoned and celebrated artists were packing their cases when the workmen came in. They brought chisels to chip off the old frescos and cloth bags of sand and lime to mix into plaster to recoat the walls. As the frescoes began disappearing, the floors were covered with a blanket of brilliant flakes, the labor of months now broken plaster. Raphael would not allow the work of his old teacher Perugino to be touched, but the other walls were chiseled bare, then replastered, rendered smooth and blank to receive the genius of the wunderkind.

What must have seemed like reckless caprice on the pope's part was a sagacious stroke in the light of history. Vasari writes that Raphael gave "such a proof of his powers as made men understand that he was resolved to hold the sovereignty, without question, among all who handled the brush."

For all his self-effacing charm and easy grace, Raphael was immodest. He wanted to prove that he was the best. There was only one more artist to surpass, and a few months later, he returned from Bologna.

❦

Sweet-talked with promises, Michelangelo came back to Rome in the spring of 1508, expecting to resume sculpting the tomb. But Julius had a very different project in mind, one that would honor the memory of his uncle, Sixtus IV, who had set him on the road to the papacy and built the Sistine Chapel. He asked Michelangelo to fresco the central vault of the chapel ceiling and offered him the very generous sum of three thousand ducats.

Michelangelo was furious. He was a sculptor, not a painter. His wet nurse was the wife of a stonecutter. "With the milk of my nurse, I sucked in the chisels and hammers wherewith I make my figures," he liked to say. He had come back to Rome to carve the tomb, he told Julius. "Get Raphael to fresco your ceiling." Michelangelo's refusals were "so insistent," Condivi wrote, "that the pope was about to fly into a rage. . . . But then seeing his obstinacy, Michelangelo set out to do the work."

Because the ceiling was so high—sixty-eight feet—Bramante had built a hanging scaffold. Michelangelo refused to mount it, insinuating that a faulty scaffold was a convenient way to dispose of a rival. Muttering that "a poor man could marry off two daughters" with the money he was saving on rope, he tore down Bramante's scaffold and built his own freestanding device.

On May 10, with extreme ill will and dark protestations, Michelangelo closed himself in the Sistine Chapel. A short time later, still complaining, he went back to Julius and renegotiated his contract. For six thousand ducats, he would paint not just the central vault but the entire ceiling—three thousand square feet—and not with the twelve apostles, as Julius had ordered. They were poor men, Michelangelo told him, and they would make a poor fresco. He wanted to choose his own subject matter.

Pride and faith impelled him. He painted for God and Michelangelo, and to show up Bramante, a man of bonhomie, as sly as a fox. Each day, as long as the light held, suspended five stories in the air, tempera in his eyes and splattering his beard, the chapel reeking of egg yolks, Michelangelo worked like a slave at forced labor. His brain roiled. Ideas for cartoons came to him mixed with dark suspicions. Bramante had foisted the ceiling on him to humiliate him. A vast space, a difficult shape, a treacherous height, an impossible position, an uncongenial medium—he was set up to fail. Even for an experienced painter, the Sistina was an impossible assignment.

Michelangelo had expanses of ceiling to paint before he could sculpt the tomb. His marble was still piled in the square, awaiting his chisel. It was the prize, the consolation that kept him climbing the scaffolding at dawn each day. One more panel, and one more, then he could return to the tomb. Weeks turned to months and months to years. His neck stiffened from peering up for so many hours, and his eyes became bloodshot from constantly wiping away the drips of paint. His body "bent like a bow," he said, and his "beard touched heaven." He wrote to his brother: "I am living here in a state of great anxiety and of the greatest physical fatigue. I have no friends and want none."

❦

While Michelangelo struggled with dampness and mildew, Raphael was completing *The School of Athens,* the first of his extraordinary narrative paintings for the papal apartments. Raphael didn't paint in quietude. The Stanza della Segnatura was Julius's personal library, and Tomasso Inghirami, his corpulent, boisterous librarian, was often in attendance. The librarian's sonorous voice could be heard booming from the book stacks, declaiming on politics and religion

or reading aloud. Julius looked in often. The library was a personal room, and the frescoes Raphael was creating were for the pope's own pleasure—a portrait of Rome in the age of Julius. Raphael welcomed the pope's visits, flattered and pleased by the attention.

The atmosphere in the Sistina was far less cordial. Michelangelo banned Julius from the chapel and guarded against intruders by rigging a canvas beneath the scaffolding. It had the double effect of a canopy protecting the chapel from splattering paint and a horizontal screen concealing his work. No one except his assistants could see the ceiling in progress, and he didn't even trust them. Michelangelo suspected that they were accepting bribes to sneak in the curious, and he took measures to deal personally with anyone who dared to come snooping.

Once, hearing the chapel door open and close stealthily, he prepared to pounce. As footsteps approached, he hurled boards down from his scaffold on the head of the intruder. Julius let out such a mighty roar that, Vasari reports, Michelangelo "became afraid" and "had to fly from his presence." He escaped again to Florence, where he stayed until the papal temper cooled.

While Michelangelo was in Florence, Raphael, who had become increasingly curious about the frustrating unknown on the other side of the chapel door, borrowed the key from Bramante and slipped in. Staggered by the raw beauty and muscular intensity of what he saw, he returned to his own finished fresco and inserted a new figure. Then, he slyly tried to dislodge his rival.

"Raphael, when he saw the new and brilliant style of this work, being a brilliant imitator, sought through Bramante to paint the remainder himself," Condivi writes. When Michelangelo discovered the duplicity, he blamed Bramante. In high dudgeon, he protested bitterly to the pope.

Michelangelo felt trapped in an artistic triangle, subservient to Bramante and competing with Raphael. They worked in close

proximity, separated only by a few corridors, the most talented artist in Italy and his wunderkind challenger—three hundred feet apart in physical distance, worlds apart in every other way except talent.

The metamorphosis of Raphael is one of the unresolved mysteries of art history. In the span of a few years, with the full confidence of the pope and the support of Bramante, he transformed himself from an unexceptional painter of Madonnas into the purest expression of the High Renaissance. It was an extraordinary and rapid evolution.

His critics, Michelangelo as vociferous as any, scorned him as a copyist, not an original talent. "Raphael did not inherit his excellencies from Nature, but obtained them through study and application," Michelangelo said dismissively. Both he and Leonardo were iconoclasts who scorned the Renaissance's golden rules. Michelangelo said, "One cannot make fixed rules, making figures as regular as posts," and broke them. Leonardo said, "I wish to work miracles," and ignored them. Raphael's easy genius flowed within the parameters of the Renaissance. He was the quintessential artist of an age that wanted to return to a classical world, not invent modern times.

Like a sea sponge, he was amorphous and absorbent. He drank in styles and techniques, made them his own, and then made them better than anyone else. "Other paintings may be said to be pictures, but those of Raphael were life itself," Vasari writes.

Michelangelo was jealous of Raphael's ease and popularity. The dueling artists met once in the square. Raphael, as always, was the center of a lively group. Michelangelo, as always, was alone. "You with your band like a bravo," he scoffed as he brushed by. "And you alone like a hangman," Raphael countered.

The papal palace became a viper's nest. The animosity that had rankled between Bramante and the Florentine faction turned venomous. The Tuscans believed that Bramante felt threatened by Michelangelo's enormous talent. They saw the sculptor's banishment to the Sistina as a perfidious plot to keep Michelangelo away

from the tomb, away from the new Basilica, and occupied endlessly on an impossible assignment.

Michelangelo imagined the tomb as his masterwork—"the grand showcase of his talent"—just as the Basilica was Bramante's. Ultimately, both men lost. Neither Michelangelo's tomb nor Bramante's Basilica would be completed as planned. But in the all-consuming throes of creation, when everything was still possible, they vied for their artistic vision. The stakes were high—immortality and the pope's favor, the one dependent on the other.

Although their characters were incompatible, the contention between Michelangelo and Bramante was as much artistic rivalry as personal animosity. Each recognized the talent of the other, and like jealous suitors, they competed for the favor of Julius. They intrigued, connived, and carped to displace each other and be first in his affection, his opinion, and his patronage.

Julius would not choose between them. He insisted on having them both in his service—the sculptor of the *Pietà* and the architect of the Tempietto. There was no escape. Their fortunes were snarled inextricably in the person and patronage of *il pontefice terribile.*

Bramante made himself agreeable, always aware that his reputation and success depended on the pope's favor. Michelangelo seemed perpetually at war with himself or another—and very often, the other was the pope. They were twin Terribiles, with huge, easily bruised egos and absolute conviction in the truth as they saw it. Both had the highest standards and the shortest fuse. When they exploded, they continued to burn. Michelangelo, who endured longer, seethed for decades.

Julius loved Michelangelo, but he enjoyed the company of Bramante. Michelangelo was so young, half his age, and a hothead. Bramante was a contemporary. There was not even a year's difference between them. Both were impulsive, decisive, and uncluttered by the doubts that plagued Michelangelo. They shared a passion for

the antiquities of Rome and the poetry of Dante. A touching letter written from Bologna in December 1510, when Julius was recovering from a serious illness, describes Bramante reciting Dante to him like an actor on a stage.

A sixteenth-century writer called Bramante "a man of great talent, a cosmographer, vernacular poet, and excellent painter." A pupil described "my teacher, Bramante" as "an artist of the first order . . . familiar with the works of the Italian poets. Though he could not write, he had a wonderful memory and spoke with ease and eloquence."*

Neither artist was an easy man. Even at the peak of his celebrity, lionized as the papal architect, with the ear of Pope Julius, Bramante remained essentially a loner. He may have been gay. He never married or fathered a child. Vasari refers to his "intimate friend" Giuliano Leno, who made himself wealthy overseeing the construction yard of St. Peter's. "Avoiding melancholy and boredom as far as possible, I have always nourished my soul on happiness and pleasure," Bramante himself wrote. "What I am permitted to do, I also think I have the right to do."

He was mercurial, unable to make a firm commitment, either personally or architecturally. "As time changes in a moment, / So my thought that follows it changes too," he wrote in a sonnet. Still, he plunged into life, as he plunged into work, with gusto. He lived lavishly in an apartment in the Belvedere. "The pope made him rich and gave him gifts and offices," a contemporary said. Asked once how he was doing, Bramante answered, "Excellently, for my ignorance pays my expenses."

Michelangelo was a tortured soul. He once said, "I live as a happy man with an unhappy destiny." He always tottered on the brink of

*"Though he could not write" refers to the fact that Bramante was not versed in Latin.

ruin—or imagined he did. Although he had invested shrewdly in real estate in his native Tuscany, he lived poor, nickel-and-diming himself and his patrons. If he smelled rank, it probably meant he was working well. Michelangelo may have been the original unwashed artist. He didn't like to break his concentration by taking time to wash, eat, or change his clothes. Often, he fell asleep with his boots on.

Life and art were a ceaseless, often painful, struggle. In a sonnet on art, he wrote:

> This savage woman, by no strictures bound,
> Has ruled that I'm to burn, die, suffer. . . .
> My blood, however, she drains pound by pound;
> She strips my nerves the better to undo
> My soul. . . .

Faith was the fuse that fired his imagination. Bramante, in typical Renaissance style, rarely allowed religion to impinge on life, especially when it came to lining up a prize commission like the Basilica. Vasari writes: "He was not over-scrupulous although his ideas were clearly better than his rivals'."

Bramante was brash, a man of keen enthusiasms and quick actions, often too quick. He was not a precise man, a dangerous failing in an architect, and certainly not a technocrat, and he gained a negative reputation as a structural engineer, even as he became acknowledged as the foremost architect in Rome. His weakness was his rush to build. Vasari notes the "extraordinary speed," even fury, with which he produced his architecture. When it worked, he was called resilient and adaptable; when it failed, foolish, even dangerous.

To Michelangelo, who was consumed by every detail, Bramante's often haphazard, hasty construction was reckless, and his Basilica yard was corrupt. Because of his loose management, overseers

enriched themselves, substituting shoddy materials. Michelangelo was appalled by the architect's cavalier building methods. According to Condivi, Bramante "feared the judgment of Michelangelo who revealed many of his errors."

Memories were long, and rivalries enduring. In 1542, thirty-four years later, Michelangelo was still brooding over perceived slights and persecution. Bramante and Raphael "wanted to ruin me," he wrote. "All the occasions for discord arising between Pope Julius and me, all of them resulted from the envy of Bramante and Raphael of Urbino; and this was the cause of his not continuing his tomb while he was still living, and was meant to ruin me. Raphael had good reason for this, for all his art he had from me."

THE DEATH OF JULIUS

✦

Raphael's frescoes are painted stories as vivid as writings, and the dramas of Julius's pontificate unfold in them. Almost thirty years after Melozzo da Forlì painted the four nephews of Sixtus IV, Raphael painted the *Mass of Bolsena* in the Stanza di Heliodorus. Julius kneels on a prie-dieu. Behind him to the right is Raffaele Riario, and gathered below them are the Swiss Guards. Riario and the guards represent money and might, apt symbols for this redoubtable soldier-pope who charged into battle to subjugate errant states and charged into building, demolishing the most sacred shrine in Europe on a whim.

There is no trace of the young cardinals who attended their uncle in this later fresco. Riario appears portly, balding, and eminently self-possessed. Julius's physical presence is diminished. The hair is white. The shoulders, though still straight, are narrower now, compressed, the cheeks sunken. The once-handsome face is bearded, a symbol of mourning in the 1500s.

He is an old man, kneeling in prayer at the end of his life (he would die the next year), and although his hands are joined, his expression is not that of a humble man. No head bowed. No eyes lowered. He stares defiantly into the distance, weary, besieged but undefeated, and still determined. He doesn't look like a contrite

sinner begging forgiveness, or even benediction. More likely, he is ordering God to annihilate his enemies with a thunderbolt and grant him another ten, twenty, one hundred years—however long it would take to complete his grand enterprise.

Next door, in his library, was *The School of Athens*. It was Raphael's first major fresco, and to help his young protégé, Bramante had sketched the setting. What Bramante did not build in stone, he drew for Raphael. *The School of Athens* is the closest approximation we have to the Basilica commissioned by Julius and conceived by Bramante.

Julius must have sat in his library in front of the fresco, only his banker or his architect for company, imagining the Basilica he would never enter. He was at the end of his pontificate. His health was declining, and his artists were sniping at one another. The great art he commissioned was composed in an atmosphere of jealousy and suspicion.

Bramante had finished the Basilica crossing. The piers were arched, and the vaults were being coffered with ornamental panels recessed into the ceiling. Julius would never see the dome raised or the Basilica finished. But in Raphael's fresco the arching vaults rise over an enormous space that seems itself a dramatic element of the architecture. Classical thinkers discourse beneath towering ceilings that converge from four arms to a central dome. There, where liturgical ceremonies should unfold, the luminaries of ancient Greece and the artists of the new papal Rome gather and become one.

Like guests at a masked ball, the Renaissance artists appear in the guise of classical Greek thinkers: Plato painted with the face of Leonardo, Euclid in the person of Bramante, the astronomer Ptolemy lecturing to the student, Raphael. In the foreground, Heraclitus, "the weeping philosopher," sits alone. More muscular than the other figures, he slumps on the steps, apart from them and looking as if he doesn't want to be there. Heraclitus, who has the broad square forehead, flat squashed nose, and melancholy scowl of

Michelangelo, came late to the fresco after Raphael's clandestine visit to the Sistina.

∞

Knowing now that he would not live to witness the dome of the Pantheon rising over the Basilica, Julius wanted at least to see the Sistine ceiling finished in his lifetime. But after four years, Michelangelo was still barricaded in the chapel. He was never satisfied. A deeper shadow here, the finger crooked a fraction more there. He couldn't let the smallest detail go, and his slowness, his perfectionism, drove the old pope to tirades. Health and patience failing, Julius threatened to knock down the scaffolding if Michelangelo didn't finish and come down.

On All Hallows' Eve, October 31, 1512, one day shy of the last anniversary of his pontificate, Julius unveiled the ceiling to the marvel and amazement of all who beheld it. Locked in a monumental battle of wills, the twin Terribiles, irascible patron and painter, had wrenched out of misgiving and mistrust, fury and impatience, one of the sublime achievements of mankind.

If Bramante thought that he was marginalizing Michelangelo by relegating him to the Sistina, the aerial act did not turn out exactly as he had hoped. Michelangelo dumbfounded his rivals and made their jealousy seem like petty malice. It was sweet revenge.

The Sistina "placed Michelangelo beyond all envy." He was without peer, and his greatest work, he believed, was ahead of him. Certainly now, Julius would allow him to return to the tomb. It was not to be.

∞

On Christmas Eve, 1512, two months after unveiling the Sistine ceiling, the old warrior received the last sacrament. Julius had seen the Sistine ceiling and convened the Fifth Lateran Council,

which presaged the coming reform of the Church. Now, in his final weeks, his mind was preoccupied with the grand enterprise he would not see—and the grand price tag it carried into the future.

The four arches of the dome were complete up to the pendentives, the curved, triangular sections that form a transition between arches and drum. "All four arches of the great chapel of St. Peter's are vaulted which is a lovely thing and admirably fine to see," a visitor wrote in July 1511. Bramante was making preparations to raise the dome—but slowly, and only on paper.

The clearest way to gauge the pace of construction is to look at the annual expenditures. From a high of 27,200 ducats in 1507, Julius spent 14,300 ducats on the Basilica in 1508, 13,438 in 1509, and 14,391 in 1510. In the last two years, 1511–12, he tightened the purse strings so drastically that building slowed almost to a standstill, and no further entries were made in the *liber mandatorum*.

Julius did not want his grandest and most controversial enterprise to become a financial burden for the Church, but neither did he want it scuttled by future popes. He needed to generate an ongoing cash flow that would continue to underwrite St. Peter's after his death. With the future of the Basilica and the fiscal soundness of the Church weighing on his mind, he decided to implement the financing plan that Agostino Chigi had proposed.

In the final days of his life, Julius issued a papal bull granting an indulgence to all those who contributed to *la fabbrica di San Pietro*. It was the last and arguably the most momentous act in a momentous papacy. What seemed like a sound solution to the dying pope would have unimagined consequences for the Church. Building St. Peter's would become the costliest crusade that the Church ever undertook.

Giuliano della Rovere—Pope Julius Secondo, the Christian Caesar and *pontefice terribile*—died on February 21, 1513, after asking his closest aides to pray for his immortal soul. What regrets did he have at death? What sins did he confess? Bribery? Misuse of power? Warmongering?

According to Paris de Grassis, the pope's conscience was heavy in his last hours, "for he had sinned greatly and had not bestirred himself for the good of the Church as he should have done."

Few popes provoked more vitriol in their lifetimes. Anti-Julius fury was pitiless. Scurrilous plays, cartoons, pasquinades, and diatribes of every sort condemned the della Rovere pope for his bellicosity, his wily politics, and his duplicitous power grabs.

To such critics as Erasmus, the Dutch satirist and armchair reformer, the Church was triumphant when it was most Christlike. The pope should be humble and penitent, concerned with saving the least among us, not strident and belligerent, hurling sacred weapons at any who dared to cross him. Erasmus abhorred Julius for his militancy and his arrogance:

> The Popes are sufficiently generous with ... the terrible bolt of the papal bull, which by a flicker hurls the souls of men to the depths of hell. Our Christian fathers and Vicars of Christ wield the bolt against no one with more zeal than against those who are moved by the devil to nibble at and diminish the Patrimony of Peter.... They look on themselves as true apostles ... scattering what they are pleased to call her enemies. As if the Church had more deadly enemies than impious Popes who by their silence cause Christ to be forgotten, who use His laws to make money, who adulterate His word with forced interpretations, and who crucify Him with their corrupt life.

But to Julius, the Church was triumphant when it was seen to be the supreme authority, when the kingdom, the power, and the glory were radiant and absolute. To that end, he envisioned a single Italian nation-state* under the auspices of the Church. With the battle cry, *"Fuori i barbari!"*—"Out with the foreigners!"—he drove intruders back across the Alps. His political alliances were expedient, because they served a larger ambition: to make the Church of Rome preeminent. He switched allegiance as it suited his ends, and if all else failed, he had no compunction in declaring an enemy state in schism. This is essentially what he did when the French retook Bologna and announced that they were convening a council to try the pope as an apostate. Retreating in mock submission, Julius retaliated by convening the Fifth Lateran Council.

In 1512, the pope's favorite orator, the Augustinian monk Egidio da Viterbo, opened the proceedings with a clarion call for reform and renewal. Few believed it was sincere. In an unpublished diary, a skeptical Venetian expressed the widespread sentiment: "In an authentic council every recent pope from Innocent VIII and Alexander VI to the present pope would have been condemned and dethroned." Although generally dismissed as a sham, one more contemptible misuse of power by an unscrupulous pontiff, Lateran V proved to be a prelude to the genuinely reforming Council of Trent.

∞

History has been kinder to Julius than his contemporaries were. The Renaissance scholar Jacob Burckhardt called him "the savior of the Papacy," which had reached its nadir under the Borgias.

*It would take more than 350 years to realize Julius's idea of a unified Italy.

Julius may have gambled the Church and risked his own eternal soul, as his critics charged, but his legacy is unmatched. He brought recalcitrant princes to heel, reclaimed papal territories (which would remain loyal to the Church until 1870), and ennobled the world with art. "It was through him that Rome became the Classical City of the World . . . and the Papacy the pioneer of civilization."

Judged by his art and not his actions, Julius was an extraordinary civilizing force. He was certainly no saint, but in the context of the Renaissance, and compared with other popes, there were worse sinners. He didn't transgress as heedlessly as other Renaissance popes. He was not guilty of nepotism or simony* except when absolutely necessary—as in the synod that elected him pope—and he seldom indulged in concupiscence, although he fathered three daughters: Felice, Clarissa, and Giulia. In the Renaissance Church a lapse in celibacy was not a detriment to career advancement.

He inherited a Church that was spiritually and financially bankrupt. When he died, the Lateran Council was in session and the Vatican treasury was full. In spite of his costly initiatives, he left the Church richer than any other pope. According to a contemporary account, there were more than 200,000 ducats in the cash box at his death, as well as tiaras and precious stones valued at 150,000 ducats and gold and silver plate valued at 50,000 ducats.

For all that wealth, Julius left the Church an incomparably greater gift—the gift of Michelangelo, Raphael, and Bramante. Today, we look back at the artists he supported with the certitude of hindsight and history, and their talent seems obvious. But the best

*Although simony assured Julius's election in October 1503, immediately thereafter he decreed that any future papal elections tainted by simony would be invalid.

contemporary talent is not always clear, and in the heat of the moment, the truest are often passed over for the most facile.

Julius saw ability, even genius, where none was evidenced. Whether the intrigues ascribed to Bramante were real or imagined, in art as in everything, Julius made up his own mind. With extraordinary prescience, he coerced the best sculptor into painting, and the result is the Sistine ceiling. He commissioned an unproven twenty-five-year-old to paint over three rooms in the Vatican palace where more seasoned artists were at work, and the result is the Stanze di Raphael. And he appointed an over-the-hill artist with only a couple of buildings to his credit to build the first church of Christendom.

Like a sea surge or a mountain avalanche, Julius overwhelmed everything and everyone and wrested from history, from bickering monarchs and pleasure-loving prelates, from carping artists with superheated egos, from the ruins of an empire and the excesses of the Renaissance Church, a vision that became forever after the symbol of the kingdom of Christ on earth.

His ambition was inscribed on the medal struck to commemorate that cold April Sunday in 1506: *Non nobis, Domine, sed tuam gloriam*—"Not for ours, Lord, but for your glory." And if he could not always distinguish clearly between the two, his patrimony is enduring.

❧

After he died, a satirical dialogue entitled *Julius exclusus* became a sensation throughout Europe. The anonymous author imagined the pope arriving at the gates of heaven and confronting Peter:

JULIUS: Why don't you cut out the nonsense and open the door, unless you would rather have it battered down? Do you see what a retinue I have?

PETER: To be sure, I see thoroughly hardened brigands. But, in case you don't know it, these doors you must storm with other weapons.

JULIUS: Enough talk, I say! Unless you obey right away, I shall hurl—even against *you*—the thunderbolt of excommunication, with which I once terrified the mightiest of kings, or for that matter whole kingdoms.... In my Pontificate I carried on in such a way that there is no one ... to whom the Church, to whom Christ Himself, owes so much as to me.... Perhaps you are still dreaming of that old Church, in which you and a few starveling bishops ran a really frigid Pontificate, subject to poverty, sweat, dangers, and a thousand nuisances. Time has changed everything for the better. The Roman Pope is now quite a different thing.... What if you could see today so many sacred buildings erected by kingly wealth, so many thousands of priests everywhere (many of them very rich), so many bishops equal to the greatest kings in military power and in wealth, so many splendid palaces belonging to priests, and especially if you could see today in Rome so many Cardinals dressed in purple with regiments of servants crowding around them, so many horses better than those of a king, so many mules decorated with linen, gold, and jewels, some of them even shod in gold and silver? But then, if you caught sight of the Supreme Pontiff being carried high in the air in a golden chair by soldiers, and everyone worshipping him all along the way as he waves his hand; if you could hear the booming of cannon, the noise of horns, the blare of trumpets; if you could see the flash of artillery, hear the applause of the people, their shouting, see everything glowing in torchlight, and even the most powerful princes having difficulty being admitted to kiss the blessed feet ... then, I say, if you had seen and heard all of this—what would you say?

PETER: That I was looking at a tyrant worse than worldly, an enemy of Christ, the bane of the Church.

When *Julius exclusus* was published, a friend in Louvain wrote to Erasmus, "Everyone here is reading the little book on Pope Julius excluded from heaven." The satire became the first international bestseller, and the anonymous author turned out to be Erasmus.

THE DEPLORABLE MEDICI POPES

1513–1534

My nature has always disposed me to desire the overthrow of the government of the Church. But fortune has so willed it that my relations with two Popes have been of a kind to force me to labor and strive for their advancement. Were it not for this, I should have loved Martin Luther more than myself, in the hope that his following might destroy, or at any rate, clip the wings of this vile tyranny of the priests.

—Francesco Guicciardini

THE FIRST MEDICI PRINCE

The death of Julius II settled over Rome like the calm after a storm. He was a turbulent force, roiling the waters and wresting from the turmoil immortal art and architecture. But the man was exhausting, and when he died, there was a desire for serenity and civility—a relief from the heroic and a return to life on a more human scale. In that spirit, the papal conclave turned to a cardinal-prince of Florence, heir to a great humanist legacy—thirty-eight-year-old Giovanni de' Medici, son of Lorenzo il Magnifico. The new pope took the name Leo X.

A Roman hostess planning a dinner party might have hesitated to invite the intemperate Julius, but Leo was the perfect guest—impeccable manners, broad interests, amusing, and just naughty enough. The quintessential Renaissance prince, born to wealth, nurtured in luxury, and enamored of beauty, Giovanni de' Medici was a pretty child of great curiosity, who grew up to be pudgy and effete—not at all a dashing figure like his father. From his earliest years, he was destined for the clergy. He was a priest at age eight, abbot of the Benedictine house at Monte Cassino at eleven, and a prince of the Church at thirteen.

When the young cardinal was leaving Florence for Rome, his father offered this advice. "Rome is a sink of all iniquity," Lorenzo

told his son. You will meet men "who will endeavor to corrupt you and incite you to vices. All the Christian world would prosper if the cardinals were what they ought to be, because in such a case there always would be a good pope, upon which the tranquility of Christendom so materially depends." It was a dire Godspeed, and like a typical teenager, the young son ignored his father's warning and reveled in the sink of iniquities.

If the medieval Church exerted a seductive hold on the imagination with the promise of salvation, the Renaissance Church held out the promise of an earthly paradise—"thy kingdom come . . . on earth as it is in heaven." Humanists were secular and worldly, and they made Renaissance Rome their arena. They staged the festivals and the pageantry, delivered the sermons and orations, and wrote the histories of the period. They gave the city its style and expressed its cultural ideals.

The Renaissance has been called "an adventure of the mind" that engaged not only artists and intellectuals but also bankers, businessmen, and heads of state. No daunting chasms separated the ivory tower or atelier from the marketplace. Men of ideas and men of action shared a delight in knowledge and a passion for Plato. In reaction to the Aristotelian dialectic of Thomas Aquinas, they enshrined him as their philosophic god. These sixteenth-century neo-Platonists made beauty their ideal and man the measure of all things—the harmonious center of creation, freed from the constraints of the medieval Church to express and realize every desire.

Amid the easygoing morality, the God of the Thomists receded from the footlights and the idea of the individual, messy and flawed, in need of confession and contrition, was replaced by the idealized man—perfectly proportioned, free to express himself sensually, artistically, and intellectually.

If Florence and Urbino, city-states of refined culture, were the

Boston of their day, Renaissance Rome was New York—noisy, flashy, and cosmopolitan. It drew churchmen and ambassadors, artists and intellectuals, from every part of Europe. It was a time of spectacle and splendor, when life, thought, eccentricity, and art were committed on a grand scale. It was also a time of malfeasance and myopia.

The Renaissance clergy believed less, enjoyed more, and blithely risked their immortal souls. Success was prized over virtue, beauty over goodness, freedom over restraint, audacity over humility. Aesthetics, not morality, were the measure, and a commandment might be broken with impunity now and then, if done with style.

The cardinals who administered the religious and political affairs of the Church were not always ordained. The office did not require them to be. They were diplomats and administrators—the Roman Senate of the Roman Church. Their red hats didn't impede their enjoyment of life. Eclectic, vain, curious, slanderous, capricious, they surrounded themselves with artists, musicians, and intellectuals, and wallowed in conspicuous consumption. The same cardinal who subsidized Leonardo for sixteen years paid one hundred ducats, three times the average yearly salary, for a parrot that could recite the Apostles' Creed. But the best of them made their palaces salons where controversial ideas were debated and construed.

In art and ideas the Renaissance of Florence emulated Athens. By contrast, the Renaissance of the popes was thoroughly Roman. Where the Greeks strove for a universal ideal, the Roman Church sought the perfection of the individual. Its preoccupation was matter and spirit, the dichotomy that makes us human—the belching, sweating, aching, lusting body versus the animating soul. An effort to camouflage, even deny, the body would emerge from the Counter-Reformation, but the Renaissance Church reveled in the fullness of human nature. The sinner didn't whine and make excuses. He

expected to pay for his sins in the next life. In the meantime, though, there was this rambunctious, expansive life to enjoy.

Since humanism had exalted man as the measure of all things, nothing was too huge, too outlandish, too extreme, to be thought and tried. Art and ideas flowed freely in the halls of the pontifical palace. Papal patronage extended to painting, sculpture, decorative arts, architecture, music, theater, literature, and science, often at the expense of pastoral care.

Leo set the tone for his pontificate on the day he was elected. "Let us enjoy the papacy, since God has given it to us," he said to his cousin Giulio. And enjoy it he did. For his coronation, he threw the biggest party that Rome had seen since the reign of Nero.

Florentines flocked south for their Medici son's consecration. Leonardo arrived for the event, as did many less illustrious Tuscans. In the crowd was a physician who recorded each gaudy detail and wrote with unabashed envy, and perhaps a trace of tongue-in-cheek: "I experienced so violent a desire to become Pope myself that I was unable to obtain a wink of sleep or any repose all that night.... I really believe that everyone would rather be made a pope than a prince."

Riding sidesaddle on a white stallion, the new pope blessed the carousers with a silk-gloved hand. Triumphal arches marked the procession route. There were days of feasting, carnivals, festivals, and pageants, and fountains gushed red wine.

In Leo X's pontificate, amusement became an art, not a diversion. There were pageants on the Capitoline, bullfights in the Belvedere gardens, and hunting parties of three hundred in the *campagna*. The Medici pope reveled in entertainment. Francesco Guicciardini, a contemporary historian and a Florentine partial to the Medici, wrote: "Rome and the whole court basked in the highest

flower of felicity . . . Leo being by nature given to ease and pleasure and now in his overweening careless grandeur . . . estranged from practical affairs."

The Medici prince kept a menagerie of civet cats, chameleons, apes, parrots, lions, and the king of his animal kingdom—a snow white elephant named Hanno. It was a gift from King Manuel of Portugal, and the purest thing seen in Rome in years. Hanno arrived at the Vatican wearing two pairs of red shoes identical to the pope's and genuflected three times. Leo was enchanted. Anything odd or exotic captured his fancy, from wild beasts to dwarfs. The flamboyant humanist Pietro Aretino remarked after watching him applaud the ribald antics of a midget: "It is difficult to judge whether the merits of the learned or the tricks of fools afford the most delight to his Holiness."

Leo was generous to a fault—a young man of unwavering family loyalty, sweet disposition, and expensive taste. He was an amateur in the true meaning of the word—a lover of wit, poetry, music, and theater. He cultivated the most skilled artisans and intellectuals of the day, surrounding himself with painters, poets, and scholars, among them Raphael, Pietro Bembo, Jacopo Sadoleto, Aretino, Castiglione, and Erasmus, whose criticism of Julius had been so scathing. Although his intentions smacked of noblesse oblige, they were generally laudable:

> Since God called us to the high dignity of the Pontificate we have devoted ourself to the government and extension of the Church, and, among other subjects, we have conceived it to be our duty to foster especially literature and the fine arts: for, from our earliest youth we have been thoroughly convinced that, next to the knowledge and true worship of the Creator, nothing is better

or more useful for mankind than such studies, which are not only an adornment and a standard of human life, but are also of service in every circumstance.

∞

Prudence and temperance were not the new pope's virtues. He preferred opulence to order, spectacle to substance, and ease above all.

Characteristically, Leo's first intervention in the new St. Peter's was dictated by personal comfort. For seven years, the cardinals had suffered the vagaries of wind and weather at Julius II's alfresco masses. Leo had shivered in the icy winters and sweltered in his heavy vestments in the sticky Roman summer. Once, on a turbulent June morning at the solemn feast of the apostles Peter and Paul, the wind churned up so much dust from the construction yard that it felt like a sirocco. Led by Leo, then Cardinal de' Medici, the buffeted princes of the Church, grit clinging to their chasubles and filling every pore, rose up as a single body and sought sanctuary in the Sistine Chapel.

Unlike Julius, Leo was more epicure than stoic. He ordered Bramante to erect a temporary shelter over the papal altar so that he could perform his liturgical duties without distress.

Bramante began to build a *tegurium,* an altar house, between the new foundation piers. He designed a graceful chapel in the style of a small Doric temple, but he left it for his assistants to complete. The Basilica had exhausted him, and he no longer had the energy of Julius to feed his own.

When Leo was elected pope, the earth shifted for Bramante. The Medici papacy brought a resurgence of the Florentine faction that he had so successfully marginalized. Tired and disheartened, Bramante had to watch Giuliano da Sangallo return to Rome and

embark on plans for an elaborate new villa for the Medici in Piazza Navona.

Bramante felt beleaguered without Julius and disconcerted by the ascension of a young Medici cardinal-prince with very different priorities than, and at best ambivalent feelings about, his predecessor. The relationship between the della Rovere and Medici families was long and tangled. The bad blood between them went back to the pontificate of Sixtus IV, when two papal nephews were implicated in the Pazzi conspiracy to unseat Leo's father and uncle.

Although being Julius's man did not endear the architect to the new pope, Leo approached the problem of Bramante gingerly. The *capomaestro* was the preeminent builder in the city, and he was too well connected to be replaced. But Bramante was an old man now, in constant pain from gout. The gentlest touch made him wince, and his fingers were so gnarled and swollen that he couldn't grip a pencil to draw a plan. His health was failing, and his hasty construction was raising questions.

Bramante had always been a one-man show. As *magister operae*, he controlled design, planning, construction, and oversight—every aspect of the enterprise. It was a Herculean task—and the Basilica was only one of the multiple Vatican projects that he administered. If every detail was not closely attended to, it was understandable, but serious structural problems were becoming apparent.

Leo made no attempt to oust the architect. Instead, he diluted Bramante's power by bringing in assistants purportedly to lighten the old man's burden. That both assistants were at least Bramante's age or older, and that one was his longtime rival, suggest that Christian kindness was not the pope's sole motivation. In place of a single chief of works, Leo created a hydra. He let Bramante maintain artistic control and his title, but he put construction and administration in the hands of the Florentines.

Leo called on eighty-year-old Fra Giovanni Giocondo to work with Bramante and address the structural concerns. The elderly Dominican monk had worked for the pope's father, Lorenzo, in Florence. He was a quintessential Renaissance man—a teacher, philosopher, bridge builder, architect, expert on classical antiquities, editor of the letters of Pliny, and illustrator of Vitruvius's *De architectura libri decem.* Most significant, he was arguably the best engineer in Italy. As Bramante prepared to raise the enormous dome, Fra Giocondo's engineering skill would be invaluable.

The monk's appointment was a wise decision, and Bramante may have welcomed it. But six months later, his position was weakened further when Giuliano da Sangallo assumed operational control of St. Peter's. The architect whom Julius had passed over in favor of Bramante finally had the opportunity denied him eight years before.

It was quite a triumvirate—the independent and proud *capomaestro* Bramante forced to share power with his gifted old rival Sangallo and the practical-minded Fra Giocondo. How it would have worked in actual terms is conjecture. Bramante did not live long enough for any real collaboration. He died in the second year of Leo's pontificate.

❦

A dialogue written by Andrea Guarna, a much gentler satirist than Erasmus, circulated around Rome. Bramante had refused to enter paradise because he didn't like the steep approach from earth.

"I will build a new, broad, and commodious road," the architect proposed to St. Peter, "so that old and feeble souls may travel on horseback. And then I will make a new Paradise with delightful residences for the blessed."

When St. Peter rejected his proposal out of hand, Bramante offered to go down to hell and build a new and better inferno. Bramante's grand plans didn't interest the keeper of the keys.

"Tell me," St. Peter demanded, "what made you destroy my church?"

Trying to assuage him, Bramante answered, "Don't worry, Peter. The new Pope will build a new, more beautiful church for you."

"Well, then," Peter replied, "you must wait at the gate until it's finished."

Bramante died in 1514. Another century would pass before St. Peter's was consecrated, and all the major architects in Rome would have a hand in its construction.

AN EMPTY STAGE

∝◊∾

The stage was suddenly empty. Within seventeen months, the twin engines of the Roman Renaissance were gone, leaving the old St. Peter's partially demolished and the new Basilica a work barely in progress. Between 1505 and 1510, Bramante had completed the Basilica crossing. He had raised the four giant piers that would support his flying-saucer dome, joined them with soaring coffered vaults, and established an internal order of paired Corinthian pilasters so colossal that the stepped bases alone were ten feet high and the shafts began far above eye level. Every element of his construction drew the eye upward. At the western end, he had completed Rossellino's tribune and faced the exterior with Doric columns, and he had begun building the corner chapels.

It has been said that Bramante built the skeleton of the Basilica, and those who came after him covered it with muscle, sinew, and skin. A truer description is that Bramante gave St. Peter's its soul, and his successors added the body.

In his eulogy, Egidio da Viterbo, the fiery orator and friend of Julius, declared:

> . . . all people are persuaded, on the basis of the visi-
> ble pile of foundations already laid, that whatever will

happen in the city of Rome and among whatever great
works there come to be, this will forever be the greatest
of them. Nothing in Italy and indeed nothing in the
universal orb of nations will ever be more sublime, or in
cost more magnificent, or in excellence greater, more
splendid, more admirable.

Although Bramante had made extraordinary progress in a very
few years, when he died nothing was certain except the scale of the
Basilica. His design was so unsettled that in his good-natured
satire, Guarna has St. Peter saying, "We still don't know where to
put the doors of my church." More alarming than the vacillation
were the structural concerns. The foundations of the new Basilica
were shifting. Cracks appeared in the piers. From the outset, the
project had been ambitious. Increasingly, it seemed impractical.

<center>∞</center>

The Pantheon is a solid cylinder, and the dome rests on top of it.
In effect, it stands on the ground, and the massive weight is distrib-
uted evenly. The design of the dome, which is four times thicker at
the base than at the top, also reduces the weight that the continuous
wall must bear. Because space was an active element in Bramante's
architecture, he wanted to keep the core—the central circle beneath
the dome—open, allowing the arms of the Basilica to extend from
it like roads from a hub. The four discrete piers would have to ab-
sorb the full weight of the dome.

After Bramante's death, there was concern that the piers were not
strong enough to support the dome, and worse, that the construc-
tion of the dome was beyond technical competence. Bramante's
concept was untried. No one had ever vaulted such a broad expanse
at such a dizzying height and balanced it on such dubious supports.
It was a risky and daring experiment—a fantasy, some said.

Serlio called the design "a great revelation to architects," but he doubted that it could be executed. Criticizing the dome as "bold rather than well-considered" and Bramante's calculations as "utopian," he wrote: "As the elevation shows, the great mass and weight of the dome was to rest on four soaring piers; any prudent architect would do well to place a mass of this kind on the ground, and not so high up."

Prudent or not, the great piers were in place and vaulted, determining irrevocably the diameter and elevation of the dome and the height of the nave. From that starting point, everything else had to proceed organically. But the surrounding Basilica was still on the drawing board.

∞

There were three contenders to replace Bramante: Michelangelo, Giuliano da Sangallo, and Raphael.

Michelangelo had no interest in the position. As a token of esteem or an effort to assuage his conscience, Julius had left him ten thousand ducats in his will to complete a much-reduced sculpture, and Michelangelo had finally resumed work on the tomb. Still, he seemed the obvious choice. He was a unique talent, a Florentine, and a boyhood friend of the new pope. But Leo wanted him immortalizing the Medici, not building an Olympian edifice for the della Rovere pope. Also, Leo knew Michelangelo too well, and he preferred to keep a comfortable distance between them. "Buonarroti is an alarming man," he said, "and there is no getting on with him."

Instead of appointing Michelangelo to work on the Basilica or allowing him to sculpt the tomb, Leo dispatched him to Florence to the Church of San Lorenzo. Denied his dream again by a second capricious pope, Michelangelo "went off in tears."

With his old friend out of contention, the candidacy of Giuliano

da Sangallo looked more promising. Sangallo had several points in his favor: he was Florentine, he had designed many projects for the Medici, he was an accomplished architect, *and* he was already in place at St. Peter's. But once again, he was passed over in favor of an artist with much less architectural experience.

Although Raphael was a painter, not a builder, he had one clear advantage. He was the new pope's favorite artist. The Italian word *simpatico* best describes the relationship between Leo and Raphael. Pope and painter were two of a kind—young, happy hedonists who seemed to breeze through life. A contemporary described them as "amiable epicureans who made Christianity a pleasure and took their heaven here."

In the summer of 1514, Leo appointed the thirty-one-year-old painter to succeed Bramante as *magister operae*. Raphael wrote excitedly to his uncle:

> I cannot be anywhere else [but Rome] for any length of time on account of the building of St. Peter's, where I have taken the place of Bramante, but where in the world is there a worthier place than Rome, and what work is worthier than St. Peter's, which is the foremost temple in the world. This is the greatest building project ever seen, which will cost more than a million in gold, and you know that the Pope has authorized spending 60,000 ducats a year on it, and thinks of nothing else.

Although he had passed them over, Leo prevailed on the two venerable architects, Sangallo and Fra Giocondo, to stay and work with the inexperienced new *capomaestro*. The solution seemed inspired, and Raphael, at least, was pleased with the arrangement. In the same letter to his uncle, dated July 1, 1514, he explained:

The Pope has given me as partner a very learned friar, more than eighty years old; seeing that he cannot live much longer, His Holiness decided to make him my partner, as he is a man with the reputation for great wisdom, so that I can learn from him if he has any secret of beauty in architecture, so that I can reach perfection in that art. His name is Fra Giocondo. The Pope gives us audience every day, and keeps us long in conversation on the subject of the building.

A ROMAN CANDLE

❧

As architect of St. Peter's, Raphael became the toast of Rome. He lived more like a prince than a painter in a palace built by Bramante and moved through the city in a swarm of fifty or so disciples, assistants, sycophants, and hangers-on. He was young, gifted, rich, and as beautiful as a Roman god.

Raphael led a charmed life. Everything seemed to come easily. His talent was effortless, as if he had a touch of divinity. His art raised no doubts, evoked no terrors, and idealized whatever it depicted. It was the apogee of Renaissance painting.

His signature velvet beret angled over his golden curls, Raphael cut a romantic figure in the streets of Rome and the salons of the Vatican. He was the darling of Pope Leo, and of a fair percentage of the most beautiful women in the city. They found excuses to visit his studio in the Spina di Borgo and dispensed their favors generously.

Raphael was a "very amorous person," according to Vasari, young, handsome, and lionized—a celebrity comparable to a movie star or sports idol today. Although engaged to be married to Maria Bibbiena, a cardinal's niece, described as beautiful and dignified, Raphael was a reluctant bridegroom. To avoid his prospective

bride, he once hid in Agostino Chigi's villa with his mistress of the moment, *la fornarina*, a baker's daughter from Trastevere.*

Raphael's commissions were as numerous as his conquests. He was designing a country villa on Monte Mario for the pope's cousin, Cardinal Giulio de' Medici, frescoing Chigi's riverside palace, painting portraits, designing scenery for the elaborate pageants that Leo enjoyed, and operating a veritable art "factory" that turned out Madonnas like *cornetti* from a bakery. Many of Raphael's Madonnas, it was said, had the face of his latest mistress.

He bragged to his uncle:

> I find myself at present with possessions in Rome worth 3,000 ducats and 50 gold scudi in income, because the Holiness of Our Lord has provided me with 300 gold ducats to look after the building of St. Peter's, which I shall not lack for as long as I live, and I am sure I shall have more from others. And then I am paid for what I do at whatever price I myself fix, and I have begun to paint another room for His Holiness, which will amount to 1,200 gold ducats. . . . And don't moan about me not writing; it should be me moaning about you, who have a pen in your hand all day long.

In spite of Raphael's enthusiasm, the second architectural triumvirate was as short-lived as the first. Fra Giocondo died within a year, and the aged Sangallo limped home to Florence, opening the way for his nephew, Antonio the Younger, to become second architect. Baldassare Peruzzi, who built Chigi's villa, was named number three.

*His famous portrait *La Fornarina* is probably misnamed.

Pope Leo's third triumvirate was young, ambitious, and overextended. Because they were building the defining edifice of the age, the three architects were in constant demand—and constant disagreement over how to realize the miracle in stone.

∞

The monumental Basilica had matched the personality of Julius. Leo's character, by contrast, lacked heroic dimensions. He was a connoisseur of the decorative arts, a lover of fine gold-work, tapestries, and jewelry more than of colossal constructions.

Critics had denounced Julius for confusing spiritual and political power, but they never questioned his conviction. To him, the glory of God and of the Church was paramount. Leo's loyalties were divided. He was a prince of the Church, but he was also a prince of Florence, and he ruled both simultaneously. Restoring Florence to the luster of the Quattrocento and his family to its rightful place as princes of the Republic were his priorities.

Although he preferred an exquisite miniature to a megalith, Leo appreciated architecture as political capital, exploited by the Roman emperors and now embraced by their successors, the Roman popes. Only the mightiest could construct a monumental edifice, and in Leo's eyes, there were none mightier than the Medici.

He was prepared to pour money into the Basilica as if gold alone could make stone rise. If Raphael's excited letter of July 1, 1514, can be believed, in the first year alone, the Medici pope was planning to spend sixty thousand ducats, more than twice what Julius had spent in any given year. But like any large-scale operation that is managed from the top, the loss of the boss threw the project into confusion.

Leo could no more oversee the enormous Basilica operation than Hanno the elephant could bless himself. The line of control, both financial and artistic—as true as a straight edge under Julius

and Bramante—grew twisted and murky. Leo was hopeless with money and not much better at administration, and while his new *capomaestro* had outstanding gifts and noble intentions, he was young and inexperienced. Raphael was neither controlling nor conniving enough to fill Bramante's role.

<div align="center">∾</div>

Julius and Bramante had completed the core of the Basilica. It was an extraordinary accomplishment given the epic size and the time they had. But their most impressive achievement was not the work they realized. It was the immensity, the sheer impudence, of their idea. Their tragic flaw was a lack of clarity. They left no definitive plan for future pontiffs and architects to follow, and no cost estimate to restrain more opulent tastes.

Given the quick enthusiasms of pope and architect, it's not surprising that they never settled easily on a single blueprint. There is some suggestion that Bramante built a wooden model. If he did, it was lost, and all that remains is boxes and books of drawings, sketches, and designs. Their volume is both a measure of his enthusiasm and an indication of how fluid his plans were. He had a quick, fertile mind. New ideas came thick and fast, and the latest always seemed the best, and captured his enthusiasm.

The only certainty in the grand enterprise was the dome. From the moment of conception, it was the locus in the scheme of the Basilica—the alpha and omega, the starting point and the sublime finale. The shape and elevation would change over time, but not the fact of the dome, repeated like a mantra in the words that Paris de Grassis recorded and that have become immortal, as if inscribed in the very stones of the Basilica: "To raise the dome of the Pantheon on the Basilica of Maxentius."

The dome was the fixed idea from which the imagination of Bramante and every architect who followed him wandered freely.

By building from the center out, Bramante not only established an irrevocable scale, he also allowed his successors wide latitude. Everything except the circumference of the dome was open to debate, even the fundamental shape of the Basilica. Although his preference was a Greek cross, according to the plans in the Uffizi and in Menicantonio's sketchbook, Bramante and Julius had considered the Latin one too—or at least experimented with both on paper. The argument between the two cruciforms—the Greek cross with four arms of equal length and the Latin cross with an elongated vertical arm—is a choice between the ideal and the practical. The symmetrical Greek cross appealed to Bramante's Renaissance sensibilities. Its pure geometric form was considered a reflection of God. The asymmetrical Latin cross was more practical, because the extended arm would accommodate the large crowds that attend papal ceremonies. Since the Latin cross was the form of Constantine's church, Julius may have asked Bramante to develop a similar design to quiet his critics—a compromise or creative deception, suggesting that the new St. Peter's would hew more closely to the original than they actually intended.

The Greek-versus-Latin-cross controversy would plague the project for more than a century. Each time it seemed resolved, a new architect or a new pope went back to the drawing board. While Leo was in office, the debate swung back and forth numerous times.

Fra Giocondo and Raphael both favored a Latin cruciform. Raphael's plan had an aisled nave, an impressive, double-storied façade, and a piazza with the obelisk of Caligula in the center— very much as it is today. Although he kept the dome and vaulting just as Bramante had planned, he encircled the apses with aisles on the theory that a ring of ambulatories would absorb some of the thrust of the dome, lessening the strain on the piers.

Unity had inspired Bramante's design. Raphael's ambulatories

had a divisive effect, creating a separation between the core of the Basilica and the external walls. He emphasized the division by introducing the Doric order to articulate the outside walls. There was little coherence between the interior and exterior of the Basilica.

Some scholars suggest that Bramante may have converted to the Latin cross before he died, because Raphael would not have deviated fundamentally from his mentor and friend. There is little concrete evidence to support or refute the argument.

More grandiose than Bramante's, Raphael's design matched Leo's extravagance if not his budget. But it was never executed. Raphael found little common ground with his partners. Antonio da Sangallo took exception to much of Raphael's Basilica plan and Peruzzi took an opposite direction. He favored a return to a centralized Greek cross with four entrances, one at the end of each apse and all leading to the papal altar.

The three young architects proposed contending designs. Irresolution is expensive, and in this case, disastrously so. It caused arguments, delays, divisions, and backbiting. With little direction and no definitive blueprint, plans multiplied like the biblical loaves and fishes, and the price tag kept rising.

In the years after Bramante's death, building was erratic at best. Some progress was made on the south arm of the church. Leo christened it the Cappella del Re di Francia—"the Chapel of the King of France"—hoping that by giving the king's name to a significant portion of the Basilica, Francis I would be induced to pay the construction costs. Although Leo continued to lavish money on the new Basilica, ordering the most expensive travertine for the exterior walls, St. Peter's did not advance significantly.

The architects and their associates were becoming wealthy men, but their flourishing careers left them little time to build the church. As a result, much of the money that went into St. Peter's was spent on keeping the work yard operating while the architects

pursued other commissions. Although more money went into salaries and supplies than into actual building, each architect wanted to leave his signature. Drafts were drawn and redrawn, the arms of the Basilica extending and contracting, the elevation of the dome peaking and flattening, then peaking again, and still there was no blueprint agreed on by all.

Raphael's most significant contribution was not in stone and mortar but in his architectural renderings. He introduced exact scale drawings that masons could read with precision.

Like most sixteenth-century builders, Bramante had marked out a working plan on-site and then explained it in detail to his masons and stonecutters. There was often a scale model in wood or clay for them to follow, as well. For moldings, capitals, and other intricate work, full-size patterns were drawn to guide the artisans.

Raphael added another dimension. He was used to drawing detailed sketches and cartoons for his frescoes. When he turned to architecture, he realized that linear perspective did not give a full or always accurate picture of spatial relations. In a note to Leo, he explained that architectural renderings need "to master all the dimensions of a building and see all its parts without distortion."

His renderings gave three views—ground plan, elevation, and section. Each element of the building, both interior and exterior, was clearly represented. This not only provided closer directions for the master masons, it also freed the architect from being on site all the time. Raphael's three-dimensional renderings would become accepted architectural practice, though not in his lifetime.

<div align="center">∞</div>

Bramante, Leonardo, and Michelangelo lived to be old men. Raphael had only a dozen years in Rome for his genius to reveal itself. He was a Roman candle, blazing brilliantly and briefly across the city. According to Vasari's romanticized version, one wild April

night in 1520, "having indulged in more than his usual excess," Raphael returned home a spent man in need of "restoratives." Instead of fortifying him, the doctors bled him. He never recovered.

Raphael died on Good Friday, April 6, more probably of the plague. It was his thirty-seventh birthday. Leo's third triumvirate had proved as short-lived as the previous two.

THE REVENGE OF THE SANGALLOS

∞

After Raphael's death, Antonio da Sangallo moved swiftly to advance himself. Whether it was a ploy to secure the coveted position of *capomaestro* or whether it was a sincere difference of artistic perception, Antonio wrote to the pope, roundly criticizing Raphael:

> Acting more out of pity and respect for God and St. Peter and respect and the desire to be useful to Your Holiness, than to myself, this is to inform you how the money being spent with little respect for or use to God and Your Holiness is like throwing money away, and the reasons are written down here.

Antonio listed numerous technical and design faults in Raphael's scheme, including a long, dark nave that would make the Basilica feel like an alley; Doric columns that were too tall in proportion to their circumference; heavier piers in the nave than in the crossing; and an insufficient number of large chapels.

His attack was scathing, but it has to be considered in context. *Magister operae* was the most prestigious and sought-after job for an architect. Whoever was chosen was assured a prominent place in

Roman society and lucrative additional contracts. Rivalry among artists was fierce. To advance his own cause, Antonio had to convince the pope that he was his own man, worthy to be more than second architect. Given the pope's affection for Raphael, Antonio's tactic seems ill-advised, yet it worked. Leo, apparently accepting his argument, named him chief architect in 1520. Peruzzi moved up to second architect.

Antonio Giamberti Picconi da Sangallo (1484–1546), known as Antonio the Younger to distinguish him from his uncle Antonio, first appeared in the Vatican record books ten years before. While his uncle Giuliano and Michelangelo seethed with anger and resentment, Antonio went to work for their nemesis, Bramante. Whether Julius hired the young artisan as a consolation for his old friend or whether Bramante was trying to divide the Florentine faction, Antonio the Younger joined the construction team as a carpenter. He was twenty-four, and building St. Peter's became his lifework. It brought him prominence and influence, and made him a wealthy man. For the next thirty-eight years, at least one, and often many, members of the Sangallo family were on the payroll of St. Peter's.

Because of his family connections, Bramante at first kept a close eye on the young Sangallo, but Antonio, who had a quick and practical mind, proved his worth. When Bramante was constructing the arches spanning the diagonal piers of the dome, Antonio built the centering, a temporary wooden frame to support the masonry until it set. Considering the vast height of the arches, it was no mean achievement, and Bramante was impressed.

Because the triangle is the only geometric form that can't be distorted unless the length of a leg is changed, it was the basic form in all centerings and scaffoldings. Antonio's frame for the main crossing arms was a series of braced triangles bound with iron straps. Two right triangles (A-B-C with B-C being the hypotenuse) stood on end, so that points B were on the ground at either end and

points C came together in the middle of the centering. A-C C-A formed a single sturdy line that also became the base of an isosceles triangle rising above it. The three triangles were buttressed at strategic points by smaller triangles. The center of the arch rested on the apex of the upper isosceles triangle. Since the span of the arches was seventy-five feet, finding and hauling timber of a sufficient length and thickness was difficult if not impossible. Renaissance builders devised various ways to splice together lengths of wood and secure them with iron bands and brackets.

Bramante grew to trust and depend on the young Sangallo's practical skills. Antonio and Baldassare Peruzzi learned their trade working in Bramante & Co. According to a money order issued to pay their salaries, by April 1510, they were two of five subarchitects working under Bramante, and there is ample evidence that they drew many of his plans. Of the two, Peruzzi was the more original talent, but Antonio mastered the technical aspects. He became a skilled structural engineer and a shrewd businessman and lived in high style when Peruzzi was still struggling to make ends meet.

Antonio had never been a sculptor, painter, or designer of any kind. He was the first pure architect to become *capomaestro*—and that was both his strength and his weakness. In Benvenuto Cellini's disdainful words, Antonio was "a draftsman not an architect." While it is true that he was a meticulous and prolific draftsman—the Gabinetto dei Disegni e delle Stampe of the Uffizi Gallery holds more than one thousand of his drawings—Antonio had two essential qualities that most of the architects of St. Peter's lacked: common sense and a practical mind. His skill was not creation but implementation. The most brilliant design, unless it is well implemented, will fail.

In what remained of Leo X's disordered papacy, Antonio completed the barrel vaulting Bramante had begun. Spanning two walls like a continuous arch, a barrel vault is another brilliant Roman invention in cast concrete. All of Bramante's arches in St. Peter's are

coffered barrel vaults, and Antonio continued the same vaulting in the southern apse.

❧

Although the Chapel of the King of France was nearing completion when Antonio became *capomaestro*, without the furious spirit of Julius, his sharp, questioning intelligence, and his determination, the new St. Peter's had lost its impetus. The funds expended were out of all proportion to the progress achieved. The Basilica became a sinkhole into which money disappeared. There were few progress reports, fewer cost controls, and no restraints. Adding to the confusion, architectural control kept changing. In the eight years of Leo's pontificate, St. Peter's had six architects.

Money was squandered, mishandled, possibly stolen. Expenses were inflated, whether intentionally or by mismanagement and poor oversight. The payroll swelled. Artisans and suppliers became wealthy men on the construction of St. Peter's. None profited more than the Sangallos. Antonio's cousins, Giovan Francesco and Bastiano da Sangallo, had the concession for the lime furnaces, pozzuolana, and tufa. According to Vasari, it "brought them very large profits and in this way Bastiano lived for a time . . . having amassed a large amount of money."

Leo X's fiscal policy consisted of extravagant spending matched by extravagant borrowing. The pattern was set from his consecration, when money flowed like wine, and Agostino Chigi picked up the check. To pay for the three-day carnival, Chigi had advanced Leo the lavish sum of seventy-five thousand ducats, enough to support a fair-sized town. Conveniently for the new pope, the banker's lease on the alum mines had just expired, and he was pleased when it was renewed for an additional thirteen years.

Through the confidence of Julius and the profligacy of Leo, Chigi had become the wealthiest man in Italy, and very possibly in

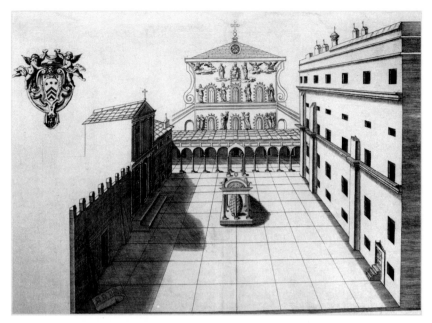

The original basilica of St. Peter, built by the emperor Constantine and consecrated in
A.D. 326: the exterior viewed from the atrium and the interior.

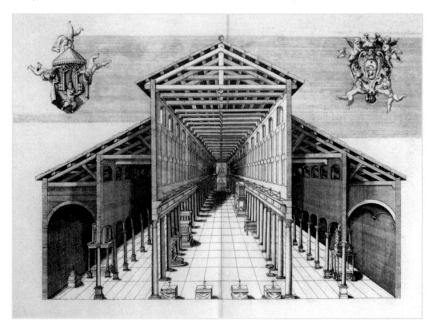

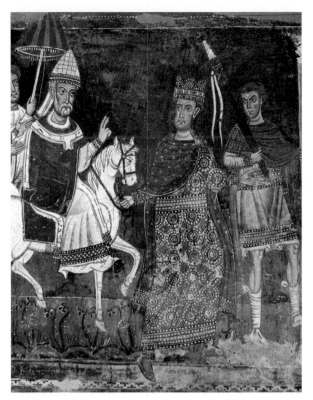

Constantine grants to Pope Sylvester the primacy of the Church in the Western empire in this thirteenth-century fresco.

While Florence basked in the Renaissance, Rome lay in ruins. Much of the city of the Caesars was still overgrown when Julius II became pope.

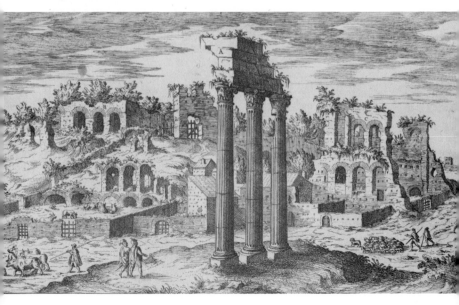

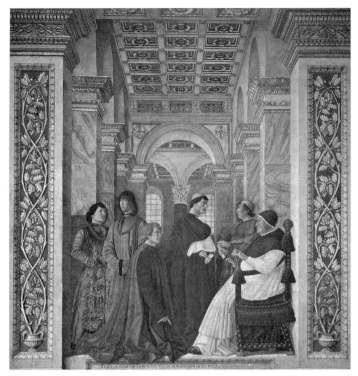

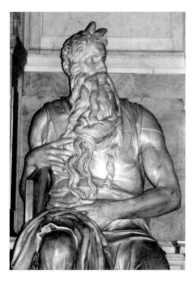

Three faces of Julius II (*clockwise*): the young Cardinal Giuliano della Rovere standing in profile in front of his uncle Pope Sixtus IV in a fresco by Melozzo da Forlì; the scandalous pope who ordered a new basilica, from the medal cast to commemorate the laying of the foundation stone; as Moses, sculpted by Michelangelo for his ill-fated papal tomb.

A drawing of the original architect of St. Peter's, Donato Bramante, believed to be a self-portrait.

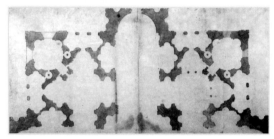

"The Parchment Plan" is the only Basilica design that we know with certainty was drawn "by the hand of Bramante."

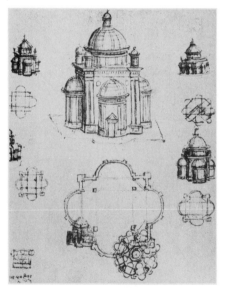

Bramante's design was influenced by his friend Leonardo da Vinci's ideas for a centrally planned church. This sketch by Leonardo dates from the period when they worked together in Milan.

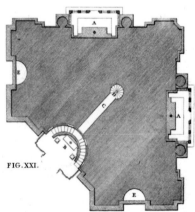

FIG. XXI.

Bramante began building the Basilica from the center. This architectural sketch of the first pier built to support the dome shows the immensity of the undertaking.

Raphael's visual narratives. Bramante drew the setting for his protégé's first major fresco, *School of Athens* (*above*). It is the closest approximation we have of the Bramante-Julius Basilica. In his *Mass of Bolsena* (*right*), Raphael painted Pope Julius at the end of his life, diminished physically yet still formidable.

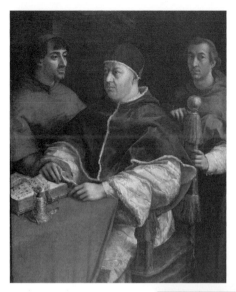

The first Medici pope, Leo X, in a portrait by Raphael. Leo's cousin and confidant, Cardinal Giulio de' Medici, who became Pope Clement VII, stands in the background with Cardinal Luigi de' Rossi.

Twin paintings by Giorgio Vasari reflect Clement VII's tragic flaw, indecisiveness. Clement vacillated between the French king Francis I (*right*) and the king's political archrival, the emperor Charles V (*below*), with terrible consequences.

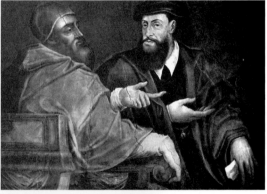

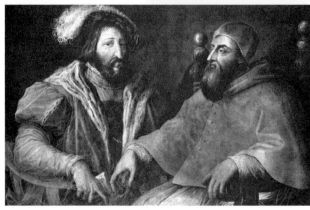

After the Sack of Rome, the Flemish artist Maerten van Heemskerck sketched the abandoned St. Peter's. The columned nave of Constantine's basilica still stands in the foreground, while, beyond it, Bramante's arched piers loom above his altar house like a failed dream.

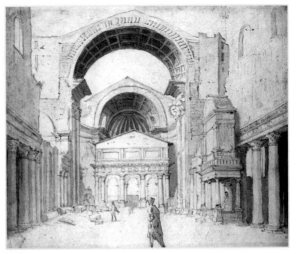

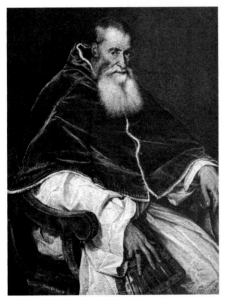

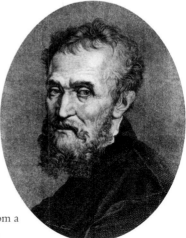

A portrait by Titian of the Farnese pope Paul III, who gave Michelangelo carte blanche to complete the basilica.

The incomparable Michelangelo, from a self-portrait that the artist sculpted.

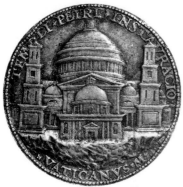

Three Basilicas of St. Peter, none ever built (*clockwise*). Bramante's original design as it appeared on the commemorative medal. Antonio da Sangallo's elaborate and costly model, rejected by Michelangelo. Michelangelo's return to Bramante's Greek cross. Note the simpler façade and squatter, hemispheric dome compared with the actual Basilica.

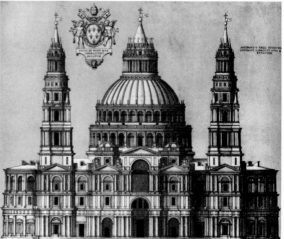

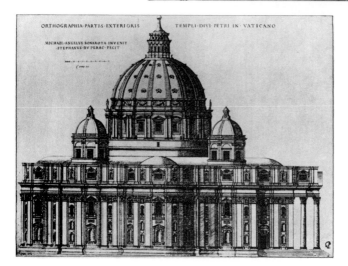

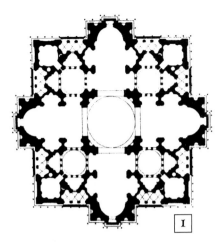

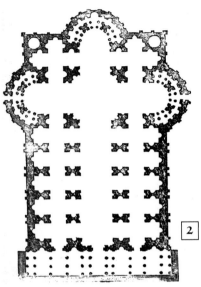

Contending plans for the new St. Peter's:
1. Bramante's Greek cross. 2. Raphael's
Latin cross. 3. Antonio da Sangallo's Latin
cross. 4. The final plan: Michelangelo's
Greek cross appended with Carlo
Maderno's long nave (in gray).

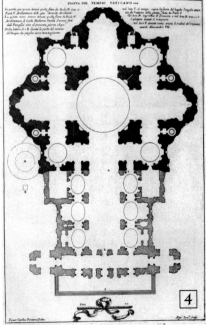

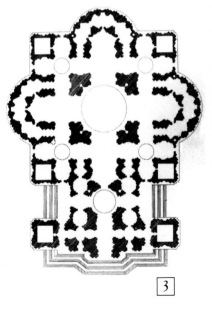

Pope Sixtus V was consecrated in the shadow of Michelangelo's unfinished dome. Sixtus complained that the open drum made the new Basilica look like a headless giant.

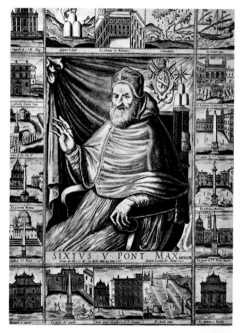

Sixtus, who started life as a swineherd, is known as the father of modern Rome. Here he is framed by his many extraordinary accomplishments— among them moving the Vatican obelisk and raising the Basilica dome.

The Vatican obelisk was believed to be an unmovable object until the irresistible force that was Sixtus V decreed that it would be transferred from the north side of St. Peter's to the center of the square. Domenico Fontana undertook the astounding engineering challenge.

Each Basilica architect proposed a different dome for St. Peter's. The designs (*top–bottom, l–r*) by Bramante, Antonio da Sangallo, and Michelangelo were rejected by Giacomo della Porta, who raised his own dome in just twenty-two months and secured it with three iron rings, indicated by the horizontal lines.

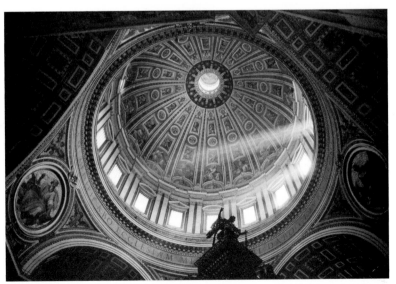

The inner shell of the cupola, which follows the contour of Michelangelo's dome, was decorated by the mosaic artist Cavaliere d'Arpino. It took considerably longer for Arpino to complete the mosaics than it took della Porta to raise the dome.

The Borghese pope Paul V, from a bust
by Gianlorenzo Bernini.

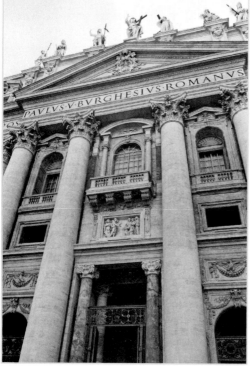

The much-criticized Basilica
façade, ordered by Paul V and
designed by Carlo Maderno.

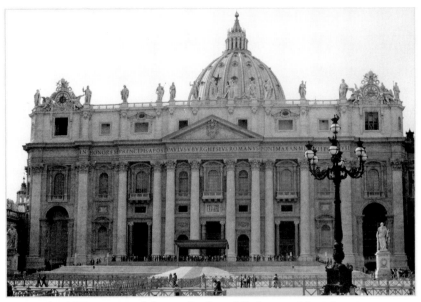

Pope Urban VIII consecrated the new Basilica of St. Peter on November 18, 1626, exactly 1,300 years after the consecration of the first St. Peter's.

The controversial Barberini pope Urban VIII, the first of the Baroque builder-popes, from his tomb in St. Peter's, designed by his protégé Bernini.

The dazzling theatricality of the Baroque genius Bernini animates this revealing self-portrait.

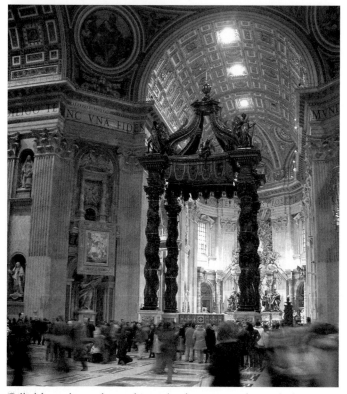

Called *la macchina*—the machine—by the artisans who worked on it, Bernini's bronze Baldacchino stands eight stories high and frames the main Basilica altar, forming a vertical axis with the dome above and St. Peter's tomb below.

Fresh from the success of his Baldacchino, the brash young artist began to build the first of two bell towers that would flank the Basilica façade. Before the first campanile was complete, cracks were noticed in the façade. To Bernini's chagrin, Pope Innocent X banished him from the papal city and ordered the bell tower razed.

The medal cast to commemorate the building of the colonnade shows, on one side (*left*), the Chigi pope Alexander VII, who commissioned the project, and, on the other (*below*), the three-part colonnade that Bernini designed. The third section in front was never built.

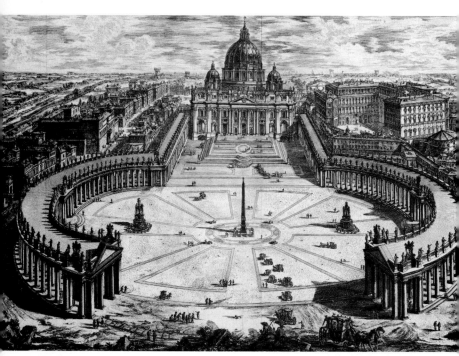

The new St. Peter's in its full splendor, from engravings by Giovanni Battista Piranesi. The Basilica and piazza, above, and below, the immense nave, culminating with the Baldacchino.

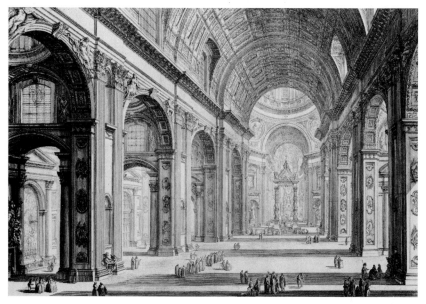

all of Europe, hailed as Agostino il Magnifico for his financial wiz-ardry. Twenty thousand men served in his employ, and one hundred ships sailed under his flag. Chigi's relation with each pontiff was unique. With Alexander, he was a banker; with Julius, a financier, adviser, friend, and confidant. With Leo, he was a reliable touch and lavish host.

The Rothschild of Rome, Chigi lived sumptuously in a pleasure dome that rivaled Kubla Khan's. It was outfitted with an ivory bed-stead and solid silver bathroom fixtures. Built by Peruzzi, the river-side villa, now known as Palazzo Farnesina, was on Via della Lungara, just down the river from the Vatican. It was the poshest neighbor-hood in Rome. The suave powerbroker Cardinal Alessandro Far-nese, the future Pope Paul III, lived directly across the Tiber. Another neighbor across the river was the cardinal-chamberlain Raffaele Riario. Compared with his solidly imposing Palazzo Ri-ario, Chigi's villa was a greenhouse.

Adapting the architectural idea that Bramante had pioneered in the Belvedere Court, Peruzzi had merged the building with its sur-roundings so that one flowed into the other—house to garden to riverbank. To extend the illusion, Raphael had frescoed the loggias with fruits and flowers.

A banker's wealth depended on the goodwill of the pope and the apostolic chamberlain. As long as he needed the Church to make him wealthy, Chigi had been careful never to outshine a cardinal or deny a pontiff. Now that he was a man of property, the circumspect banker turned flashy prince and flaunted his fabulous wealth even at the risk of offending the pope himself. His dinner parties were sumptuous, and one in particular that he gave for Leo became the talk of Rome.

❧

Lofted in the air by brawny servants, Agostino Chigi's gold dinner plates sailed across the garden like discuses. Glowing for an instant

in the torchlight, they hung over the river, then, one by one, began to drop into the black water, each one hitting with a flat thud.

Conversation stopped abruptly. A shocked gasp turned to awed whispers, all eyes fixed on the river. The wine had been flowing so freely that when the first plates floated over the Tiber, several cardinals wondered if the last goblet had been too much, and their eyes were deceiving them. But as they finished the nightingale pies and pheasant tongues, one dirty golden dish flew after another, until the night sky was raining Agostino il Magnifico's entire dinner service.

"Save the servants the work of cleaning up," the host quipped. Wearing a Sphinx-like smile, he sauntered from table to table, enjoying the expressions of disbelief and awe on the faces of his illustrious guests. Long colorful tapestries hung from the rafters and swayed gently in the evening breeze. Chigi was a slender man of medium height, supremely confident but still careful not to be overbearing. His dress and grooming were impeccable, sure indications of his status. Renewed interest in classical Roman culture had brought bathing into vogue again, at least among the enlightened elite. Personal hygiene was much improved from the pungent Middle Ages, and the well-heeled were also the well scrubbed.

Pope Leo loved spectacles. Anything odd, exotic, or offbeat caught his fancy, and Agostino il Magnifico had obliged with his own singular display. This was entertainment for a pope who had everything, from dwarfs to entertain him with ribald antics to his own zoo.

Leo stared as plate after plate sank into the river, stunned by such nonchalant largesse. If his host was dumping his own gold dinner service, could the papal tiara be far behind? The coronation loan was only the first of many Agostino il Magnifico had advanced the pope. The tiara and papal jewels were locked in his countinghouse, held in escrow against the hefty outlays.

The river smoothed. The servants brought out platters of fruits and cakes. As conversation resumed, fixed on the sunken treasure, Chigi surprised his guests again. At his signal, the servants pulled down the tapestries, revealing rows of stalls. Agostino il Magnifico had been entertaining Pope Leo and a dozen cardinals in the stables that Raphael had designed shortly before he died. You know you've arrived when Raphael builds your stables and the pope wines and dines there.

Later that night, after the last guest had staggered home, the servants brought in the horses and retrieved the gold dinner service. Chigi had taken the precaution of spreading nets on the river bottom. He always secured his investments. Although the Church condemned usury and Chigi considered himself a devout Christian, he was profiting handsomely by acting as pawnbroker to Leo and his friends. His personal loans to the extravagant Medici were made at rates that can only be described as usurious. That Leo paid without complaint and Chigi cashed in without compunction reflects the mood of the time. He would never have imposed such an unconscionable interest rate on a loan to Julius—and *il pontefice terribile* would never have let himself be bilked.

Julius had left the Church not just solvent but flush. Leo had no hesitation in spending its wealth. The average cardinal had fewer than two hundred in his household, or *famiglia*. Leo's swelled to almost seven hundred. The Medici* were a banking family, yet Leo "could no more save a thousand ducats," a friend of Machiavelli said, "than a stone could fly through the air," and the papacy suffered as a consequence.

Careless of the damage that his extravagance was doing to the Church, Leo continued his spending spree, dispensing funds

*Lorenzo, scion of one of history's most renowned banking dynasties, virtually bankrupted the family business by his romance with humanism.

recklessly to beautify the city, reward his favorites, and pamper himself. Like his father, Lorenzo, he had an eye for beautiful objects but no head for business, and even less interest in it. He squandered fortunes with benevolence and emptied the Vatican treasury in two years. When the coffers were bare, he came up with ever more creative and corrosive ways to pay for his largesse. Leo sold more cardinal's hats. He also increased the number of venal offices by almost one thousand, bringing some six hundred thousand additional ducats to his treasury and prompting one critic to complain, "Everything is for sale—temples, priests, altars … prayers, heaven, and God."

When Leo had exhausted the wealth of the Church, he hawked indulgences like tickets to paradise.

SALVATION FOR SALE

❧

For my intent is only pence to win,
And not at all for punishment of sin.
When they are dead, for all I think thereon
Their souls may well black-berrying have gone!

—Geoffrey Chaucer,
"Pardoner's Prologue,"
The Canterbury Tales

I n the theology of the Church, only confession and contrition can bring about the forgiveness of sins. A contrite sinner admits his errors, receives absolution through the sacrament of penance, and is given prayers to say or a task to perform in reparation. An indulgence doesn't buy forgiveness. It only lessens the penance imposed.

The process is roughly analogous to a civil court proceeding. A person turns himself in, admits his crime, is granted a hearing, and receives a sentence or penalty. The judge can suspend the sentence or order community service in lieu of prison time. Granting an indulgence is comparable to commuting a sentence. From the Latin *indulgeo*—"to be kind or tender"—it derives from Roman

law and from the Old Testament book of Isaiah (61:1). The prophet says, "The Lord hath anointed me . . . to heal the contrite of heart."

Indulgences are a quid pro quo. A confessed sinner performs good works or makes a charitable offering in exchange for a reduced penance now, or a shortened purgatory in the next life. When motives are pure, both sides benefit. The Church raises revenue for its capital expenses. The contrite Christian feels good, because he has a direct route to heaven with no detour to purgatory, and he is helping his neighbor and supporting his Church.

As early as the eighth or ninth century, "redemptions" were given for good works: feeding the hungry, tending the sick, any of the corporal works of mercy. In the free-and-easy years before the Protestant Reformation and the Catholic Counter-Reformation, the Church also dispensed redemptions for making a pilgrimage, giving alms, joining a crusade, or endowing a hospital—all eminently worthy causes, it was thought.

Even if the intention were as pure as a shriven soul, misuse was endemic. As always, the abuse came when money changed hands.* Julius had issued a redemption in 1513, offering an indulgence with a contribution to the Basilica fund. Leo renewed and expanded it. As his money troubles worsened through poor management and personal extravagance, the sale of indulgences became a way of keeping the papacy solvent.

Mass runs of indulgences rolled off ecclesiastical printing presses. The man behind the marketing blitz was the pope's friend and fellow Florentine Lorenzo Pucci—the same Pucci who

*In 1567 in the reconvened Council of Trent, Pius V cancelled all grants of indulgences that involved fees or financial transactions.

would mishandle Henry VIII's divorce appeal and lose the English Church. Pucci's preachers crossed the Alps and spread throughout Europe. Many of them were as corrupt as Chaucer's Pardoner, and they peddled the indulgences like eternal annuities, speculations against the Day of Judgment. Absolution was bartered for building funds, and a wholesale fleecing of the faithful ensued.

To a young Augustinian monk in Saxony, the trafficking in indulgences to finance an enormous new Basilica was the tipping point. Martin Luther had been profoundly shaken by the decadent behavior he saw when he visited Rome in the summer of 1511. "If there is a hell, then Rome is built upon it," he said. Now, six years later, he questioned the increasingly mercenary Church. From the perspective of a penurious friar, a Medici prince did not need the pennies of the working poor to finance an opulent new church.

"Why does the Pope not build this Basilica with his own funds instead of with the money of the poor faithful?" Luther asked.

Over several autumn nights, he wrote out a long list of grievances railing against the expense of the new St. Peter's and the spurious indulgences that were financing it. Among his theses:

#50: Christians should be taught that, if the pope knew the exactions of the indulgence-preachers, he would rather the church of St. Peter were reduced to ashes than be built with the skin, flesh, and bones of the sheep. . . .

#82: Why does not the pope liberate everyone from purgatory for the sake of love (a most holy thing) and because of the supreme necessity of their souls? This would be morally the best of all reasons. Meanwhile he

redeems innumerable souls for money, a most perishable thing, with which to build St. Peter's church, a very minor purpose.

All Hallows' Eve, October 31, 1517, five years to the day after Michelangelo unveiled the Sistine ceiling, Luther tacked his Ninety-Five Theses on the door of the Castle Church in Wittenberg.

SWEET REVENGE

❧

Leo had been pope for four exorbitant years, and the Church was about to discover the true cost of his profligacy. For now, though, the constant hectoring by his own cardinal-chamberlain was more annoying to the pope than the distant caviling of an insignificant friar. To the young Medici prince, Raffaele Riario was not a voice of reason and fiscal restraint. He was a mean-spirited old man, too long in the same job, more than thirty years, and acting as if he were more important than the Holy Father. Riario lectured the pope as if he were the supreme pontiff and Leo an errant sinner, and his criticism grew louder as Leo's questionable schemes escalated.

Helpful advice, the cardinal called it. Leo called it feigned concern. He saw it as more della Rovere treachery against the Medici. Vengeance is never forgotten, just laid aside until it can be exacted. Leo's manner was amiable, but his memory was long. He remembered the story of Riario, younger but just as cagey, lurking in the background on the Sunday that his uncle Giuliano de' Medici was murdered in the Florence cathedral and the della Rovere–Pazzi plot to destroy his family was foiled.

Two of Sixtus IV's nephews were implicated in the conspiracy. One was clearly guilty. The other was Raffaele Riario, now the

Vatican's chief financial officer and the second most powerful man in Rome. The incident had sparked a tit-for-tat feud between the della Roveres and the Medici, with Riario claiming that he was an innocent bystander who happened to be in the wrong place at the wrong time and Lorenzo imprisoning him for conspiracy. Sixtus had countered by excommunicating the Medici prince. No secular prince possessed a weapon of comparable power, and rather than risk eternal damnation, Lorenzo capitulated. Riario was released after two months but never exonerated in the eyes of the Medici.

A political animal, schooled in the papacies of three artful pontiffs, Cardinal Riario conducted himself like a prince, traveling with a retinue of three hundred and attracting a coterie of intellectuals. His palace across the Tiber was one of the grandest in Rome, and his art collection rivaled his cousin's, which became the basis of the Vatican collection.

Riario was shrewd, prudent, and one of Leo's most persistent critics within the Curia. To add to the intrigue, he was the cardinal protector of the Augustinians, the monastic order to which Leo's other irksome critic, Martin Luther, belonged.

Like his cousin Julius, Riario had a flair for drama and an appetite for risk. He was a gambler by nature as well as a conservative fiscal force within the Vatican. He had built Palazzo Riario with the fortune he pocketed in one memorable night of gambling against another cardinal and papal nephew, the dissolute Franceschetto Cibo.

Riario always chose his game shrewdly. Having learned the cost of profligacy in the pontificate of Alexander VI, he had worked closely with his cousin Julius to solve the fiscal crisis inherited from the Borgias, rebuild the city, and improve living conditions. They had made Rome a power center and the Church not only solvent but wealthy. Now the self-indulgence of the Medici pope threatened to bankrupt it again. The old cardinal sought to stop him but he underestimated Leo's wiles.

Leo, who was always scrambling for new revenue sources, un-
covered a novel one: an assassination plot against his own august
person, hatched quite conveniently by Riario and another equally
wealthy cardinal. Whether it was paranoia, extortion, or a cunning
case of sweet revenge, the cardinal-chamberlain and his accomplice,
Cardinal Alfonso Petrucci, were charged with conspiring to assassi-
nate "by poison and poignard" His Holiness the Medici pope.
They were arrested, taken away in ropes, and imprisoned in Castel
Sant'Angelo.

At first, Riario was defiant. Even from his prison cell, he was
scornful of the intemperate, undisciplined pope. Confident of his
position in the Curia and the city, he was more critical than ever of
Leo. Riario was demanding release and an apology when Cardinal
Petrucci was strangled in his cell. Fearing the same fate, the seventy-
year-old Riario signed away everything except his life. He ceded
ownership of his palazzo to the Medici, and agreed to pay an exor-
bitant price for his freedom.

Leo's demands exceeded even the old cardinal's substantial per-
sonal wealth. When he couldn't meet the pope's ransom, Agostino
il Magnifico, whom Julius and Riario had made the Midas of
Rome, stepped up and paid the Medici piper.

Raffaele Riario would die the same year as Leo, poor, alone, and
forgotten by the many "friends" who had once curried favor with
him. On the façade of his sumptuous palace, now called La Can-
cellaria, Leo had ordered the Medici balls emblazoned over the
della Rovere oak tree.

∞

Silencing Riario did nothing to quiet the storm gathering in the
north. Copies of Martin Luther's Ninety-Five Theses were flying
off the new printing presses as fast as the indulgences. Guten-
berg did not introduce mass communication—the masses were

illiterate—but his inky miracle was revolutionizing communications as dramatically as the computer would more than five hundred years later.

Scribes were becoming obsolete. The meticulous work that had kept scribbling monks laboring for months by candlelight could be replaced in minutes by the multiple printed copies that rolled off the presses. Italy had one press in 1465. By 1500, there were 150. The Vatican had Arabic and Hebrew presses, as well as Latin, Greek, and vernacular Italian.

Without the power of the printing press to spread his message and the encouragement of German princes hoping to break free of Rome, Luther would have been just another lone, if irksome, voice carping in the wilderness. But printed pamphlets disseminated the complaints of the obscure Augustinian monk far beyond Saxony.

Pesky priests had gotten under the skin of princes before. When Henry II of England asked, "Will no one rid me of this priest?" Thomas à Becket was murdered the next night in Canterbury Cathedral. More recently, Alexander VI had answered the Florentine friar Savonarola's bonfire of the vanities with his own bonfire and tossed the friar on the pyre. Luckily for Luther, when he began decrying Rome, a gentler Medici was pontiff.

Although he could compose clever verses in Latin and Greek, Leo could not parse the message from Wittenberg Cathedral. The monk's screed was a veiled attack on the authority of the pope. Martin Luther did not emerge from a void or preach to a hostile audience. German princes were abetting him, and disgruntled Catholics, already paying the priest from cradle to grave, were growing restive. When Luther's Theses reached Rome, the Curia warned that the fuss over the indulgences was just the smoke. But Leo's interest in what was happening north of Rome stopped at Tuscany. Instead of curbing his feckless tax-and-spend habits, the pope ignored the growing protest.

Ensconced in his golden cocoon, Leo continued to scandalize. On the feast of St. Augustine, August 28, 1519, he officiated at the wedding of Agostino Chigi to Francesca Ordeaschi, a grocer's daughter from Venice. Fourteen cardinals and most of Roman society attended the wedding, which was the most lavish event of the summer. The bride had been Chigi's mistress for eight years, and the loving couple was attended by their four children.

Luther's attacks grew more rancorous. Branding the pope the Antichrist and Rome the whore of Babylon, he denounced the indulgences as "pious frauds of the faithful" and the Basilica of St. Peter as an outrage.

Like Nero fiddling as Rome burned, Leo dithered as the Church sundered. He spent more time on pageants and boar hunts than on the annoying monk and his laundry list of complaints. The clamor echoing across the Alps had less urgency than the horn of his huntsman, Domenico Boccamazza, or the baying of his hounds. Leo kept seventy or eighty prize hunting dogs in kennels near the Vatican. The hounds lived better than many of the poor souls who were spending their pennies on the spurious indulgences.

Although hunting was his passion, Leo's method was bizarre. Because he was too myopic and corpulent to ride to the hunt, he would watch from a stand through his monocle. Waving a white flag, he would signal the start of the chase to his cardinals, who had exchanged their cassocks and skullcaps for gray jackets and sombreros. Occasionally, a boar was lured into a penned area so that the pope could deliver the coup de grâce.

On the afternoon of June 15, 1520, while hunting in the hills of the *campagna* north of Rome, Leo paused in his curious entertainment just long enough to sign a papal bull, *Exsurge domine,* condemning the tiresome monk as a heretic.

Rome's troubles were just beginning.

Intent on immediate gratification and with little apparent concern for the future, Leo X presided over what would be both the apogee and the final act of the Renaissance. The history of Rome was repeating itself. Renaissance Rome had not only rediscovered classical culture, it had embraced the licentiousness that precipitated the fall of the imperial city.

When Leo was consecrated pope, Romans anticipated a second Golden Age of Augustus to crown the imperium of the second Julius. The Medici prince had seemed the ideal choice. He was a young man of noble intentions, refined taste, and the best education, excessively generous to friends and artists. By his death in 1521, his reign had been shown to be fool's gold.

"As of his pontificate, everything began going bad, and from bad to worse," Girolamo Seripando, who would become one of the strongest voices in the Council of Trent, wrote, "whether we're dealing with the war against the Turks, or the empire [the Papal States], of which we lost a large part: Modena, Reggio Emilia, Parma, Piacenza. Or morals, of which every light had gone out, or of reputation, which has never been worse in the minds of men. Or authority, which has never been less, to the point where it has almost evaporated in a joke."

By the end of Leo's disastrous, eight-year pontificate, all the main players in the first building phase of St. Peter's were dead: Giuliano della Rovere, Donato Bramante, Giuliano da Sangallo, Fra Giovanni Giocondo, Raphael Sanzio, and Agostino Chigi. The Church was impoverished, spiritually and fiscally, and the future of the Basilica was very much in doubt.

A BRIEF MOMENT OF TRUTH

❧

I f the Renaissance had been a heady, hedonistic time for the humanists and hierarchy in Rome, it had been a less happy time for the faithful who expected their priests to be pastors. Many pilgrims, especially travelers from Britain and Germany, had been shocked by the dissoluteness of the clergy. One wag quipped that the northern countries "were too poor to rival Italy in immorality."

A participant in the Lateran Council that Julius convened in 1512 deplored the abasement of the Church: "How many of the clergy," he asked rhetorically, "do not wear clothes laid down by the sacred canons, how many keep concubines, are simoniacal and ambitious? How many carry weapons like soldiers? . . . How many go to the altar with their own children around them? How many hunt and shoot with crossbows and guns?"

Catholics in the north countries were losing respect for the papacy and growing resentful of the constant demands for more and more generous contributions. All their money was flowing to Rome with no return. Whether blind to its own shortcomings, scornful of its critics, or bored by the prospect of cleaning house, the Medici papacy had underestimated the divide that was looming.

When the cardinals met in papal conclave in the final days of 1521, the writing was on the wall. They realized that stringent measures were necessary to appease the restive Christians in the north and avert the looming "agony of Catholicism." Turning away from the dissolute Roman prelates, they elected Adrian of Utrecht, a strict monk who had been tutor to the emperor Charles V. He kept his given name.

Adrian VI was an aberration in the Roman Renaissance, like John Ashcroft on a Stones road trip or Grandma Moses at a Mapplethorpe opening. A northerner and a man of rigid strictures, he had no tolerance for moral lapses. Taking his mandate seriously, he addressed the German protestors:

> God has permitted this persecution of the Church because of the sins of mankind, especially of priests and prelates. . . . We are conscious that much that is vile has befallen this Holy See over the past years. . . . We have all strayed from the right path and so must all honor God and humble ourselves before him. . . . For our part, we pledge ourselves, that the Curia, perhaps the source of all the evil, shall be wholly renovated.

Adrian was preaching to closed minds. The dissidents didn't trust his sincerity, and Rome wasn't ready for such drastic self-improvement. After a few months of the no-nonsense Dutchman, Romans began looking back nostalgically to the pampered Medici prince. Humanists deplored the day that the Church had chosen a non-Italian to sit on the throne of Peter.

Adrian "took no delight in pictures, sculptures, or in any other

good thing," Vasari reports. He did not see beauty as a reflection of truth, or art as an instrument of religion, and he stopped work on all the painting and architecture that Julius and Leo had ordered. Raphael's assistants, who were finishing his frescoes in the Great Hall of the papal palace, were dismissed, and construction of the Basilica halted.

Conceived as *the* glorious monument to God and his Vicar, the Basilica of St. Peter came to look increasingly like Julius's Folly. It had become a financial nightmare, an administrative quagmire, and a burr abrading the faithful. Adrian closed down operations. The teeming work yard was silent. The lime furnaces were cold. Oxcarts and mule wagons no longer crowded the Ponte Sant'Angelo with loads of timber and travertine. Without the lush papal patronage that had made many of them wealthy, artists began to look for contracts outside the city.

"Driven to despair" and "almost like to die of hunger," they were beginning to leave Rome, when "by the will of God," Vasari writes, the foreign pope died.

The pontificate of the dour Dutchman lasted twenty-one months, interrupting, but not breaking, the Medici grip on Rome. When the cardinals met to elect his successor, they chose Leo's bastard cousin and confidant Giulio de' Medici. He took the name Clement VII, "and with him all the arts . . . were restored to life in one day."

Elected in the moral backlash against Leo's dissolute style, Adrian served as an ellipsis between the two Medici papacies. Although his pontificate was so joyless that 450 years would elapse before the throne of Peter was given to another foreigner,* the

*The next non-Italian pope was Karol Wojtyla of Poland, who was consecrated John Paul II in 1978.

Renaissance Church was in dire need of an Adrian—or some equally unpleasant medicine.

License has a limited life span. Rome was cavorting on the edge of a precipice. Whether brought down by outside forces—the unholy alliance of politics and religion forming in the north—or by self-destruction, the end of the Church appeared inevitable.

MEDICI REDUX

❧

Clement VII's pontificate began with high expectations. Guicciardini, the most notable and opinionated contemporary historian, recalled, "The Marquis of Pescara said to me that this was perhaps the only occasion on which he had seen what all men desired come to pass."

Guicciardini was a fellow Florentine and Medici stalwart, grateful for their patronage and prejudiced in their favor. He had little positive to say about Julius II except by way of comparison with the new pope. "No two men could have been more unlike in character than the Popes Julius and Clement," he wrote. "For while the former was of great and even excessive courage, ardent, impulsive, frank and open, the latter was of a temper inclining rather to timidity, most patient, moderate, and withal dissembling."

Born Giulio de' Medici, Clement was the illegitimate son of Lorenzo's brother, murdered in the Pazzi conspiracy. Although he had been Leo's close adviser, the cousins were very different. Clement was a canon lawyer, by every account a man of intelligence and high personal morals, and he took a number of steps to bring coherence to the chaos that Leo had left. He established an international council of bishops to study and respond to Luther's complaints, and he named a commission, the Collegium LX Viro-

rum, to look into the finances of the Basilica. Its stated mission was
"the crusade of the Great Pardon of the Marvelous Fabbrica of St.
Peter's"—in other words, to correct the faults that had crept in and
bring some accountability to the project.

The Collegium recommended the establishment of an interna-
tional oversight committee with authority to organize, administer,
and finance the entire enterprise and float bonds to pay for it. On
December 12, 1523, by the papal bull *Admonet nos suscepti,* Pope
Clement instituted the Fabbrica di San Pietro nel Vaticano, com-
posed of sixty experts drawn from all parts of Europe. He placed
it under the direct jurisdiction of the Holy See.

From this promising beginning, Clement's pontificate de-
scended into hell. With the possible exception of Hamlet, no figure
real or invented has been a more infamous vacillator than this sec-
ond Medici pope. Aretino derided him as "a sheep instead of a
shepherd," and the Venetian ambassador said, "He talks well but
decides badly." It could have been Pope Clement's epitaph.

Two complementary portraits show a handsome patrician with
a long face, gentle eyes, and a concerned expression. The paintings
are almost identical in size, palette, and composition, except that in
one Clement is pictured with the French king Francis I, and in the
other he is conferring with the emperor Charles V. That very neatly
points up the fault that did much more than clip the wings of the
"vile tyranny of the priests." It brought ruin to Rome, division to
the Church, and shame to the papacy.

The grandson of Ferdinand and Isabella, Charles V ruled an
empire that made the Caesars look land-poor. At the peak of his
power, it was twenty times larger than Rome's and comprised the
Hapsburg kingdom of Austria, Germany, Luxembourg, and the
Netherlands; Naples, Sicily, and Sardinia in Italy; Burgundy and
Artois in France; and Spain, Mexico, and Peru.

Since the death of Julius, Italy had been the battlefield where the

dueling armies of Charles and Francis vied to tip the balance of power in Europe. Scarcely a year passed without one or the other alternately threatening the Papal States and allying with or attacking the various city-states. Florence, Venice, and Milan were prime targets.

In 1525, Charles captured Francis at Pavia, south of Milan, and tossed him in prison. Eventually, the two signed the Treaty of Madrid, which lasted just long enough to spring Francis from his jail cell. Then the battle was on again.

During his cousin's pontificate, Clement had two power bases. He was Leo's proxy in Florence and his vice chancellor in the Vatican. As pope, his loyalties remained divided. Like Leo, he was a Medici first, last, and always, and his preoccupation with Florence kept him vacillating between emperor and king. Concerned that Charles wanted to add Tuscany to his seemingly boundless kingdom, Clement wavered: Should he ally with the French or appease the emperor?

Guicciardini encouraged him to act decisively.

> I once told Pope Clement, who was wont to be disquieted by every trifling danger, that a good cure for these empty panics was to recall the number of like occasions on which his fears had proved idle. By this I would not be understood as urging men never to feel fear, but as dissuading them from living in perpetual alarm.

When Clement finally took decisive action, he provoked worse than alarm. Ever since his election, there had been friction between the pope and the powerful Roman families. To win the papacy, he had cut a deal with the Orsini cardinal, angering the rival Colonnas. In a series of terrible miscalculations, the Florentine pope alienated Cardinal Pompeo Colonna, the patriarch of the clan, and then, even more disastrously, alienated the emperor. When he finally chose sides, Clement joined the French, Venetians, and

Milanese against Charles in the League of Cognac. It was a virtual invitation to invasion.

∞

When the monk from Saxony posted his gripes against Rome, he wanted to instigate debate, not incite a holy war. But ten years later, forty thousand angry men trudged over the Alps. Many of them were mercenaries owed their pay, Protestants but not necessarily protestors on a mission to reform or reshape the Church. They may never have heard of Martin Luther, but the Protestant princes who led them knew him well. Luther preached what they wanted to hear. The Church, the intercessor between God and man, was redundant, which in practical political terms meant that civil rulers did not have to bow to the higher authority of Rome.

Under the imperial banner of Charles V, German and Austrian troops marched south and joined the Colonna forces. Wiping out the papal army, they ravaged the city. A horrified Cardinal Colonna witnessed what he had wrought through arrogance and spite and tried to turn back the invaders. His remorse came too late to save his city.

∞

Rome may hold the record for the "most sacked city in history." In the fifth century, waves of invaders charged over the Alps with pillage and rape on their minds and ravaged the peninsula. Visigoths, Huns, and Vandals were followed in A.D. 846 by the Saracens, who, seeking vengeance against the infidels, desecrated the grave of Peter, the most sacred site in Europe. The Normans continued the conquest in 1084, mounting the papal altar in Constantine's basilica with swords drawn. All things being relative, though, the barbarian hordes were compassionate invaders compared with the troops of the Roman Catholic emperor Charles V, a pious Christian, champion of the faith, and an avowed foe of Luther.

With a nod and a wink from the princes, the soldiers were loosed on Rome like a biblical plague. Mercenaries took their back pay in gold chalices, in the rape of convents of nuns, in the humiliation and murder of priests, in the desecration of consecrated Communion hosts, and in the destruction of iconic art.

When his imperial army swarmed over Rome in 1527, everything sacred was profaned. According to one witness, "All were cut to pieces even if unarmed, even in those places that Attila, the most cruel of men, had in former times treated with religious respect."

Soldiers broke into the reliquaries in the Basilica of St. John Lateran and, according to contemporary reports, played ball with the heads of Peter and Paul. A priest who refused orders to give Communion to a donkey was butchered. Roman countesses and baronesses were raped, forced into brothels, and labeled "the relics of the Sack of Rome." Men were tortured for money and ransom. Guicciardini's brother Luigi described the brutality:

> Many were suspended for hours by the arms; many were cruelly bound by the genitals; many were suspended by their feet high above the road or over the river, while their tormentors threatened to cut the cord. Some were half buried in the cellars, others were nailed up in casks or villainously beaten and wounded; not a few were branded all over their persons with red-hot irons. Some were tortured by extreme thirst; others by insupportable noise and many were cruelly tortured by having their teeth brutally drawn. Others again were forced to eat their own ears, or nose, or their roasted testicles, and yet more were subjected to strange, unheard of martyrdoms that move me too much even to think of, much less describe.

The streets were fetid with the stench of corpses. Anywhere from six thousand to twenty thousand Romans were killed. Many had tried to escape across the bridges. Those who weren't crushed in the stampede were slaughtered. Two thirds of the buildings were destroyed, and fires raged unchecked. The siege continued for four months. In the orgy of violence, an epidemic of plague broke out. A Spaniard gave this picture of the spoiled city:

> In Rome, the chief city of Christendom, no bells ring, no churches are open, no masses are said. Sundays and feast days have ceased. Many houses are burned to the ground; in others the doors and windows are broken and carried away; the streets are changed into dunghills. The stench of dead bodies is terrible; men and beasts have a common grave and in the churches I have seen corpses that dogs have gnawed. In the public places, tables are set close together at which thousands of ducats are gambled for. The air rings with blasphemies fit to make good men—if such there be—wish that they were deaf. I know nothing wherewith I can compare it, except it be the destruction of Jerusalem. I do not believe that if I lived for two thousand years I should see the like again.

Since the barbarian invasions, Castel Sant'Angelo had been the papacy's last defense against a hostile and violent world. Direct access from the Vatican palace to the fortress on the bank of the Tiber River gave the popes a citadel against capture and imprisonment. Clement, thirteen cardinals, and his entire household escaped along the *passetto* to the fortress. A bishop described their escape: "I flung my own purple cloak about the pope's head and shoulders lest some Barbarian rascal in the crowd below might recognize the

pope by his white rochet as he was passing a window and take a chance shot at his fleeing form."

Terrified Romans took refuge with the pope. In all, about three thousand barricaded themselves in Castel Sant'Angelo. Rome was an inferno. To the east, the city was in flames. In the north, halfway up Monte Mario, Villa Madama, the pope's summer palace,* was burning. From the parapet of the fortress, Clement watched and wept.

The German troops commandeered the Vatican. They set up headquarters in the Vatican library, converted the papal palace into barracks, caroused in Raphael's Stanze, and turned the Sistine Chapel into a mortuary. Horses steamed and stomped under Bramante's arches in the new Basilica.

∞

Some pious Christians saw the Sack of Rome as divine retribution against the pervasive corruption in the Church. They recalled the words of Psalm 78:

> Oh God, the heathens have defiled thy holy temple. . . .
> They have given the dead bodies of thy servants to be
> meat for the fowls of the air, the flesh of thy saints for
> the beasts of the earth. We are become a reproach to
> our neighbors, a scorn and derision. . . .

The righteous, wielding their swords in holy war, became butchers. "In trying to make themselves angels," Montaigne wrote, "men transform themselves into beasts." Even those who saw the lesson

*When he died, Raphael was building Villa Madama for Clement, who was then Cardinal de' Medici.

of Sodom and Gomorrah in the punishment inflicted on the city deplored the ravaging.

The ever-critical Erasmus mourned. Calling Rome "the mother of nations," he lamented: "This is not the ruin of one city but of the whole world." In England, Henry VIII put aside his marital woes and joined forces with the French king Francis to rescue the pope.

With Rome lying in ruins again, the Catholic emperor, who earlier had vowed "to stake his dominion, life, blood, soul and friends" on stopping the heretic Luther, protested that he had been too preoccupied in saving the Church from Moslem infidels to halt the advance of his German princes. Ignoring the fact that the pope had gone over to the enemy, Charles first denied unleashing terror as a political tool. But finding himself isolated and abjured throughout the Christian world, he finally compromised.

Clement ordered his goldsmith Benvenuto Cellini, who had been manning a cannon on the ramparts of Castel Sant'Angelo, to melt down the papal jewelry. With the gold, the pope paid the emperor's ransom and promised him absolution. In exchange, Charles called off his troops, returned the Papal States, and made his peace with Rome.

⚮

In the fifth century, Pope Leo the Great famously rode out to meet Attila the Hun and turned away "the Scourge of God" by the power of his words. Pope Clement by his ill-conceived policies had invited the invaders in. Broken in spirit and shamed before the world, he returned to the scorched earth of the imperial city. "Rome is finished," a member of his household cried. "Four-fifths of it is quite uninhabited."

But Renaissance politics were so volatile that three years after the Sack, Pope Clement not only bestowed public absolution on the invader, he rode to Bologna and crowned Charles V Holy Roman Emperor. It was the last imperial consecration performed by a pope.

In no time, Francis and Charles were once again making the Italian boot their battleground. After the horror inflicted on Rome, even their royal families said enough. The bloody bickering had to end. The king's mother, Louise of Savoy, and the emperor's aunt Margaret of Austria, who had raised him since he was a baby, forced the two to sign a truce in 1529—officially the Treaty of Cambrai, but always known as the Ladies' Peace.

With the Italian peninsula tranquil at last and revenue flowing from the restored Papal States, Pope Clement started the sorry business of salvaging what was left of the city and reaffirming the authority of the Church.

∞

In the sixteenth century, art was such a cogent moral and political force that, in the abyss of devastation and desolation, the pope commissioned a painting that would serve as a warning to those who had defied the Church with the Reformation and destroyed the city. Clement turned to the one artist who, more powerfully than any other, could sear a message into the soul with his brush. In 1534, he called Michelangelo back from Florence to paint a Last Judgment scene on the altar wall of the Sistine Chapel.

Michelangelo's relationship with Leo had been murky, but Clement was more *simpatico*. Condivi said, "Clement considered Michelangelo as something sacred, and he conversed with him on both light and serious matters with as much intimacy as he would have done with an equal." The pope's own comment was wryer.

"When Buonarroti comes to see me," he remarked, "I always take a seat and bid him to be seated, feeling that he will do so without leave."

∞

The horses were gone, but the stink of the stable still clung to the stones of the new St. Peter's when Michelangelo, for whom the fires of hell were real and frightening, returned to Rome. He brought with him the first cartoons for the *Last Judgment,* and the continued hope that there would also be time to sculpt the tomb of Julius, long delayed but never abandoned. Once again, death intervened.

Two days after receiving Michelangelo, Clement VII died after accidentally eating poisonous mushrooms. Bitter Romans, blaming the hapless pope for the sack of the city, wiped the inscription CLEMENS PONTIFEX MAXIMUS off his tomb and, in their anger, wrote in its place, INCLEMENS PONTIFEX MINIMUS.

THE MICHELANGELO IMPERATIVE

1546–1626

I am at the eleventh hour, and not a thought arises in me that does not have death carved within it; but God grant that I keep him waiting in suspense for a few years yet.

—Michelangelo Buonarroti

A VIOLENT AWAKENING

T he Reformation was an alarm going off in the night, rousing the Church from somnolence. The call was clear: Reform or self-destruct.

To bring it through the most serious crisis of its fifteen-hundred-year history, the Church turned to the ultimate insider—His Eminence Cardinal Alessandro Farnese. A power player and leading *papabile* in every conclave, Cardinal Farnese knew everyone who was anyone. In 1534, following the disastrous Medici inter-regnum, he was elected pope without serious opposition and took the name Paul III.

Although Julius had appropriated Constantine's imperial title, Pontifex Maximus, Paul III personified it. He was the "supreme bridge-builder," spanning the divide between the Roman Renaissance and the Counter-Reformation. Farnese was not only well connected, he was scandalously connected. His sister was "la Bella," the legendary beauty Giulia Farnese who became Alexander VI's mistress. To please Giulia, the Borgia pope gave her brother a red hat, and Farnese gained the sobriquet "Cardinal Petticoat."

Farnese was no saint. His personal history suggests that he should have been the quintessential Renaissance pope. Like the Borgias, he pursued a life so notably lacking in poverty, chastity,

and obedience that he postponed ordination so that he could continue enjoying it. His behavior was conspicuous for the worldliness and loose morals railed against by reformers inside and outside the Church. A bon vivant and art patron, Farnese lived lavishly with a household of more than three hundred, a mistress who was a Roman noblewoman, and their four children. As pope, his one glaring weakness was his grandchildren. He couldn't refuse them anything.

A Renaissance pope by disposition, Paul III became the first Counter-Reformation pope by necessity. He was the most pivotal and paradoxical character in the Basilica story. Paul sponsored the monk Nicolaus Copernicus and his seminal work, *On the Revolution of the Celestial Spheres,* which posited the revolution of the planets around the sun decades before Galileo. But he also reinstituted the Inquisition.

In the aftershock of the Sack and the furor roused by the Protestant reformers, the status quo was no longer acceptable. Patience with clerical malfeasance and moral decay had run out, and the air was rife with the perfume of the righteous. The one, holy, catholic, and apostolic church was no longer one and no longer holy in the opinion of much of the laity. Its catholicism was compromised, its apostolic authority challenged.

Paul moved decisively to stanch the wounds inflicted by Luther. Smooth, charming, and persuasive, with the silken manners of a diplomat, he put aside his more questionable habits and, over the course of fifteen years, the longest pontificate of the century, began a long-overdue reform. He appointed smart, moral cardinals like Reginald Pole of England and encouraged strict, intellectually rigorous new religious orders, particularly the Society of Jesus, which became known as the Jesuits. He established the Holy Office to safeguard orthodoxy and revived the Inquisition to root out heresy. Most consequential of all, he convened the Council of Trent to

correct ecclesiastical abuses and promote reconciliation with the dissidents in the north.

To Paul, the Protestants were not souls lost to the Church, but sheep who had strayed and could be coaxed back to the flock, if the Church cleaned its own house. The Reformation had exposed a system rotted from within. The Council of Trent answered it. Although it took several years to get off the ground, it gave the Church a second chance.

Cardinal Pole defined the Council's mission as "the uprooting of heresies, the reform of ecclesiastical disciplines and of morals, and lastly the eternal peace of the whole Church. These we must see to, or rather, untiringly pray that by God's mercy they may be done."

In time, Paul became convinced that the breach with the Protestants was beyond repair. There was some consolation. Magellan's round-the-world voyage showed that the earth was many times larger than anyone had suspected. This was welcome news to Rome. The number of souls lost to Protestantism was a drop in the oceans compared with the number of new souls ripe for conversion.

Moving decisively to cut his losses, Paul dispatched missionaries to the New World, and when England became a lost cause as well, he excommunicated Henry VIII. Then he began to clean house. All hope of reconciliation abandoned, the Council of Trent concentrated on internal reform. Familiar habits were forbidden, among them: appointing family members to high office regardless of merit (nepotism), carving dynastic family estates out of church lands (alienation), buying and selling offices (simony), drawing income from many offices and benefices (pluralism) without attending to the duties of any (absenteeism), and remitting the punishment of sin for a price (the sale of indulgences).

Protestant reformers in the north were insisting that the Church make a public confession, beg forgiveness, and accede to their demands. Paul refused to force the Church to conform to the colder, more reserved northern sensibility. The Catholic Church was the Church of Rome in more than name. However far the faith had spread, its soul was Latin, not Bavarian.

Reformers, both those who broke with the Church and those who stayed to fight from within, might have expected a penitent pope. Something comparable to a medieval-style scourging—Paul with a crown of thorns, cardinals in sackcloth, gold chalices and ciboria melted down, matchless art and precious manuscripts auctioned, and the wealth of the Church distributed to the poor. The reality was sharply different. Paul was persuasive when possible, ruthless when necessary, but he refused to grovel.

He had two remarkable answers to counter the Reformation and restore the moral authority of the Church, and he pursued them both with fervor. The first was the Council of Trent. The second was Michelangelo.

❧

A cavalcade of carriages carried the new pope, a dozen cardinals, and several members of his household along Via della Lungara. They crossed the river at Ponte Sisto, just beyond Chigi's Palazzo, now owned by the pope's family and called Villa Farnesina. Across the river, on the east bank near Palazzo Riario, now renamed and bearing the Medici coat of arms, Antonio da Sangallo was planning a new palace for the new pope. If time permitted, Paul might stop on the way back to see the construction.

The cavalcade proceeded east over the Capitoline hill toward Trajan's Column. It was a humble neighborhood for a papal visit. The statue of the emperor that once crowned the one-hundred-

thirty-one-foot-high column was long gone. In time, it would be replaced with a statue of St. Peter. For now, though, it wasn't the condition of an ancient relic that concerned the new pope, but the mood of the aging recluse who had taken a studio in Macel de'Corvi in the shadow of the column.

With his cardinals forming a train behind him, Paul approached a narrow door and knocked. He waited for several moments before an old man, dressed in the coarse black clothes of a servant, opened it a crack and peered out. Seeing the august visitors, he stepped back in some confusion. Paul recognized the man—there was no more faithful or long-suffering servant than Francesco Urbino. He pushed open the door.

"We have come to see your master's drawings for the altarpiece," he said.

Behind Francesco, a second man, scruffier and ill kempt, watched warily. No pope had come banging on his door since those heady, early days with Julius when everything seemed possible.

Michelangelo knelt and kissed Paul's hand. They hadn't seen each other in years—probably not since 1527, when the Medici lost Florence for the second time—and they had both aged noticeably.

Paul III was tall and slender, his shoulders stooped now. Titian painted him in midlife wearing his papal robes easily. He looks out on the world, watchful and reserved. His face is narrow and elongated, his eyes large and dark. His hair, side-whiskers, and heavy eyebrows are a steely gray in contrast with the white mustache and coarse square beard. What is most striking about the portrait is the hands, the fingers long and tapered like a pianist's.

Standing in the doorway of the sculptor's studio in his white robe and short, hooded velvet cape, Paul was the epitome of elegance. On his knees, in a soiled, wrinkled tunic and scuffed work boots, Michelangelo appeared uncouth. He was considerably

smaller than the Farnese pope, wiry and disheveled, his hair white from years and marble dust. He looked as if he had slept in his clothes, and judging by his rankness, he probably had.

Many artists became wealthy men working for the popes. Bramante, Raphael, and Antonio da Sangallo enjoyed the good life. But Michelangelo always lived as if he were on the brink of ruin, a prisoner of the tomb and preyed on by his mercenary family. "I live like a poor man," he would say to the faithful Francesco, "without retinues or velvet britches."

Paul offered him an annual lifetime salary of 1,200 ducats if he would honor the commitment he had made to Pope Clement and paint the *Last Judgment* fresco—600 ducats paid directly from the Vatican treasury, and 600 in revenue from the Po River ferry. Since Michelangelo's father had lived to be ninety-two, it was a very generous offer.

But with Clement dead, Michelangelo finally felt free to return to the heroic sculpture he had dreamed as a naïf, untouched by intrigue, a pure concept to be purely chiseled. Through all the years, he had clung to the unfinished tomb of Julius. Like an escaping dream, it had seemed always just beyond his grasp.

Michelangelo had been thirty-one when he proposed the tomb to Julius. He was almost sixty now. He had outlived all his rivals, his old nemeses, and four popes. Now, another imperious, iron-willed old man sat in the chair of Peter. They had known each other for years. Paul knew the saga of the tomb.

The once-mighty mausoleum had been scaled down and diminished through the years, first by Julius himself, then by his executors and heirs, and again by the Medici popes. They had kept Michelangelo working in Florence, causing a conflict with the della Rovere heirs, who claimed Michelangelo had pocketed thousands of ducats with little or nothing to show for it. They charged, somewhat ludicrously given the disposition of the sculptor, that he was living "a

life of pleasure" in Florence on money he had received to sculpt the tomb.

Believing that Julius's heirs were impugning his integrity, Michelangelo had responded furiously. The memorial became tangled in probate questions and acrimonious payment disputes. What Condivi called "the agony of the tomb" had eaten away the years, scathed Michelangelo's soul, and corroded his spirit, yet like a spurned lover he kept returning to it and being disappointed.

Although Paul handled the prickly artist with velvet gloves, he was determined to bring the agony to an end, finally. He insisted on seeing the statues that Michelangelo had carved, the cartoons he had drawn for the altarpiece, "and every other single thing."

Michelangelo had made numerous preliminary drawings for the Last Judgment, and Francesco laid each cartoon on the studio floor for the pope to view. The cardinals fanned out around him to study the sketches. The terrors of Dante's Inferno seemed to leap from the floor and engulf them. When the images filled the huge space behind the altar in the Sistine Chapel, they would strike the fear of the Lord in all who viewed them.

Paul, overwhelmed by what he saw, ordered Clement's commission carried out. But Michelangelo, who did not suffer popes gladly, remained obdurate, insisting that he was under contract for the tomb. It had become his obsession and his bane—the grail just out of reach, the cross he refused to lay down.

"Where is this contract? I will tear it up," Paul threatened. "I am quite set on having you in my service come what may. I have harbored this ambition for thirty years, and now that I am pope, I shall have it satisfied."

Paul assured Michelangelo that he would reach an agreement with the heirs of Julius. "Paint and don't worry about anything else," he advised. But negotiations took time. Michelangelo wrote despondently to the pope's nephew: "One paints with the head and

not with the hands, and if he can't keep a clear head a man is lost. . . . I shall paint miserably and make miserable things."

The tomb haunted, imprisoned, and embittered him. "I lost all my youth chained to this tomb," he lamented. Even after so many years he could never accept that Bramante's Basilica had replaced it. Finally, in 1542, the confusions ironed out, Paul imposed a final contract on artist and heirs, in effect rolling back the stone of the tomb and allowing Michelangelo new life.

Reduced five times over the course of forty years, what Michelangelo dreamed as "the triumph of sculpture" ended as a modest memorial in San Pietro in Vincoli, distinguished only by the marble Moses, a commanding horned figure with the rugged visage of il Terribilis.

Julius II was never laid to rest beneath Michelangelo's Moses, and never given his own memorial in the Basilica he had conceived. After starting his pontificate with such a lofty plan, he ended up in its humblest grave. Interred without a sepulchre, he was stuffed into the same space with his uncle Sixtus. So many wasted years, so much anger and animosity, and nothing commensurate to show for the agony it had caused.

∞

Julius and Paul were both patrons, popes, and dominant personalities, yet Michelangelo's relationship with the two men was very different. With Michelangelo and Julius, two supreme egos contended—one young, ambitious, and full of himself, the other old, ambitious, and absolute. Paul and Michelangelo were contemporaries. They had witnessed the defilement of the Church and city, and they found common ground.

There is a certain irony to the fact that, for his first assignment unshackled from the tomb, Michelangelo returned to the Sistina. This time, he felt no reluctance. It was a catharsis. The bondage of

the tomb behind him, the savagery of the Sack before him, he went back to the Chapel where he had triumphed to paint the *Last Judgment.* In early spring 1535, preparations began in the Sistine Chapel according to Michelangelo's directives. Scaffolds went up and the altar wall was primed—windows blocked, earlier frescoes scraped away, and the wall itself sloped to prevent dust from gathering. The altar wall was an immense undertaking. The surface area—43 feet wide by 55 feet high, or 2,365 square feet—would make it the largest fresco in Rome. Michelangelo completed his cartoons in September and began painting the following spring when the weather had warmed.

Painting frescos was possible only in mild months, but each day that weather permitted, his assistants applied a ground of damp lime and mortar to the wall area that he would paint that day. By counting the applications, art historians extrapolate that Michelangelo worked 450 days over a span of six years. They say that up close you can see hairs from his brushes still stuck in the wall and the holes from the nails that held his cartoons in place.

Michelangelo's *Last Judgment* is not an orderly display, the scales of justice calmly calibrated and brought into perfect balance with acceptance and decorum. It is the *dies irae*—the day of wrath that will dissolve the world into burning coals when every evil and every wrong will be avenged.

His day of reckoning is chaotic humanity's final tumult. Time exhausted and hope extinguished, four hundred giant figures, some more than eight feet high, flail and tangle, ascending or falling as salvation and damnation become fixed for eternity. Some of the faces are familiar: Michelangelo's faithful servant Francesco; Vittoria Colonna and Tommaso de' Cavalieri, the two dearest to him; the charismatic preacher Savonarola, who had stirred his soul when he was an aspiring young artist in Florence; and Dante, whose *Divine Comedy* was a source of inspiration.

Michelangelo granted salvation to his friends and heroes, but he showed no mercy to his critics. When the pope's master of ceremonies, Biagio da Cesena, dared to criticize the fresco, Michelangelo painted him as Minos, lord of the underworld, with the ears of an ass and a snake wrapped around him nibbling on his testicles. The irate Biagio went to Pope Paul demanding redress and was dismissed with the wry rebuff: "*Ibi nulla est redemptio*"—"From there, no one is redeemed." If you were in purgatory I could intercede, Paul told him, but not even the pope can rescue a soul from hell.

Few works of art have provoked greater outrage or greater awe than the *Last Judgment*. When it was unveiled on Christmas Day, 1541, Vasari writes, all Rome was filled with "stupor and wonder" at the huge, disquieting fresco. Seeing the finished altar wall, Paul reportedly knelt and wept at the terror that awaits us all.

Artists were spellbound. Counter-Reformation zealots were apoplectic. Ironically, it was Aretino, the flamboyant swindler, plagiarist, and pornographer, who summed up the objections by declaring that the *Last Judgment* was more suitable for a public bath than for the Sistine Chapel.

After Paul died, the reactionaries gained greater influence within the Church. They denounced the fresco as prurient and obscene and called for the entire altar wall to be whitewashed. El Greco volunteered to paint over it. The controversy seethed for a decade, until Pope Paul IV ordered Michelangelo's nudes covered. Daniele da Volterra, the unfortunate artist chosen to clothe the naked, earned the nickname *il brachettone*—the pantaloon maker.

Dante's Inferno was not an abstraction to Michelangelo; the stakes were real and eternal—salvation or damnation. His art has no palliative vistas to soften the human condition. There is not a flower, a tree, or a landscape of any kind in his frescoes—only us, teeming, struggling, aspiring. His art is in motion, animated by the primordial struggle of spirit with flesh, of man with God, and with

himself. And if, too often, he seemed to be losing the struggle, he was not an optimist by nature. "Let him who does not know what it is to live by anguish and by death join me in the fire that consumes me," he said.

Single-minded, with a wild, consuming energy, he tortured himself with work. What he made was never as true as the picture in his mind, which is not to suggest that he was falsely modest. Michelangelo didn't think he was good. He knew he was great. Once a man sitting for a bust complained, "But it doesn't look like me." The sculptor shrugged—"Who will know five hundred years from now?"—and went on working. Another time, overhearing someone else claiming to be the sculptor of his *Pietà*, he sneaked into the old St. Peter's at night and incised his name in the marble. It is his only signed work.

There was an unalloyed quality in Michelangelo's art, and it was mirrored in his personality, in his religious fervor, and in his dealings with others. He was—and maybe the greatest artists must be—a supreme egoist, so consumed by what he was creating that he could not understand how anything could be of greater importance. Harmony, so vaunted in the Renaissance, was alien to his character and his art.

His service was prized, yet he always worried that he was facing penury. Michelangelo was his family's pride and cash cow. He seemed to support them all—father, brothers, sisters-in-law, and nephews. He was a generous son and brother, but their incessant demands for money unnerved him. They were leeches bleeding him dry. "I will send you what you demand of me," he wrote to his father on one occasion, "even if I have to sell myself as a slave." In another letter written from Rome to his favorite younger brother, Buonarroto di Ludovico Simoni, he complained, "Let me tell you that I don't have a penny and that I am practically barefoot and naked."

Michelangelo lived in anguish and created out of tension. In his

old age, freed finally from the tomb, he turned increasingly to poetry and found some degree of solace in the friendship of the poet and radical reformer Vittoria Colonna and the companionship of a young Roman noble, Tommaso de' Cavalieri. Some believe that he and Tommaso were lovers. Although there is no way to prove or disprove the contention, Michelangelo's age, his deep religion, and his art weigh against it.

He poured his passion into his work, living as austerely as a monk, and Condivi says, as chastely. His art was his life, his life was his art. "I have only too much of a wife in my art," he said, "and she has given me trouble enough. As to my children, they are the works that I shall leave and if they are not worth much, they will at least live for some time."

CHAPTER TWENTY-ONE

JULIUS'S FOLLY

❦

When Paul III came to the papacy, the Basilica that had begun so audaciously with the laying of the first stone—the intemperate Julius bellowing from the depth of the foundation pit—stood abandoned. The new St. Peter's had sparked the gravest crisis in Christianity since the crucifixion. If Julius could have foreseen what it would provoke—the damage to the Church and the chaos loosed upon the city—he might never have launched his grand enterprise.

In the aftermath of the Sack, the Basilica had seemed like an extravagance that the papacy could ill afford. The vital work of getting the city and the Church functioning again had taken precedence. Once amends were made between the pope and the emperor, the extensive, and lucrative, work of rebuilding and refortification began. Much of it went to Antonio da Sangallo.

When the Protestant troops came over the Alps, Antonio had been building a church in Loreto, east of the city. He returned to Rome when so many others were fleeing and stayed with Clement, the steadfast servant of the pope. Although he received many major commissions throughout the Papal States, there was enough reconstruction work to keep scores of architects employed, and Clement called Baldassare Peruzzi back to Rome.

During the sack, Peruzzi had been captured by German soldiers as he tried to flee, accused of being a priest, and threatened with torture and death. To prove he was an artist, he drew a corpse for his captors. The drawing secured his release, but not the end of the dangers. Trying to leave Rome a second time, Peruzzi had been robbed and stripped of his possessions. Half-naked and terrified, though otherwise unharmed, he finally reached his home in Siena, where he sat out the debacle.

Six years passed before Peruzzi finally ventured back to Rome to answer the pope's call. He become coadjutor of the Basilica with Antonio once again. Since funding St. Peter's was the spark that ignited the Protestant Reformation and the Sack of Rome, the free-spending days were gone. Nothing could be built unless the money to pay for it was in hand. The emphasis now was on keeping costs to a minimum, a slower pace, and a more modest design.

With these restraints in mind, both architects submitted new designs to Pope Clement. Antonio scaled back his so drastically that he eliminated the central dome entirely. Peruzzi proposed a significantly smaller Basilica, with each arm only three bays in length. It was a workable, cohesive solution in the wake of disaster, but Peruzzi, never a lucky man, died before the indecisive pope had made up his mind to proceed. According to the gossip in Rome, the probable cause of Peruzzi's death was poison, administered by a jealous rival.

Although some work was done on the main bay of the southern arm—Pope Leo's "Chapel of the King of France"—a visitor to Rome in 1514, returning twenty-five years later, would not have seen any notable difference in the rest of the Basilica. The northern arm and the east-west axis were virtually unchanged since Bramante's death, and no architect had attempted to raise his dome.

In the decade since the Sack, Romans had become accustomed to the sight of the unfinished Basilica like one more ill-conceived

experiment—an apt symbol, some might have thought, for a
Church that had lost its way, forgotten its purpose, and forsaken its
mission.

Sketches drawn by the Flemish artist Maerten van Heemskerck
around the time of Pope Clement's death show the husk of the
Basilica like a failed dream. Bramante's towering piers loom solitary
and neglected, new ruins to add to the old.

Clement had been wary of returning to any ostentatious build-
ing. Paul had no such compunction. When Charles V made a tri-
umphal visit to Rome in 1536, nine years after his troops had
ravished the city, Paul, taking a cue from his Medici predecessors,
named the still unconstructed northern arm of the Basilica Cappella
dell'Imperatore—"Chapel of the Emperor."

Paul saw a new St. Peter's rising in glory as a metaphor for the
city and the Church. Completing the Basilica in unparalleled splen-
dor would be an affirmation as deliberate and unabashed as the
Council of Trent.

Through the years, the clarity of Bramante's geometric cross
had been lost in a proliferation of contending designs. Paul asked
Antonio da Sangallo to draw a final, definitive plan and create a
scale model of the Basilica. In a papal bull of 1540, he authorized
the architects of St. Peter's to excavate for "materials" in the Ro-
man Forum and Via Sacra. Over the next nine years, eighty-six
loads of stone were carted from the Forum. Some of the plunder
never made the full route to the Vatican. It was diverted to the new
Palazzo Farnese that Antonio was building for the pope.

Although Paul was certainly a more patient pontiff than Julius,
one year passed, and then a second, and still there was no Basilica
model. The architect made excuses. He was busy with the pope's
new palace and with repair work on Bramante's structures. Antonio
was fortifying the Basilica, rebuilding the loggia of the Belvedere—a
portion of the east wing had collapsed, almost killing Paul—and

bolstering the façade of the papal palace, which was also in danger
of collapsing.

Then, as now, there is real time and Roman time. Romans are
famous procrastinators and laggards. If you're in a hurry to have
something done, the Eternal City is not the place to be. "*Domani,
sempre domani*"—"There is always tomorrow"—is the classic re-
joinder to every delay. Three years passed, and still Paul waited.
All the while, the money was disappearing, yet no model was
forthcoming.

Finally, he sent his accountant Jacopo Meleghino to the archi-
tect with an ultimatum: "*Quoad architectos salaria mandarant non satisfieri
nisi incepto modello*"—"No model, no pay." In the summer of 1543,
Antonio unveiled his Basilica to the pope.

<p align="center">୧୬</p>

Today on permanent display in a well-lit circular stone room in
St. Peter's is the intricate model of Antonio da Sangallo's Basilica.
Constructed of lime wood, on a scale of 1:29 and correct in every
detail, it was twenty-three feet long by twenty feet high, five years in
the making, and very expensive. Contemporary reports give the
cost as anywhere from four thousand to six thousand ducats. Anto-
nio could have built a conventional church for a comparable
amount. In spite of the exorbitant price tag, the detailed model was
precisely what the Basilica had been lacking since its conception: a
definitive design, executed to scale, accepted in its entirety by the
pope and ratified by the Fabbrica.

In Antonio's model, two giant bell towers dominate the exte-
rior. Between them, the dome rises over two tiers of columns re-
sembling a wedding cake, and a lantern with more columns
crowns the cupola. A large atrium seems appended to the body of
the church, which is encircled by ambulatories, or passageways.
The only lighting comes from narrow windows shaped like *la*

bocca di lupo—"a wolf's mouth." All three orders of columns—Doric, Ionic, and Corinthian—are repeated in dizzying profusion. It is a gaudy, overelaborate, disjointed extravaganza that looks more like a Disney theme park than a sublime metaphor.

On architectural merit alone, Paul might have rejected Antonio's model, but there were extenuating circumstances. The model had taken so long to build and cost so much that if Paul asked for revisions, he might not have lived long enough to see them, and construction had been stalled for far too long. Then too, officials at the Fabbrica backed the design, and the pope must have had confidence in Antonio, since the architect was also building Palazzo Farnese. Finally, Paul was preoccupied with affairs of the Church. The Council of Trent was in session. He was brokering another peace between France and Spain, and the Inquisition was rooting out alleged heretics. Whatever his reasons, Paul accepted Antonio's model.

For the first time in the building of St. Peter's, the three essential elements were in place. There was a clear plan to follow. There was a skilled engineer to ensure that construction was sound. And there was money to finance it. Finally, it seemed as if there were no impediments to construction. The majestic project, mired so long in artistic confusion and fiscal mismanagement, would go forward. A new St. Peter's would rise, out of the agony of the Sack and the confusions of prior papacies—a new Basilica in a reborn city.

From 1529 to 1540, Clement and Paul had spent 17,600 ducats on the Basilica. Since the salary of Antonio and Peruzzi was 300 ducats a year, on average, less than 2,000 ducats per year had gone into building. Over the next six years, expenses increased more than 100 percent—a clear indication of Paul's commitment. Between 1540 and 1546, he poured 162,000 ducats into St. Peter's. A full half of that was the treasure of the Incas brought back to Spain by the conquistadores. Gold and silver were flowing across the Atlantic,

and the Spanish monarchy was funneling the riches into the Vatican treasury.*

Antonio spent a substantial percentage of the money on a single project. He raised the entire floor of the Basilica 12.5 feet. It was an ambitious engineering challenge, accomplished at great cost. It was also a radical aesthetic change that destroyed the interior perspective Bramante had ordained.

Antonio's motive is unclear. It may have been necessary to shore up Bramante's crumbling foundations. With a building as enormous as the Basilica, there is a real danger of the entire edifice sinking, and the ground beneath the Basilica was marshy. One hundred fifty years later, Carlo Fontana would complain that the nave was on shaky ground because new channels had not been dug to drain the water from the hillside into the river. And in fact, part of the construction would collapse. On the other hand, Constantine's church had stood firmly on the very same ground for more than a millennium.

To support the new floor, Antonio built a series of parallel walls almost three feet thick and some seventeen feet apart, connected by barrel vaults. "If this masterpiece of care and prudence were upon the earth, instead of being hidden as it is beneath it," Vasari wrote, "the work would cause the boldest genius to stand amazed."

The higher floor altered the vertical dimensions. Now the large niches that Bramante had cut into the piers appeared too close to the floor. Antonio filled them in and strengthened the piers, squaring them off and chamfering, or fluting, the side under the dome.

*After Columbus's voyage, Alexander VI fixed the dominion of the New World. On a map, he traced a meridian passing one hundred miles from the Azores, giving everything to the west to Spain and to the east to Portugal. A grateful Queen Isabella sent the pope the first gold from America. It was used to gild the ceiling of the Basilica of Santa Maria Maggiore.

Each part of Bramante's piers and columns—base, shaft, and cornice—was colossal. His bases were ten feet of stepped travertine. Their overwhelming height, much taller than an average person, would have forced the eye up to the column shaft and conveyed the subliminal message of an infinite power. By lifting the floor, Antonio, in effect, cut off the bases, leaving the columns without pedestals and diminishing their effect.

There is no way to know if the aesthetic ramifications were inevitable or intentional—a necessary cost of buttressing a shaky construction, or an artistic choice. Around that same time, Sebastiano Serlio, whose views on architecture were highly regarded, was writing, "Columns whose bases rest on the floor of the building are far more beautiful than those which stand on a pedestal." To an architect like Antonio, who always wanted to be in the forefront, Bramante's gigantic stepped bases may have seemed passé.

Raising the Basilica floor did have several unanticipated advantages. It provided space for the work yard to slake the lime needed for the new wall. It offered relief from the terrible humidity of Roman summers, and it created space for the crypt and grottoes underneath St. Peter's.

Once the floor was finished, Antonio built a dividing wall separating the construction site from what remained of the original church of Constantine, which was still being destroyed bit by bit. Pilgrims could now visit the hallowed shrine without maneuvering around scaffoldings or tripping over bags of sand. Work proceeded apace on the eastern ambulatory and the pendentives of the dome. Antonio was completing the barrel vaults of the south and east arms and coffering them with decorative recesses, when, not for the first time, it seemed as if Divine Providence intervened. He died suddenly in 1546.

Although the Basilica was saved from disaster, Sangallo's unexpected death left a void. The architect had controlled the building

projects of the Vatican for more than a quarter century. He would be difficult to replace.

Fabbrica officials considered various artists. There was talk of Jacopo Sansovino, but he was content in Venice. Giulio Romano, who had been Raphael's student, was offered the position, but he was an old man retired in Mantua, and he died in November before he could take up the assignment. Fabbrica officials were still debating a successor when the pope made his own choice. Only one artist remained from the glory days of Julius, and he was bent with age and anguish. Paul summoned him to an audience.

Michelangelo's *Last Judgment* was a defiant response to the Protestants, affirming the authority of the Church. Now desiring a Basilica "clear and luminous" to proclaim its unity, Paul turned again to Michelangelo.

It is one of the intriguing what-ifs of history. What if Paul and Michelangelo had succeeded Julius and Bramante without the interruption—damaging for the city, divisive for the Church, costly for the Basilica—of the Medici interregnum? It is too much to suggest that northern Europe would not have broken with the Latin Church, because the moral decay was so pervasive. But the demands for reform might have been heeded, the rift healed, and the grand enterprise of the century progressed without corrupt indulgences, confused plans, or extravagant expense, in an unbroken line, Julius to Paul, Bramante to Michelangelo.

MOTU PROPRIO

❦

The old man shuffling back to center stage was as combative and uncompromising as he had been when Julius and Bramante relegated him to the impossible ceiling. Michelangelo had resisted then, and he resisted even more forcefully when Paul asked him to complete the Basilica.

He had never supervised a big construction yard like St. Peter's. He had never worked for a committee, and he was leery of the Fabbrica. Organized by Pope Clement, it had gained authority and influence in collusion with Sangallo. Michelangelo dismissed it as a factory intent on enriching itself.

Paul pressed. Michelangelo made excuses. Paul pressured. Michelangelo refused. The whims of popes infuriated him. Paul flattered, insisted, wheedled, commanded. He was willing to conciliate, but just so far.

A century after Nicholas V imagined a new Basilica and almost four decades after Julius II laid the foundation stone, Michelangelo agreed "with infinite regret" to become chief architect, sculptor, and painter to the Vatican. Julius had been seventy when he died, and Michelangelo would be seventy when, having finally conceded defeat and let go of the tomb, he agreed to take over Julius's grand enterprise.

Michelangelo had reasserted the supremacy of the Church with

the *Last Judgment.* Now he would renew the simple faith of Peter in its grandest construction. Under Antonio the Fabbrica had corrupted a glorious expression of Christian faith into an ostentatious display of vanity. The Basilica had become a work of show. He would make it once again a work of faith, affirming again the words on the foundation-stone medal—"Not for ours, Lord, but for your glory."

Michelangelo complained that the work of St. Peter's had been imposed on him as a penance by God and refused to accept payment.* It was an act of conscience and maybe a grudging contrition. He would build the first church of Christendom for the glory of God, and, perhaps, the memory of Julius—but on one condition: that he would have full and complete authority, responsible to no one except the pope himself.

After a lifetime wrestling with pontiffs and prelates over the doomed tomb of Julius through charges and countercharges, slavish labor repeatedly halted, aborted, and diminished, Michelangelo insisted on setting his own unequivocal terms. He refused to work on St. Peter's unless Paul put in writing that he, Michelangelo Buonarroti, born in Florence in the year 1475, would have absolute, complete, and total authority, and that it could be altered or overridden only by the Holy Father himself.

What Michelangelo demanded, Paul III decreed. He issued two official, apostolic letters, one in January 1547 and a second in October 1549, granting Michelangelo complete authority *motu proprio*— "of his own accord." Reluctantly, grudgingly, and as he described it, "*contro mia voglia con grandissima forza messo da papa Paolo nella fabbrica di San Pietro*"—"building St. Peter's against my will and with the greatest force exerted by Pope Paul"—Michelangelo turned to the Basilica. He had full authority, and he used it like a bludgeon.

*Eventually he received fifty ducats a month, but payment was made by the papal treasury, not the Fabbrica.

The officials of the Fabbrica assumed that construction would continue according to Sangallo's model and at a comparably high cost. They may have expected an elderly man mellowed by the years, whom they could manipulate. Or an impractical artist who wouldn't bother with such details as supplies and costs. They certainly didn't anticipate Michelangelo.

He was a singular talent and a singularly difficult individual— crabby, suspicious, beatific, inspired—who always wanted to do everything himself. In a perfect world, he would have chosen the supplies, quarried the travertine, cut and placed the stones, built the scaffolding, slaked the lime, mixed the cement, and carved the cornices. No detail was too mundane to consider. No idea was too challenging to confront.

Michelangelo rejected the dark designs of Sangallo. Antonio's model was an elaborate, overwrought conception—a mistaken notion that more ornate meant more majestic. It had "so many projections, spires and bits of pieces," Michelangelo complained, "that it looked more like a German work than a good antique style or a beautiful charming modern manner."

After what the German troops had wreaked on Rome, the comparison was incendiary, but his criticism did not stop there. Antonio's Basilica was too big, too ostentatious, and too expensive. In his always-colorful hyperbole, Michelangelo said, "If it were attempted, one would sooner have been able to hope to see the last day of the world than St. Peter's finished."

According to his harsh, always dramatic judgment, Antonio had bastardized Bramante's design, mangled and desecrated it:

> Anyone who has distanced himself from Bramante's arrangements, as did Sangallo, has distanced himself from the truth. Sangallo's plan has no light of its own and its numerous hiding places, above and below, all

dark, lend themselves to innumerable knaveries, such as providing shelter for bandits, for coining money, ravishing nuns, and other rascalities.

Michelangelo had been a lifelong friend of Giuliano da Sangallo, but he had little use for Antonio. He found the nephew artistically dull and personally arrogant, his building solid but uninspired. Added to his personal distaste and artistic disdain were Michelangelo's suspicions that Antonio's cronies had been fleecing the Church, more intent on lining their own pockets than in glorifying God with a new Basilica. He accused *la setta Sangallesca*—the Sangallo set—of giving suppliers kickbacks, accepting shoddy materials, and padding the accounts.

On November 30, 1546, he fired Antonio's two closest collaborators, saying that he didn't want anyone who had worked for Sangallo to work for him (*"che non voleva . . . homo et officiale e ministro che fossero stato al tempo del Sangallo"*). The next day, he assembled the officials of the Fabbrica and announced that he was in sole control of the construction yard and would answer only to the Holy Father.

Late in January, when his nomination was officially ratified, Michelangelo put the Fabbrica on further notice. There would be no more stealing or fraudulent acts. Special arrangements with the quarries were forbidden, and all supplies would go through him. He did not mince words:

Those who accept supplies which I have refused connive with and make friends of my enemies. All their pourboires and presents and inducements corrupt the true sense of justice. I beg of you, therefore, in the name of the authority with which I have been invested by the

pope not to accept henceforth any building materials
that are not perfect, even if they come from heaven.

❦

When Michelangelo came to St. Peter's, integral parts of the Basil-
ica were fixed. The monumental crossing that defined the scale of
the edifice and the size of the dome was complete. The south arm of
the Basilica was finished and vaulted, fixing the size of the transept,
and the east arm was partially finished. Working within those con-
straints, he made a clay model in just fifteen days, compared with
Antonio's five years, and for a fraction of the cost—87 ducats, com-
pared with the four-to-six-thousand-ducat cost of Antonio's model.
As much as possible, given how far construction had progressed,
Michelangelo returned to the essence of Bramante's original plan.

Michelangelo had a long memory for treacheries, real or imag-
ined. All these years later, he still blamed Bramante for the failed
tomb, yet he recognized the purity of the architect's design. Personal
animosities were incidental beside artistic merit. Michelangelo had
not forgiven the man but he admired the artist.

Bramante was "as skillful in architecture as anyone from the
time of the ancients up to now," he wrote. "The first stone of St.
Peter's was laid by him, not as an obscure or confused plan, but in
accordance with a design which is clear, comprehensive, and lumi-
nous. Those who departed from his thought left truth behind."

Michelangelo's model stripped away Antonio's extraneous
additions—bell towers, atrium, ambulatories, and chapels—and
returned the Basilica to a central dome rising over a pure Greek
cross. He shortened the barrel-vaulted arms and freed the cross
from the inscribed square in which Bramante had set it, in effect
eliminating the perimeter and creating a diamond shape, each point
being an apse, the semicircular end of a main arm.

Michelangelo repeated Bramante's colossal order of Corinthian pilasters on the exterior and gave the outer walls the contours of a sculpture. Like the *David* that the young Michelangelo hewed from a huge block of marble, the exterior of St. Peter's seemed truly the rock of Peter, chiseled from a single stone.*

His Basilica was smaller than Bramante's or Antonio's, and stark. He imagined an interior and exterior of bare, unembellished stone. After the tumult the Church had endured, out of years of in-coherence and confusion, Michelangelo created unity. As Vasari wrote, "He reduced St. Peter's to its simplest form and greatest power."

Not everyone saw it with that same clarity. When Michelangelo began tearing down Antonio's ambulatories, the Fabbrica deputies complained to the pope. His architect was squandering Basilica funds by demolishing work that was already complete. Paul sup-ported Michelangelo, replying that he was saving three times what he was losing.

Backed by the full authority of the pope, Michelangelo followed his own schema, as secretive about St. Peter's as he had been about the Sistine ceiling. He never disclosed his ideas, only making blue-prints of a specific section as construction was ready to start. Like Bramante, he was constantly revising, his design continuously in flux.

Although the dome had dominated the plans of Bramante and every architect who followed him, the engineering challenge it posed was so daunting that no one had attempted to raise it. Michelangelo played with the proportions of each part—base,

*So many changes were made to Michelangelo's design—the central plan reversed, the dome altered, the stark interior decorated to a fare-thee-well—that the clearest view of his work is the back of St. Peter's.

drum, attic, cupola, and lantern—and the ratio of one to the other. As consumed by the dome as Bramante had been, he wrote to Florence for the specifications of Brunelleschi's cathedral dome, built a century before.

While he was experimenting with designs, Michelangelo took a number of practical measures to fortify Bramante's structure and disperse the weight of the dome. Antonio had strengthened the piers. Michelangelo reinforced them further and sank well-holes under their foundations, which he filled with concrete. He thickened both the piers and the exterior walls, shortening the distance between them. This reduced the breadth of the crossing from 69 to about 58.5 feet. Michelangelo also checked the strength of the Basilica foundations and devised a series of ramps so that mules could haul loads of material up to the various stages of scaffolding. These linked walkways allowed men and supplies to easily reach each level of construction.

Once these practical steps were complete, Michelangelo began building a circular base, about 12.5 feet high and 28.5 feet thick, for the drum to rest on. A passageway almost six feet wide ran through it, forming an external wall eight feet thick and an internal wall approximately fifteen feet thick. Narrow passageways, slightly less than three feet wide, cut through the interior wall, making stairwells to connect four spiral staircases within the wall of the drum.

Bramante's drum was similar to the tympanum of his Tempietto—a circle of evenly spaced columns with a continuous entablature. In Michelangelo's drum, colossal fifty-foot paired Corinthian pilasters frame sixteen windows and continue the unified order of the Basilica. The windows are large to flood the crossing with light and are designed to alternate with a triangular or half-circle eyebrow. More than sixty-five feet in height and more than six hundred feet in

circumference, the drum is built of cemented masonry faced with thin slabs of travertine.

Michelangelo intended to carve statues to stand on the drum, forming a circle around the cupola. Although Carlo Fontana would revive the idea many years later, it was never carried out. With Bernini's "cloud of witnesses" over the colonnades and Maderno's giant Christ and his apostles commanding the façade, more statues would have been overkill.

<p style="text-align:center">∞</p>

Still a firebrand defending truth and beauty, Michelangelo built with undiminished fervor—and received the unwavering support of a succession of popes. Although repeatedly challenged by younger architects and Fabbrica administrators, he would not concede a pilaster, a cornice, or a column. For seventeen years, through five pontificates, he battled attempts to dislodge him or dilute his authority. Paul III and his successors—Julius III, Marcellus II, Paul IV, and Pius IV—repudiated all efforts to interfere with the impolitic artist. They ratified and extended his authority, and each remained true to his word.

Julius III, who followed Paul, not only renewed Michelangelo's mandate, he reinforced it with the threat of interdiction against anyone who dared "to reform or change in the least, at any time or in any way, the model and design made by you." Although Julius was an ardent supporter of Michelangelo, in an effort to ease tensions and appear evenhanded, he allowed the Fabbrica a hearing to vent its grievances. The officials rebuked him with bitterness:

> From 1547 to the present day, during which time we deputies of the Fabbrica have counted absolutely for nothing and have been kept by Michelangelo in absolute

ignorance of his plans and doings, because such was the will of the late Pope Paul III and of the reigning one, the expense has reached the total of 136,881 ducats. As regards the progress and the designs and the prospects of the new Basilica, the deputies have known nothing whatever, Michelangelo despising them worse than if they were outsiders. They need, however, to make the following declarations to ease their own conscience: they highly disapprove Michelangelo's methods, especially in demolishing and destroying the work of his predecessors. This mania of pulling to pieces what has been already erected at such enormous cost is criticized by everybody; however, if the pope is pleased with it, we have nothing to say.

If Julius III had hoped to be a peacemaker, the attempt failed utterly. Michelangelo delivered a fierce rebuttal:

I am not and will not be obliged to tell either you or any of the deputies what I expect to do. Your only business is to collect and administer the funds, and see that they are not squandered or stolen; as regards plans and designs, leave that care to me.

Although the next four popes reaffirmed Michelangelo's mandate, the pace of construction slowed after Paul III's death. The river of gold that had been flowing through Spain to the Vatican since the reign of Ferdinand and Isabella dried up. In 1556, when the wall of the drum had reached the height of the windowsills, construction was suspended for lack of funds. It did not resume until 1561. Although the work of quarrying and transporting the travertine

for the drum continued, Michelangelo lost five critical years. It was a lonely, despairing time. "I have lost my memory and my wits," he wrote to Vasari, but "if I quit . . . I would make a few thieves happy and would be the cause of the building's ruin, and perhaps even of having it shut up forever."

When work finally resumed, Michelangelo was half-crippled, his body weakened by age and illness. He needed help now to mount and dismount, but he still rode to work on a docile, slow-gaited chestnut pony, plodding to the same site he had once fled. Although the young man who had galloped away from the Basilica swathed in a lavender cape was unrecognizable, his passion was undiminished.

At eighty-six, Michelangelo was still waging art—obdurate, intransigent, unforgiving, sparing neither himself nor others. Gradually, the new church began to emerge on his terms, according to his vision. The south crossing was almost finished and work was under way on the north wall.

Ambitious young architects carped that he was impossible to work with. He was too old. His faculties were failing, and the building was suffering as a result. But he refused to go gently until, as he wrote to Vasari, St. Peter's is "brought to completion, so that it could not be changed and given a different form. . . . I am at the eleventh hour, and not a thought arises in me that does not have death carved within it; but God grant that I keep him waiting in suspense for a few years yet."

Michelangelo's method of building was very personal. Instead of drawing to scale or giving the masons precise measurements, he made small clay models and sketched individual parts—a window, say, or a cornice—to capture the effect he wanted to achieve. Sometimes he had sections made first in wood and positioned exactly so that he could see how they would look. In his last years, age and illness kept him from the work site, and misunderstandings

multiplied. When a master mason miscalculated the vaulting of the south apse, a large section had to be destroyed at great expense. "If one could die of shame and suffering, I should not be alive," Michelangelo said. Unable to cope any longer with the multiple difficulties and frustrations inherent in such a monumental project, he agreed to the appointment of a foreman.

Michelangelo outlasted every contemporary, every rival, or would-be rival, and went on working until the very end, completing the drum and part of the attic. He wanted, at the very least, to bring the dome to a point of construction where his design could not be changed.

Michelangelo died on February 18, 1564, fifty-one years almost to the day after Julius. He was in his eighty-ninth year and still struggling for the unattainable. Inscribed on a memorial raised in his honor in the Church of Santi Apostoli are the words: *Tanto homini nullum par elogium*—"No praise is sufficient for so great a man."

Michelangelo was as powerful in death as he had been in life. His spirit and his Basilica lived on, protected by every successive pope as if it were a Church dogma.

Pius IV, a nasty man by all accounts (when he died angry Romans beheaded his statue), felt so bereft by Michelangelo's death that he could not bring himself to name a replacement for five months. He finally appointed Pirro Ligorio, one of the younger architects who had made the old man's final months so miserable. Ligorio was given the firm stipulation to follow Michelangelo's design exactly. When he deviated from it, Pius replaced him with Jacopo Barozzi, called Vignola, and gave him the same commandment.

Although Vignola disapproved of Michelangelo's unorthodoxy, he followed the master plan, completing the attic of the drum, where great garlands are now carved. Vignola also vaulted the north apse, and may have begun work on the minor domes.

❧

It is one of the ironies of art history that the commissions Michelangelo rejected initially and was badgered, cajoled, and battered into accepting are his masterworks: the ceiling and altar wall of the Sistine Chapel and the Basilica of St. Peter.

His memory was so revered and his talent so intimidating that for more than twenty years, no architect or pope dared to tamper with his Basilica plan or raise his dome, until a self-taught swineherd took control of the Church.

AN IMMOVABLE OBJECT

❧

The consecration of Sixtus V was held in the open atrium of Constantine's church, with Michelangelo's unfinished dome casting a wide shadow behind it. Sixtus V bowed his head to receive the jeweled miter of Peter and extended his left hand to accept the shepherd's crook. He leaned heavily on the crozier and felt the cool of the golden shaft, the crude crook transformed through more than fifteen hundred years of Christianity into a symbol of power. As Bishop of Rome, Sixtus would use that power to the utmost, undaunted either by the lamented genius or his unfinished masterwork. As ambitious as Nicholas V, as redoubtable as Julius II, as shrewd as Paul III, Sixtus would leave his mark on Rome more indelibly than any other pope of the Counter-Reformation. He lived as austerely as a monk and dreamed extravagantly.

One of his first acts was to attempt the impossible. Since the imperial days of Rome, an Egyptian obelisk had stood in what had once been the Circus of Caligula. The obelisk had posed a nagging problem for every pontiff whose ambitions turned to a new Basilica. Its position at the south side of the old St. Peter's was a distraction, drawing the eye away from the main entrance (see Vatican plan, page 56). In Nicholas V's utopian plan for a papal Palatine,

the obelisk was positioned where it is today, in the center of the piazza in front of the Basilica. But 320 tons of granite rising eighty-three feet in the air are not easily dislodged, let alone moved, and no engineer could figure out how to reposition it.

Michelangelo said flatly that it could not be done. Bramante, who always had ideas to spare, tried to finesse the question. He presented Julius II with a novel solution. Instead of moving the obelisk to align with the new Basilica, align the Basilica with the obelisk, a far simpler task. It required only repositioning the main entrance to face south and repositioning St. Peter's tomb accordingly. What seemed a clever and practical solution to the architect caused a papal explosion. Julius quashed the plan unequivocally. Bramante would accommodate Peter. Peter would not accommodate Bramante. And so the obelisk problem was accepted as insoluble, until the unmovable object met the irresistible force of Sixtus V.

In the early part of the first century, Caligula brought the granite monolith from Heliopolis to mark the site of his imperial circus. According to Pliny the Elder, it took twenty thousand slaves to lift the obelisk to its base, where it withstood the numerous barbarian invasions. Romans came to believe that the ashes of the original Julius, the first of the Caesars, were preserved in the bronze ball at the top.

⚭

Sixtus V did not suffer fools, excuses, or imponderables. If he wanted something to happen, he found the talent and the funds to realize it. The more impossible the feat, the more insurmountable the challenge, the more adamant he was to achieve it.

In 1585, the first year of his pontificate, the indomitable Sixtus announced a competition to transfer Cleopatra's Needle from the south side of the Basilica to the center of St. Peter's Square. More than three hundred architects, engineers, scientists, and savants

from all over Europe submitted plans; some even suggested a miraculous intervention.

The winner was the pope's incorrigible favorite, Domenico Fontana. Like the Sangallos, the Fontanas were a building family whose name and livelihood are linked inextricably to the construction of St. Peter's. Domenico, his brother Giovanni, and his grandnephew Carlo Maderno made *la fabbrica di San Pietro* the family business. A small, wiry man who seemed to be in perpetual motion, Fontana had a sharp nose, long eyebrows like porch awnings, and a neatly trimmed beard. He was both an adept engineer and a clever showman. Instead of simply outlining his idea on paper, he rigged a model and demonstrated his plan to the pope. To show how confident he was of success, Fontana offered to pay all the expenses himself in advance.

Sixtus, who was so tightfisted that he kept the Vatican treasury in a locked strongbox in Castel Sant'Angelo, was delighted. He gave Fontana full power to requisition whatever materials he needed: block pulleys, iron banding, nails, hammers, mallets, beasts of burden, provisions, etc.

Fontana spent seven months in preparation. No detail was insignificant. He ordered quantities of hemp woven into miles and miles of rope, razed the small buildings that crammed the quartermile distance from the obelisk to the square, and built in their place an elevated track. Formed of embanked soil shored up with wooden beams, it ran from the monolith to the square.

Fontana studied the writings of the imperial historian Ammianus Marcellinus, who tells in detail how to raise an obelisk, and read Pliny's *Natural History*, particularly the thirty-sixth book, which describes how the ancient Egyptians moved the obelisks down the Nile:

> Two wide barges were loaded with cubes of granite . . .
> until the weight of the blocks was double that of the

obelisk . . . their total volume being also twice as great. The ships were thus able to float beneath the obelisk which was suspended by its ends from both banks of the canal. Then the blocks of granite were unloaded, and the lightened barges took up the weight of the obelisk. . . . The consultant responsible for this scheme was paid fifty talents.

Inspired by Pliny's description, Fontana devised a land-raft called the *strascini*. It resembled a series of flatbeds on wooden wheels. The eighty-three-foot monolith would lie on its side on the contraption and be transported along the runway to the square.

Fontana ordered seventy enormous winches to hoist the granite monolith from the base where it had stood for more than fifteen hundred years. Made from rough-hewn, carved oak, each winch had an open-box base with a spindle in the center for winding the rope. The plaited hemp, two feet thick and 350 feet long, was rigged from the obelisk and wound onto the winches. Eight square holes were carved into the upper portion of the spindle, and turning poles, cut from chestnut trees, were fitted into them. The poles were six feet long to give the men and the horses leverage. Each winch required two horses and ten men to work it.

By late March, a castlelike structure was rising beside the obelisk. Made of oak bars so immense that it took two pairs of oxen to haul each one, the wooden tower was secured with thirteen tons of iron. The obelisk itself was wrapped in straw, then crated in wooden planks lashed together with iron brackets. As the intricate preparations neared completion, a date was set.

Very early, on the morning of April 30, 1586, Pope Sixtus celebrated an open-air mass for Fontana and his crew. Then 907 men, 70 winches, and 145 horses assembled at the site, where a throng had gathered to watch. Spectators crowded on the rooftops of nearby

houses and covered the Vatican hill. A gallows stood close by the scaffold tower, erected as a warning to anyone who uttered a sound. Sixtus had decreed that no one speak on pain of death during the difficult operation.

"*Benedicat vos omnipotens Deus.*" As his voice rose in blessing, the crowd stilled. Fontana mounted a rostrum to direct the operation. Men and horses assumed their positions. At the sound of a single trumpet blare, they began to move. Whips cracked. Ropes creaked. The winches started to turn. An eyewitness reported, "The wheels made such a noise that one might have thought the very earth was going to split and the sky above to open."

At the first complete revolution, the granite monolith jerked from its ancient base. The winches turned again, and again. By the twelfth revolution, the obelisk was dangling ten feet in the air. The immense mass, which weighed as much as forty bull elephants, was lifting slowly when suddenly it stopped, all motion suspended. The ropes were giving way.

In the terrible silence, the gallows rope swung like a pendulum. No sound was uttered. Then a voice cried out, "Acqua alle funi!"—"Water the ropes!" Fontana followed the advice. With the ropes wetted, the obelisk began to lift again. Separated from its base with wedges, it was set into vertical position within the tower. Finally, an hour before sunset, as the earth trembled and the tower creaked, the obelisk was lowered onto the *strascini* without a scratch.

The man who had dared to shout was a sailor from Bordighera, a village on the Italian Riviera replete with palm trees. Sixtus, in gratitude, granted Bordighera the privilege of furnishing the Easter palms to St. Peter's in perpetuity. Every year in the week before Palm Sunday, a barge filled with palms drifts down the Tiber from Bordighera.

❧

The obelisk lay on its side in the piazza throughout the summer months. While he waited for the cooler weather, Fontana had the tower dismantled and hauled piece by piece to the square, where it was reassembled. He built a new base in the center of the piazza, sealing within it three caskets of relics, and removed the ball from the top of the obelisk. Although no imperial ashes spilled out, Sixtus exorcised the pagan spirits anyway and consecrated the monolith to the Holy Cross. The ball was replaced with a cross.

At dawn on Wednesday, September 10, after the worst summer heat had passed, the obelisk was raised in St. Peter's Square. So many Romans turned out to watch that the piazza had to be cordoned off and grandstands set up around the perimeter. After fifty-two full turns of the winch, with bells, trumpets, and Palestrina's Vatican choir providing musical accompaniment, the obelisk was set down in the center of the piazza in front of what remained of the original basilica.

With guns firing from the ramparts of Castel Sant'Angelo and the crowd cheering, the workmen carried a jubilant Fontana around the piazza on their shoulders. That night around the obelisk, he gave a banquet for the workmen, and sent each one home with bread, cheese, ham, and two bottles of wine.

For achieving the impossible, Domenico Fontana was made Cavaliere della Guglia—"knight of the obelisk"—and given a pension of 2,000 ducats. His operation—which cost a total of 37,975 ducats—is still considered one of the boldest achievements in engineering technology. Fontana had reckoned the weight of the monolith with extraordinary precision and calculated that the equipment needed to raise it had to be of equivalent weight.

Attentive to every detail to the last, he had had a horse harnessed and waiting at the Leonine wall just in case the operation failed.

THE SWINEHERD WHO
BUILT ROME

❧

Moving the obelisk encouraged Sixtus to undertake other seemingly impossible projects. He not only demanded Herculean tasks, he believed they could be accomplished. His own experience had given him confidence that every obstacle could be overcome.

Born in poverty, Felice Peretti had herded pigs in the inhospitable mountain passes of the Marches, but there was no doubt in his mind that he was destined for greatness. His father, a gardener in Grottamare on the Adriatic Sea, believed that God had ordained his son to be pope one day. If the elder Peretti had understood the questionable moral character of so many of the popes over the past century, he might have prayed for a different destiny for his son. But he was a simple, God-fearing man, and the pope was the Vicar of Christ. What higher, more hallowed goal could he set for his boy.

The gardener's faith was based on a voice that spoke to him one night in a dream: "Rise, Peretti, and go seek thy wife, for a son is about to be born to thee and to whom thou shalt give the name of Felice since he one day will be the greatest among mortals!"

The story could only have been reported by Sixtus himself.

Whether truth or biography invented to explain his name, which means "happy" or "fortunate," Sixtus never intended to spend his life herding pigs. He must have been a precocious boy, because he taught himself to read, and when he was a teenager, he joined the Franciscan order.

The life of a humble mendicant would never have satisfied him. Early on, he earned some renown as a preacher and reformer and came to the attention of Ignatius Loyola, founder of the Society of Jesus. Encouraged by the Jesuit, Felice Peretti advanced steadily in the Church. He became grand inquisitor, general of the Franciscan order, a cardinal, and in 1585, pope.

Sixtus was the quintessential self-made man. He invented a Horatio Alger story for himself with the added fillip of divine intervention. Perhaps it was true, or perhaps he came to believe his own fiction. He certainly behaved as if he had a divine mandate to bring the Church through its crisis of faith and rescue Rome from the wreck of the Sack. His goal was not art but a vibrant, workable city.

Admired and feared in equal measure, Sixtus was a harsh, unpolished man possessed of raw ambition and practical good sense. Today he would make a formidable CEO. He scowls from his portrait, his face pinched, his expression vigilant. He certainly doesn't appear endearing. Small sharp eyes like lead beads and a nose as hooked as a hawk's give a predatory cast to his face. It takes no imagination to picture him as the grand inquisitor mercilessly grilling an uncontrite apostate. His portrait is bordered by a series of small rectangles. Each box celebrates one of his achievements.

Sixtus was both the spiritual authority of a divided church, struggling to regain its conviction and its conscience, and the civil authority of a broken city. Fifty years after the Sack, Rome still suffered from a ruined infrastructure, poor transportation, pervasive

lawlessness, astronomically high rates of joblessness and crime, and no clean water. Sixtus took on not one but all of these intractable problems.

Neither the utopian dreams of Nicholas, the imperial ambitions of Julius, nor the aesthetic sensibility of Paul impelled him. He may have been history's first modern manager, because his only motivation was a desire to get the job done. Efficiency, productivity, economy, accountability, and results were his prime concerns. To suppose that even a fraction of what he demanded could be achieved seemed absurd, yet in his brief, five-year pontificate, Sixtus did it all.

He began with lawlessness. According to an old custom, each pope on his consecration day issued a blanket pardon to prisoners in the jails of Rome. Sixtus would have none of it. A law-and-order man from the outset, he was as impatient with the crime that plagued the city as he was with the dirty water that bred disease, the rutted paths that passed for streets, and the unfinished hulk of the Basilica that resembled another ruin. Instead of pardoning prisoners, he announced, "While I live, every criminal must die," and ordered one sentence for all offenders: beheading.

To solve the chronic unemployment that bred crime, Sixtus proposed turning the Colosseum into a wool factory "to provide work for all the poor in Rome and to save them from begging in the streets." Every workman would have a workshop on the ground floor and a free two-room apartment with an open loggia above it. If he had carried his plan through, the Colosseum might have been the first urban mall.

To facilitate transportation, Sixtus laid out the broad avenues that define the modern city. Slicing through the hills and fields of the ancient town, he built a network of roads that opened up the surrounding hills for housing, improved access into the city, and

linked the important basilicas for the convenience of the pilgrims who were beginning to return to Rome. To ease congestion in the overcrowded inner city, he offered tax inducements to move to the newly opened exurbs.

The engineer who realized most of the pope's projects was Domenico Fontana. He redrew the map of the city for Sixtus, built a new papal palace at St. John Lateran and a new library in the Vatican, drained the unhealthy marshes, and piped in fresh water. The vaunted aqueducts of the Romans had crumbled years before. Fontana rebuilt them with twenty-two miles of overhead channels and underground pipes. Extending from Palestrina to the center of Rome, they fed twenty-seven fountains.

Out of the mouldering wreckage of the Sack, Sixtus raised a metropolis. No town planner until possibly Robert Moses four centuries later was more ruthless or more successful. Tearing down what he termed "ugly antiquities" if they interfered with his modernization plans, he transformed Rome from a Renaissance town to a Baroque city. Fifty years after being pillaged, burned, and humiliated, the city was reborn as a resplendent spiritual and political center.

Whether the concern was civil or sacred, Sixtus's approach was the same. Equal parts urban planner and reformer, he established the outlines and institutions of the modern Vatican. He reorganized the Curia into the fifteen congregations that remain the basic administration of the Church today, and he reformed the College of Cardinals, fixing the number of members. To spread the gospel of the Church, he established the Vatican printing press, and to protect its truth, he unleashed the full fury of the Inquisition.

Sixtus was sixty-five when he became pope, not a felicitous man in spite of his name, but intrepid. His rough edges were on display. He was uncouth, blunt, and even more impatient than Julius. His

health was poor from years of poverty. He had much to accomplish, and he knew that time was not on his side.

Generally considered the father of modern Rome, Sixtus was the last of the great reforming popes of the Counter-Reformation and the last in the lineage of iron-willed old men, without time or patience, who pushed St. Peter's toward completion.

RAISING THE DOME

❧

A monastic quietude pervades the Basilica of St. Paul's Outside the Walls. It is a soothing sanctuary apart from the rush of the city. In June 1588, morning just breaking and the even cadence of monks chanting the matins seeping from the distant recesses of the choir, Giacomo della Porta and his assistant Domenico Fontana spread a huge drawing on the pavement.

Della Porta had been the chief architect of St. Peter's for a dozen years when Sixtus V became pope. He had started as a sculptor under Michelangelo, shaping stucco reliefs, and had built in his teacher's shadow. Michelangelo had taken on a number of major projects during his final years, and della Porta became the cleanup man, faithfully executing the master's designs for Palazzo Farnese, the Campidoglio, and now the Basilica of St. Peter.

According to the records in the Fabbrica archives, on the recommendation of Michelangelo's friend Tommaso de' Cavalieri, della Porta was named architect of St. Peter's on May 12, 1574. The Basilica progressed rapidly under his direction. Della Porta tore down the old Rossellino-Bramante tribune and rebuilt the west apse to conform to the other arms. He completed the large northeast corner chapel, called the Chapel of St. Gregory for Pope Gregory XIII, and raised the first of the minor domes over it. Then he broke

ground for a corresponding chapel in the southeast corner. In June of 1584, the Fabbrica reported, "The Church of St. Peter is growing on every side."

By 1588, della Porta had successfully completed more of the Basilica than any single architect, and he had never deviated substantially from his teacher. But on this June morning, he was proposing an extraordinary exception—a new Basilica dome, radically different from both Michelangelo's and Bramante's.

∞

When he died, Michelangelo "left his soul to God, his body to the earth, and his goods to his nearest relatives." Those goods included more than eight thousand ducats tied up in handkerchiefs and small bags and stashed in various places—a polished walnut box, a copper vase, and a majolica jug—as well as a variety of household items, including an iron bed with a white linen canopy, a kidskin blanket, and an assortment of linen and clothing. But his true last will and testament was the fifteen-foot scale model of the dome of St. Peter's, fashioned from limewood on a ratio of 1:15. Michelangelo had built the large model in his final years so that, in the event of his death, the Basilica dome would be completed exactly as he had intended.

Every pope since Paul III had sworn a solemn vow to continue Michelangelo's work precisely as he had ordained even after his death. Awed by his talent, intimidated by his genius, and bound by their promise, the popes became paralyzed. How do you follow genius? No one had been able to build the dome to Michelangelo's precise specifications or dared to suggest another plan. Twenty-two years later, the Basilica drum still loomed over the city like a headless giant—overgrown, neglected, moss and wildflowers sprouting in the window frames.

Michelangelo was a legend in life, and in death he had become one of the immortals. If artists were canonized for their talent, he

would be seated at the right hand of God. Della Porta was an experienced, competent architect. He did not pretend to have the gift of his teacher, yet he had not simply modified Michelangelo's dome, he had redrawn it.

Now he and Fontana were laying a huge paper cutout of the new dome on the sanctuary floor of St. Paul's. The large open space was removed from the distractions of the city, and looking down from the adjoining choir at the cutout spread on the pavement, a layman like Sixtus V could picture the cupola clearly.

Della Porta was not easy with this new pope. The architect was a genial, easygoing man of ample appetites. He liked the good life—good food, good wine, good company, all in abundance. Sixtus was a fierce taskmaster, driven and driving. He had no patience with jobs unfinished or problems unsolved, and he wanted to see Michelangelo's dome rising triumphantly. In his determination to complete the Basilica, he had made the Fabbrica a congregation within his reformed Curia, renamed it somewhat grandly La Congregazione della Reverenda Fabbrica di San Pietro, and given it the means, the authority, and the money to get the job done.

Now, framed in the arch of the choir with the cardinal administrators of the newly organized congregation pressed around him, Sixtus appeared like a white staccato note in a field of red. Pushing the others aside, he leaned over the rail for a closer look.

For the entire century, ever since Bramante had drawn his first smooth saucer shape, the dome had posed a challenge: Could it be built? Could the piers bear its weight—even strengthened and reinforced several times so that now they were 240 feet in circumference, eight feet thicker than Bramante had made them?

Della Porta's reasons for altering the dome were practical, but even with his changes, the challenge was enormous, and success was not foreordained. In the ambivalence of a summer morning, he waited nervously for the pope's reaction, bowing humbly one

moment, then straining the next to read the expression that clouded the papal countenance. Della Porta anticipated many questions from the former grand inquisitor. He expected the pope to consider the design over several weeks and confer with his cardinals, but Sixtus was as decisive in this as he was in all things. He asked only one question: How long will it take?

There was no way to predict with certitude. The last time an undertaking of such magnitude was attempted in Rome had been 1,450 years before, in the reign of the emperor Hadrian, when the dome of the Pantheon was raised.

How long will it take if all goes well, with God's help and no complications? Della Porta estimated ten years. Sixtus allowed him thirty months, and promised all the money and men he needed.

The architect must have tried to protest. Or he may have been so stunned that all thoughts and words emptied from his mind, and he stood speechless, staring at his own bold drawing. He could not deny or contradict the pope, and there was no common ground between them. He must have wanted to throw up his hands and curse such a ridiculous decree. Ten years, and he was being optimistic, a courtesy because the pope was an old man and dogged in his insistence on seeing the dome in his lifetime.

Rome was not built in a day, and neither was its church. It had taken Bramante seven years to set the piers, and then they had to be strengthened twice. It had taken Michelangelo seventeen years to build the drum, and now the pope was giving him, Giacomo della Porta, a mere mortal, not a genius, not divinely gifted, thirty months. It was a *scherzo malevolo,* "a black joke."

Della Porta must have appealed to Fontana to point out, with humility, the utter, utopian madness of imposing such a timetable. Fontana was one of the few in the Vatican who enjoyed an easy relationship with the pope, and he knew better than to argue. Sixtus was in failing health. Death was more than a shadow. It was a proximate

reality. He was determined to restore the city, and even more determined to see the dome of St. Peter's raised in his lifetime.

In the summer of 1588, as the Spanish Armada sailed toward Britain to regain England for the Church, della Porta began to raise the cupola. The construction yard in front of the Basilica teemed with masons, stonecutters, bricklayers, cement mixers—as many as eight hundred laborers. There were no siestas, no dinner breaks. The work was continuous night and day, every day, with only an hour of quiet for Sunday mass. In the wicked heat of the Roman summer, bolts of sun-bleached canvas stretched across the building site. The stench of manure from the mules and oxen that lugged the wagons, the rumble of the carts, the shouted orders, the belch of the forges, were ceaseless, and nights seemed louder than days because the din of the city quieted.

Bramante had analyzed the techniques of the ancient Roman architects. Michelangelo had sent to Florence for the measurements of Filippo Brunelleschi's cathedral dome. But each step in the construction was an experiment—a process based on a mix of imagination, guesswork, intelligence, and experience.

Over time, every aspect of the dome—its slope, contour, rise, and angle of elevation—had changed. Bramante's shallow hemisphere was a horizontal, saucer-shaped dome—a single shell of cemented masonry on the model of the Pantheon's. Antonio da Sangallo's dome was a tiered wedding cake. Michelangelo's rounded dome brought elements of Brunelleschi's Duomo in Florence to Bramante's Pantheon.

One of the most impressive constructions of the Renaissance, Brunelleschi's dome had taken sixteen years and enormous ingenuity to raise. It was the only model on a scale comparable to the Basilica dome, and Michelangelo borrowed several elements from it—the two shells, the ribbed construction, and the windows in the drum and cupola.

Double shells offered the advantages of a protective shield

against the weather and a heightened, more visible profile. Della Porta's dome was also double skinned, but far bolder. While his inner shell retained Michelangelo's rounded contour, the outer shell that fills the sky over Rome diverged radically. Separating from the interior skin, it rises at a steep angle, changing the emphasis from a disk to an ellipse.

Della Porta's concerns were not purely, or even primarily, aesthetic. He believed that the higher, more pointed shape would disperse the weight and lessen the lateral thrust. Later science would support his theory. An elliptical arch generates as much as 50 percent less radial thrust than a hemispherical arch.

Physics was in its infancy, and as late as the sixteenth century, architects and engineers did not understand the science of statics and equilibrium—the engineering principles underlying the design of a stable structure. They knew, for instance, that walls had to have a certain thickness proportional to their height, but not the precise ratio of one to the other. The most basic analyses—how to determine the stability of a site or measure the thrust of an arch—were conjecture.

In essence, a dome is a series of arches, and conventional wisdom held that the semicircular Roman arch directed the thrust down into the piers, abutments, and foundation base. Architects knew that an arch exerted a thrust that had to be either balanced by another arch or absorbed, and that the mechanics of a dome are similar to those of a barrel. Both have a natural tendency, called hoop tension, to burst out. Still, calculations were often erroneous.

An architect like Bramante, constructing a monumental edifice on the scale of St. Peter's, had very little true understanding of the forces of physics involved—stress and strain, action and reaction, statics and tension. The surprise is not that the bell tower of Pisa listed or that the Gothic cathedral of Beauvais collapsed but that so many marvelous buildings have stood for so long. The principles of stable construction were not understood clearly until Galileo

formulated the laws of mechanics and applied them to architecture.

Raising a dome of such monumental scale was an experiment never before attempted. The base of the drum began ten feet above the height of the oculus of the Pantheon, and if its construction were accomplished, the dome of St. Peter's would be the equivalent of a ten-story building placed on top of Brunelleschi's dome.

As the vaulting rose over the Basilica, how many times in the long nights of construction must della Porta and his masons have woken up in a cold sweat? Were the foundations deep enough? Would the drum hold the massive weight? Should they diminish the thrust of the cupola? Many prayers must have been offered and fervent promises made to God, to the Blessed Mother, and to St. Peter at each step in the precarious construction.

Michelangelo had intended the pilasters of the drum and the ribs of the cupola to act as buttressing forces. But by increasing the angle of elevation so radically, della Porta reduced those elements to little more than ornamentation. His heightened cupola is an almost perfect catenary curve. All its parts should support one another by their own weight, allowing it to hang freely between its two points of support in perfect equilibrium.

Della Porta formed the shells almost entirely of heavy masonry laid in a herringbone pattern. Frequently used by the architects of ancient Rome, the method of fitting bricks together in an inverted V design applies pressure equally from both sides, preventing hoop tension. The two shells spring from the attic as a single form for almost twenty-eight feet before they begin to diverge. As they separate, the space between them forms a third element that affords both ventilation and access. Sixteen ribs, corresponding to the sets of pilaster-framed windows in the drum, start at the point of departure. They divide the cupola into sections, creating a frame or skeleton. Carved at the base of each rib are three mountains, the symbol on Sixtus's papal crest. The ribs are uniform in width and

extend through both shells, curving inward and tapering as they ascend, gradually increasing in depth as the distance between the shells widens, until the thickness is almost double.

Three rows of small eye-windows pierce each section, bringing more light into the interior dome and illuminating the vaulting. A team of masons worked on each section, constructing the shells simultaneously. The two skins begin as a solid, almost ten feet thick. At a height of just under twenty-eight feet, they start to separate, diverging gradually until there are ten feet between them at the apex.

To support the enormous weight and further counteract the outward thrust, three iron rings were forged in the Vatican foundry and fitted within the masonry—two in the solid mass of bricks where the curve begins, and the third midway to the apex. Like the iron bands around a wine barrel, the rings around the majestic dome of St. Peter's contain its tension. The larger iron rings weigh more than 18,000 pounds each, the smaller ones more than 16,500.*

By Christmas, the cupola was more than forty feet high and still rising. Romans were astonished. The oldest had lived their entire lives with the unfinished Basilica silhouetted against the western sky. It had become a dream with no reality. Children had grown up, had children of their own, and grown old, and still the Basilica stood unfinished. Now, all of Rome watched with mounting excitement and unconcealed wonder as the vista changed. Waking up each morning, they scanned the skyline. Sixtus watched with the

*Even with the iron rings, significant cracks eventually developed around the dome's base. Mattia de Rossi examined them for Clement IX and found that the structure of the dome was sound. Carlo Fontana examined them for Innocent XI and reached the same conclusion. In 1743, Benedict XIV brought in Giovanni Poleni, a physicist at the University of Padua, who also saw streaky ruptures probably old and caused by a combination of factors: the weight of the dome, the process of structural setting, the materials used, and the hasty construction. He proposed adding two more iron rings as a safety precaution.

rest of the city and received regular progress reports. As long as the dome was proceeding, he didn't meddle.

In the rush to meet the pope's schedule, della Porta pressed forward in fair weather and foul. His men labored through the summer, working at heights of more than two hundred feet, exposed to the broiling sun. Ingenious time-saving measures were sometimes called for. Once when an extra container was needed for water, a mason commandeered the sarcophagus of Innocent VI and used it as a trough. Rather than waste time descending and ascending again, the workmen took their midday meal high in the air, and some days were so hot that the cheese in their meal bags melted on the bread and the wine mulled in their kidskin flasks.

In autumn, they huddled in the passageways within the walls of the drum and waited out the rains that come in sudden, short drenchings in Rome, then went back to work. When lightning flashed, it seemed close enough to singe their beards, and when winter blustered in, the wind at such a height was a slashing knife. Scaffold castles rocked, and the men hung on, fingers stiff and blue, and in the blue distance they looked out on the Sabine mountains, and beyond to the *campagna*, the Alban Hills, and the sweet vineyards of Frascati. They looked out so as not to look down.

The men and stone and furnaces below were blurred spots before their eyes, and they tried not to remember the iron band that had snapped on a scaffold, setting in motion a fatal chain of cause and effect—the scaffold castle tilting, one triangular leg slipping off the attic, and a mason dangling over the vast construction, his mouth wide open, the wind swallowing his voice. He floated over the Basilica, caught on a thermal, before tumbling in free fall, gathering speed. Against all odds, the men kept climbing the infinite height each day, and each month the cupola rose another seven feet.

Conceived in the fall of 1505, the dome of St. Peter's was completed eighty-five years later. Such a magnificent architectural achievement would seem to require calm deliberation and slow, careful construction. But the dome was raised in a hurry—or more precisely, in several intense, often incautious bursts of feverish work by old men racing against their own mortality—Bramante setting the foundation piers that made the Basilica his own, Michelangelo approaching his eighty-ninth year and staving off death to assure that his dome would crown the mother church, Sixtus V holding his architects to a frenzied schedule, twenty-four hours a day seven days a week, only allowing a break for Sunday mass.

Finally, on May 14, 1590, as the Basilica choir sang the *Te Deum* and Sixtus gave thanksgiving, the final stone, carved with his name, was set. A week later, on May 21, the indomitable pontiff issued a formal announcement: "To the perpetual glory of His Blessedness and the discomfiture of his predecessors, Our Holy Father Pope Sixtus V has completed the vaulting of the cupola."

The dome of St. Peter's was raised at last, not to the design of Bramante or Michelangelo but to the specifications of the unsung hero of the Basilica story, Giacomo della Porta.

In architectural renderings, Bramante's hemisphere feels earthbound, flattened over a vast diameter. Michelangelo's globe seems aspiring, as if it is reaching toward heaven, recalling the hope of salvation. Della Porta's dome seems not to rise from below but to be suspended from on high, brick and mortar and iron rings freed from the gravity that holds us earthbound. Visible from every point in the city, his dome is inescapable. It is the symbol of both the city and the Church of Rome, dominating the Roman skyline and proclaiming the faith: *Cristos aristos.*

Instead of the thirty months allowed by Sixtus, della Porta and Fontana had achieved the impossible with time to spare. They had raised the highest dome ever built in just twenty-two months.

Dwarfing every other construction, it soared 438 feet and spanned a 138-foot diameter. The dome of St. Peter's is three times the height of the Pantheon dome, more than twice the height of the Hagia Sophia dome, and 100 feet higher than the Duomo in Florence.*

Three months later, Sixtus V died. True to his name, he was a happy man, his deepest desire fulfilled. Inscribed around the eye of the cupola that he pressed to completion is the legend: "This dome was built for the glory of St. Peter by Sixtus V."

∞

Over the course of his five-year pontificate, Sixtus spent one million ducats on building. Unlike other popes who were big spenders, he left a city and a church to show for it. But Sixtus was so formidable that perhaps no one could fill his shoes. The three popes who followed him—Urban VII, Gregory XIV, and Innocent IX—each died within a few months of their election. Unaffected by their presence or their passing, della Porta persevered.

He faced the cupola with thin slabs of travertine, coated it with a protective lead covering, and bronzed the ribs. In 1591, he completed the lantern. Although it carried through the pattern of windows and buttresses from the dome, in concept and proportion it was very different from Michelangelo's design. Della Porta's lantern was low, to conform to the elevated cupola, and surrounded with a row of candles, or finials. A copper ball and bronze cross were added in successive years.

Forged in the Vatican foundry, each is immense. The ball, or *palla*, is eight feet in diameter and weighs 5,493 pounds—sixteen people can stand inside it. The cross is sixteen feet high and holds

*St. Peter's Basilica was the largest church in the world until 1989, when it was surpassed by the Church of Our Lady of Peace in the Ivory Coast.

two lead caskets within its arms, one filled with relics, the other with Agnus Deis, wax medallions made after Easter from the paschal candles and imprinted with the image of the Lamb of God.

Palla and cross were hoisted to the acme of the Basilica by a series of pulleys and positioned on top of the lantern. The cross was raised in a single day—November 18, 1593. Including the cross, ball, and lantern, more than 616,000 tons rest on Michelangelo's drum, and the height from the ground to the tip of the cross is 452 feet.

When each element of the dome was finished, della Porta redesigned the two minor domes to correspond with the central cupola. By then, he was working for his sixth pope—Clement VIII. In his first years as *capomaestro*, della Porta had built the large northeast corner chapel for Gregory XIII. Now, in his final years, he built the corresponding southeast corner chapel for Clement. At the same time, work began on the interior decoration of his dome.

Given its extraordinary height, every element had to be enormous to be visible. A frieze of purple-blue letters, each six feet high, circles the lower rim of the cupola on a broad band of gold, spelling out the words: *Tu es Petrus et super hanc petram aedificabo ecclesiam meam et tibi dabo claves regni caelorum*—"Thou art Peter and upon this rock I will build my church and I will give to you the keys of the kingdom of heaven." To fill the interior of the dome, Giuseppe Cesari, an extraordinary mosaic artist known as Cavaliere d'Arpino, began a series of cartoons. His mosaics are so huge that the pen that St. Luke holds in one of the panels is eight feet long.

Although it would take many more years for d'Arpino to complete the mosaics than it had taken della Porta to raise the dome, the tumultuous century of construction was over. Giacomo della Porta died in 1602, believing that he had brought the new Basilica of St. Peter to the point of completion.

A NEW CENTURY

❧

B attered but unbowed, cleansed of the brilliant, scandalous
excesses of the Renaissance, the Church of Rome entered
its sixteen hundredth year sanitized and set on a straight
and narrow road. Its housecleaning complete, the edifice buffed
and gleaming, the Church recast itself. What it had lost in political
power, it gained in moral authority.

The Counter-Reformation Church had slowed the momentum
of Protestantism and reaffirmed its mission, creating a new Church
for a new century. Three million pilgrims thronged Rome for the
Jubilee of 1600. A reorganized and reformed Curia set the standard
for efficient government. Moral and ethical standards were de-
manded of the clergy, and missionaries brought the faith to Asia
and the Americas.

In the new century, the Holy Father emerged as the exemplar of
the new and improved Church. No more mistresses in the papal
apartments, illegitimate children showered with benefices, or fami-
lies made wealthy. No more war parties or papal bulls discharged
like cannon fire. The pope became the model of the blameless
Christian life. It was quite a change from the Renaissance popes
and even from Peter, the flawed Everyman.

A mere fifty years after its unity fractured, the Catholic Church

was reborn, more confident than ever, but increasingly closed. The resurgent Church became cautious, not humble. Orthodoxy became paramount. What was lost was not munificence but magnanimity— that largeness of spirit that made anything possible, that allowed every voice and every cockamamie idea to be aired. The church that had invented the term *devil's advocate* to raise intellectual challenges became leery of open debate. That is, perhaps, one of the lasting legacies of Protestantism.

Still, the Church flourished, and the city flourished with it. By 1600, Rome was the third-largest city in Europe, surpassed only by Paris and London, and the Church of Christ was more distinctly than ever the Church of Rome. Although its embrace was universal, its soul was Latin, and it was expressed in an exultant new art. The resurgent Church gave Rome the Baroque. It was a heavenly marriage.

Like the city and its people, the new art was emotional, sensual, and unrestrained. Renaissance art was intellectual, intended to be appreciated by the ennobled few and instructive to the rest. It taught but it didn't touch the illiterate masses of faithful Christians. The romance of the Baroque was an unabashed appeal to the emotions. In its graphic displays, the agonies and ecstasies of saints and martyrs and the sorrow and sweet solace of the Virgin Mother, deplored by Luther, became potent visual narratives that everyone could read.

Where the Protestants rejected Mary, the Church of Rome made devotion to her a cult. Where the Protestants attacked miracles as hogwash and black magic, the Roman Church enshrined relics in the four piers of the new Basilica. The Protestants had denied the authority of the pope and chastised Rome for its ostentatious wealth, and the Church had countered by forging ahead with the most audacious statement of its supremacy, the new Basilica of St. Peter. In the spirit of the Counter-Reformation, the Fabbrica

reconstituted itself. Once Sixtus made it a congregation, it accrued greater authority and greater accountability. Vastly different from the committee that Michelangelo had deplored and steamrolled, the Fabbrica now established offices in many cities to collect and handle contributions and legacies earmarked for the Basilica. It arbitrated disputes relating to the building—settled legal issues, probated wills, and the like—and supervised the final phase of construction.

∞

Today, the Fabbrica is housed in the upper realms of the Basilica, far above the tomb of Peter, in two spacious octagonal offices, each with a graceful cupola. Known as the *ottagoni*, they were probably the workrooms of the last great architect of St. Peter's, Gianlorenzo Bernini. Equipped with recessed lighting, climate control, and computer banks, the *ottagoni* are lined with more than 2,400 feet of glass-fronted metal cabinets containing the full archival history of the Basilica.

Stored in bound volumes, boxes, folders, and packs of documents are a day-to-day record of the gradual destruction of Constantine's basilica and the often agonizingly slow progress of the new construction. Registers and receipts detail expenditures for material. Account books, contracts, and bills of authorization spell out the payments to architects, artists, and workmen. Other files contain reports and legal documents pertaining to wills, disputes, gifts, and the like. There are lead and wax seals used to stamp papal bulls, edicts, decrees, parchments, and letters from the architects.

The Fabbrica not only preserves the history of the Basilica, it maintains the physical building with all its art and treasure, and oversees a unique corps of maintenance workers. Known as the Sampietrini, the corps was conceived as the Basilica neared completion. At the start of the new century, realizing that maintaining

such an immense construction could not be left in the hands of casual laborers, an illiterate mason recruited thirty workers skilled in the various building trades and decorative arts. They made St. Peter's their lifework, and in turn, trained their sons.

Over time, the Sampietrini became a unique hereditary force with particular rules and customs. Still operating today from shops concealed in the depths of St. Peter's, they travel through the cavernous chambers and narrow twisting stairways within the walls to reach the most dizzying heights. Like circus acrobats, they balance on cornices and capitals, run along the dome and lantern, squat on the heads of the giant statues, and hang from the soaring vaults.

Their ancestors, the original Sampietrini, were the masons, carpenters, painters, stuccoists, glaziers, and gilders who worked with the master of the Baroque to transform the very stones and mortar that had sparked the Reformation into the transcendent symbol of the Roman Church.

THE KNAVES OF ST. PETER'S

∞

In the first decade of the new century, near the gentle slope of the Pincio, Rome's eighth hill, twenty-seven-year-old Scipione Caffarelli Borghese, newly elevated to cardinal, was breaking ground for a beautiful park and charming palazzetto. Strolling through the gardens today or visiting the villa, now a museum, you might assume that Borghese is an old and noble name. By Roman standards anyway, the Borgheses were parvenus—an undistinguished family as recently as the Cinquecento. In those free-and-easy, pre-reform days, the Borgheses sought to better their lot by purchasing a venal office in the Curia.

Investing in Curial positions was a lucrative business. Families of modest means hoping to improve their status often begged, borrowed, and gambled their future to secure a post for an eldest son. If a young man was smart and shrewd, it was the first rung up the Curial ladder. After working in a venal office, he could sell it, often for a higher price than was paid, and with the profit, buy a better job.

For all its faults, the Church was a leveler. No special pedigree or piety was required to be pope, and the same was true for the men who worked under him. Curial jobs were open to all. Money might buy your way in the door, but brains and talent assured advancement.

Church patronage served a variety of purposes, some of which, at first glance, seem incompatible. It was a means for powerful families to further entrench themselves. It was also a way for families of modest means to move up in the world.

The Borgheses scrimped, mortgaged their meager worldly goods, and bought the office of auditor of the Apostolic Chamber for the eldest son, Oratorio. No sooner was the transaction completed and Oratorio ensconced in the Curia than the family was threatened with ruin. Before any rewards could accrue to the Borgheses, Oratorio died.

Faced with financial collapse, the family appealed to the cardinal-chamberlain, who gave the position, bought so dearly, to the second son, Oratorio's brother Camillo. Few employment opportunities have had more lasting repercussions for St. Peter's Basilica, and few family gambles ever paid off as handsomely.

Camillo Borghese rose through the Curial ranks to become Pope Paul V. A stocky man, with a closely trimmed triangular beard and the stolidness of a prosperous burgher, Paul was a model of propriety. He was prudent, practical, and a paragon of most of the virtues that the Counter-Reformation deemed essential for advancement in the Church, but he had one conspicuous sin: nepotism. Perhaps because his family had risked so much, he could not resist lending a helping hand. His generosity made the Borgheses one of the most illustrious families in Rome.

While construction proceeded flawlessly on his nephew's villa, construction of St. Peter's halted abruptly. Except for the eastern apse and façade, the exterior of the Basilica was virtually finished, and anticipation was high throughout the city. Romans expected the new pope to consecrate St. Peter's at last. Instead of setting a date for the long-awaited ceremony, though, Paul called in the cardinals of the Fabbrica and sent them back to the drawing board.

He had several reservations about the Bramante-Michelangelo-

della Porta design nearing completion—most notably its shape and its size. Paul dismissed the aesthetic and metaphorical concerns that had impelled the architects and their patrons. The Greek cross was Byzantine, he said—too obvious a reminder of the Orthodox schism at a time when the Holy See was recovering from the Protestant defection and redefining itself as the Church of Rome. Paul had practical concerns as well. The four equal arms would not accommodate the large crowds that attended the liturgical services, canonizations, and feasts; reduced in size by Michelangelo, the new Basilica did not even cover all the hallowed ground of the original.

In 1607, after much deliberation, Fabbrica officials proposed a competition to redraw the plans. The challenge was huge. The winner had to redesign a building that had already taken one hundred years, cost many fortunes, and was virtually complete. Even more daunting, he would be tampering with Michelangelo's final creation.

Five popes had given Michelangelo carte blanche and had refused to alter a stone in his plan. It was shocking enough that della Porta had redesigned the dome of "the divine Michelangelo." Now the Basilica beneath it was about to change, as well.

In 1607 when the contest was announced, Constantine's church was still being used, protected from the construction site by Sangallo's dividing wall. More than 160 years after Alberti warned that its condition was dangerous and 100 years after Bramante began to raze it, about a fourth of the old church remained standing—the atrium, porch, and part of the nave. The hazard it posed was acute. The walls of the nave had cracked and were leaning in some three and a half feet from top to bottom. The wooden rafters and roof were on the verge of collapse. The situation had become urgent in 1605, when a large chunk of marble dislodged from a column and nearly crushed pilgrims at prayer, who ran screaming into the piazza.

Paul signed a final decree ordering the last of Constantine's

church torn down immediately. Protesters, as vociferous as those who had denounced Bramante as il Ruinante, filled St. Peter's Square. The final demolition proceeded slowly and with great care over three years. On November 15, 1608, the last mass in Constantine's basilica was celebrated, then workmen brought down the huge wooden beams, three feet thick and as long as seventy-seven feet. Still discernible on one massive truss, rotted by age and gnawed through by rats, were the letters CON.

While the old basilica was disappearing, nine artists submitted plans to redraw the new Basilica, a third of them from the same family: Domenico Fontana, his brother Giovanni, and their nephew Carlo Maderno.

Maderno had started working on the Basilica as a stonecutter and learned various trades. Now at fifty-one, he beat his elderly uncles and won the competition to reinvent St. Peter's one last time. A carpenter named Giuseppe Biancho made a wooden model of Maderno's extension. It was last seen in 1667, in a storeroom with older models made by Bramante and Michelangelo. All have disappeared.

To convert the Basilica to a Latin cross, Maderno added three bays to the eastern arm, extending it by almost two hundred feet. Maderno respected Michelangelo's plan and diverged from it so seamlessly that the three additional bays don't feel grafted. They seem to extend organically from Michelangelo's cruciform and draw attention to it. When you stand in the nave, the Basilica spreads out before you.

For his new bays, Maderno retained the same titanic internal order of Corinthian pilasters, the arches, barrel vaults, and coffered ceilings. Thirty-two marble columns formed a path leading to the transept crossing. The appearance of the long nave was simple and dramatic. Granite aisles rose from a brick wall. Stucco pilasters

stood on travertine bases. The elaborate marble and mosaic were added much later.

Because of the length of the nave and its distance from the outer walls, lighting posed a challenge. Maderno opened lower windows and perforated vaulting to allow more light into the nave, and sloped the portico roof to allow light from the upper windows to enter.

While the nave was taking shape, construction started on the façade. On November 21, 1610, thirteen horses drew the first column into place at the main doorjamb. Because of its huge size, ninety feet tall with a nine-foot diameter, the haulers probably used the same oak winches that had raised the obelisk to lift the first column into place. Satisfied with the job done, Maderno gave the men a deposit for the remaining seven columns.

Maderno's redesign was strikingly similar to Raphael's plan a century before. Both artists proposed a Latin cross with a wide façade flanked by bell towers. Higher, showier, and more ornamental than Michelangelo's portico, Maderno's façade is wide and columned—three stories high plus an attic. The imposing façade is 375 feet wide by 167 feet high from the ground to the attic and balustrade. In the center of the portico, directly above the new nave and equal to it in width, is the Benediction Balcony, a dramatic loggia from which the pope blesses the city and the world—*urbs et orbis*—the purview claimed by the Roman empire and the Roman Church. Christ and his apostles, each nineteen feet tall, stand in heroic proportions over the five entrances.

On May 16, 1612, Maderno closed the last vault of the portico. Fireworks lit up the skies over Rome, and word went out to every bishopric across Europe. Church bells pealed and Catholics offered prayers of thanksgiving. Although construction of the bell towers would not begin until autumn and the interior embellishment would go on much longer, after 165 years of planning, a century of

construction, and too many false starts to count, the body of the Basilica appeared finished at last.

But one integral element was missing—a suitable approach to the grave of St. Peter. From the first stone, the new Basilica had risen to enshrine the bones of the apostle. The altar and dome formed a direct line above the crypt, and because Peter was the "confessor of faith," the whole was called il Confessio di San Pietro.

Paul announced a second competition to design a Confessio, and the winner was again Maderno. To point the way to the underground chapel and grave, Maderno formed an entranceway in front of the papal altar. A double flight of marble stairs from the altar curve left and right, then come together at the door of the crypt.

❧

Maderno labored on St. Peter's for twenty years and has been excoriated for five hundred years. Criticism began while the foundations of the nave were being laid. Maffeo Barberini, a newly elected cardinal who would become the next pope, took issue with Maderno's solution. His criticism ranged from the most particular—the kind of flower carved on the capital of a column—to the general principle of the Latin cross.

Although Barberini was appointed to the Fabbrica congregation too late to effect any substantial change, criticism of Paul V and Maderno continues to this day. The pope who had the audacity or foolishness to think he could improve on Michelangelo's design and the architect who committed the affront are often cast as the knaves of this creation story. But given the inflexible parameters set by Paul V—a Latin cross that covered the same ground as the original church and would accommodate great crowds—Maderno imagined a subtle solution. He gave the Basilica an interior space that holds fifty thousand people and a dramatic entrance.

A façade is always tricky. It is a two-dimensional form imposed

on a three-dimensional space, and so it is inherently problematic. Maderno's façade is considered too wide in proportion to its height. But the arched openings at either end that create this impression were begun as bell towers. Construction of the campanili, which had reached the height of the Basilica attic, stopped when Paul V died in 1621.

Maderno's statues of Christ and the apostles that top the façade are also denigrated as grandiose and distracting. But no element of his design provokes louder lamentations than the nave. Although it may have been a practical imperative and an artistic compromise, Maderno's extension ruins the view of the dome from the piazza. The dream of Bramante, the marvel of Michelangelo, the achievement of della Porta, is blocked by Maderno's elongated nave. The full splendor of the Basilica dome can only be appreciated from a distance.

Both the Borghese pope and his Mannerist architect died before the Basilica was consecrated. Although their legacy has been debated ever since, they acted decisively and brought the grand enterprise to its conclusion. In case anyone forgets, incised across the portico in five-foot-high letters is a reminder: IN HONOR OF THE PRINCE OF THE APOSTLES PAUL V BORGHESE BY NAME SUPREME ROMAN PONTIFF 1612 SEVENTH YEAR OF HIS PONTIFICATE.

Camillo Borghese had made the most of his serendipitous career.

1,300 YEARS LATER

❧

On November 18, 1626, thirteen hundred years to the day after Pope Sylvester I dedicated Constantine's church, Urban VIII consecrated the new Basilica of St. Peter. A row of cardinals in crimson cassocks and skullcaps, banked on each side of him like walls of flames, stood at solemn attention. Clouds of incense wafted over them and dissipated in the immense dome. The construction yard had been tidied for the occasion, the square swept clean, and long horizontal canopies of canvas extended from either end of the façade like the tails of the papal miter.

All of Rome turned out for the ceremony, just as it had when Julius II laid the first stone on that memorable April Sunday in 1506. Noble Roman families and Vatican bankers resplendent in the finest silks and brocades, the Swiss Guard halberd-straight and striking in their striped uniforms, the entire Curia, dignitaries, ambassadors, and legates from the courts of Europe, conquistadores back from the New World, artists and architects, stonecutters and carpenters, gilders and artisans of every kind, filled the nave of Maderno. They pressed against the piers of Bramante and crowded under the dome of Michelangelo and della Porta.

They came in carriages and cavalcades, intense young aspirants to the Society of Jesus in their black soutanes, Franciscan friars in rough brown habits, cinched at the waist with hemp, who had walked from Assisi, cowled Benedictines from as far south as the Abbey of Monte Cassino, princes and peasants, saints and sinners, clerics and laity. They streamed through the five doors and pushed into the aisles of the Basilica. The overflow crammed into the open square around the obelisk and jammed the surrounding streets.

Turning to face the throng, Urban VIII intoned the apostolic blessing, consecrating the new Basilica of St. Peter. It was a Roman holiday. .

Bells pealed from every church in Rome, and those who couldn't attend in person paused in their homes and fields, in their shops and ateliers at the first chime. They looked to the west where the dome of all domes hung white on blue in the clarion day, and made the sign of the cross.

<div align="center">∞</div>

For sheer size, the building was a marvel. It was so high that the entire Pantheon could fit beneath its dome, and it covered an area so large that Notre Dame of Paris and Hagia Sophia in Istanbul could both fit inside it with room to spare.

Michelangelo had imagined a pure interior, the architectural space and articulation uncluttered by decorative embellishments, the porous and pockmarked travertine defining the space and giving the Basilica strength and transcendence. But infinitely patient artisans of mosaics and gilt were dressing the interior in a sumptuous display.

Since Nicholas V, twenty-seven popes over a span of 178 years had imagined this day. They had already spent 46,800,052 ducats*

*Innocent XI commissioned Carlo Fontana to produce an illustrated account of the construction story. In his book, Fontana noted the cost. Worried that the mention of

and paid an incalculable price—the Basilica of St. Peter had cost his successors the unity of the Church. And still the building was not done. The basic construction was complete, but the last genius to put his signature on the Basilica was just beginning his work.

such a huge price tag would provoke more criticism from the Protestants, the pope suspended publication. The book was issued in 1694 by Innocent XII.

BERNINI'S GRAND ILLUSIONS
1623–1667

With arms wide open to embrace
The entry of the human race

—Robert Browning

THE ROMANCE OF THE BAROQUE

∞

Eight years after the dome was raised, a child was born in the southern port of Naples who would become the last great architect of St. Peter's. Gianlorenzo Bernini inherited his looks from his mother, a southern beauty, and his dexterity with a chisel from his father, a Florentine sculptor. His genius was uniquely his own.

Bernini was ten when he visited Rome for the first time. His father, Pietro, a favorite artist of Paul V, introduced his son to the pope. Gianlorenzo was an elfin boy with black-olive eyes, a crown of black curls, and the face of an angel. The pope was charmed and he asked the boy to sketch a portrait. The young Bernini remained thoughtful for a moment and then asked Paul whether he wanted a portrait of a man or a woman, a youth or an old man, and with what expression—sorrowful or happy, disdainful or pleasing? The precocious boy soon gained two eminent cardinal-patrons—Paul's nephew Scipione Borghese and the wealthy intellectual Maffeo Barberini, who urged Bernini not to concentrate exclusively on sculpture but to study architecture and painting as well. At the age of twenty, the prodigy was working on his first papal commission, a portrait of Pope Paul.

Bernini was brash and young, with all the flaws inherent in such

a combination. Extreme talent at such an early age is often a flash in the pan, but his gifts deepened. Older artists resented him. Contemporaries despaired of surpassing him.

Like the artists of the Renaissance, he was a man of many talents. An English diarist, visiting Rome in 1664, wrote: "Cavaliero Bernini, Sculptor, Architect, Painter & Poet... gave a Publique Opera (for so they call those Shews of that kind) where in he painted the Seanes, cut the Statues, invented the Engines, composed the Musique, writ the Comedy, and built the Theater all himself."

Bernini had a charismatic personality and swashbuckling good looks. In a self-portrait, he pictures himself with flowing black hair, a devilish mustache with the ends curled and waxed, and a narrow, affected goatee. It is the portrait of an actor who relishes theater.

The Baroque infused art with theater, and Bernini was its master. He personified the Baroque, as the Baroque mirrored the man. His genius gave it a distinctive style. You are hard pressed to find a flat plane or straight line in any work of his. His art is all light, shadow, and movement—curvaceous, sensual, and whimsical. Theatricality is integral to Bernini's art and to the Basilica of St. Peter.

❧

Religion is illusion. No institution understands that more profoundly than the Church of Rome. More than tenets and ethics, religion is mystery and magic, the ultimate conjuring act, body and blood from bread and wine. And the gleam of gold, the clouds of incense, the remote elevated person of the pope, the sacred art and evocative music, create that illusion. Stripped bare of all but its dogma, it would be exponentially reduced. Just as religious belief requires both reasoned argument and a leap of faith, so its practice requires both truth and illusion.

Rarely, if ever, can the spirit be reached and released by intellect

or engineering alone. Religious faith comes through the heart to the head. It causes sinners to repent, the proud to humble themselves, and the powerful to bow to a higher authority. Emotions and imagination make zealots, saints, and martyrs out of clay-footed mortals.

The Baroque is to art what opera is to music—the elevation of pathos; a spectacle of color, emotion, and drama; fantasy rising to frenzied ecstasy. Bernini's Baroque was art designed to serve religion, and more specifically to serve the needs of the Counter-Reformation. Whether it was contrived to meet a clear purpose or whether it was a spontaneous expression, it fulfilled the mandate of the resurgent Church. The static perfection of the Renaissance was the art of the elite. The hot, intense Baroque was art to move the masses. It was popular art in the truest sense—cinematic special effects without a camera lens.

Bernini is the grand illusionist of the Basilica story. In art and architecture, he believed that the lie was more beautiful than the truth, camouflaging or concealing as it does the underpinning play of physics and statics.

Bernini was twenty-five, as young as Raphael had been when his patron Maffeo Barberini became Pope Urban VIII. Before the sun had set on the new pope's consecration day, he called Bernini to service. "It is your great good luck, Cavaliere," Urban said, "to see Maffeo Barberini Pope, but we are even luckier that the Cavaliere Bernini lives at the time of Our pontificate." Their relationship was as intense as the one between Julius and Michelangelo, but considerably less volatile. Urban looked on Bernini as a son.

The first of the great Baroque builders and patrons, Urban VIII was himself a musician, poet, and scholar—a man of vast personal wealth and deep learning, at home among Italy's intelligentsia. There was neither the stern dominance of Sixtus nor the slight pomposity of Paul V about him.

Born Maffeo Barberini in 1568, the scion of a noble Florentine family, he was educated in Rome by the Jesuits. Barberini was a fiercely intelligent young man, in the vanguard of the arts and sciences. He enjoyed lively intellectual debate so much that one cardinal on his way to a papal audience quipped: "I don't go to the Vatican to obtain a hearing but to grant one."

Elected almost unanimously with fifty of the fifty-five votes of the College of Cardinals, on August 6, 1623, Urban was expected to return the papacy to the humanistic spirit of the Renaissance, turning it from the rigidity it had been forced to embrace to answer the Reformation. Through his patronage of art and science, he would engage the Church in the intellectual movements that were percolating in the early seventeenth century.

Urban VIII's ambition was to be as true and astute a patron as Julius, and in the precociously talented, alarmingly handsome young Neapolitan, he found his Michelangelo.

A clear line extends from the mature Buonarroti to the precocious Bernini. Both artists embraced the human body, Michelangelo its physicality, Bernini its sensuality, and for both religious art was an expression of personal faith. For all his cockiness, Bernini was sincerely religious. He followed the exercises of St. Ignatius Loyola, founder of the Jesuits, and took Communion twice a week. In some ways, he was Michelangelo's alter ego—the agony that tormented Buonarroti replaced with an ecstasy for life and art.

Bernini was not a solitary artist prey to doubt and anguish. He described himself as a virtuoso and lived his life at center stage, surrounded by family, patrons, and numerous assistants, who carried out his orders, drew his detailed plans, and realized his ideas. Bernini's architectural drawings are all quick sketches, dashed off to capture an idea, not to convey precise directives to masons and carpenters. Often he used his walls as notepads, grabbing a piece of

charcoal and sketching thoughts for a project as they came to him until he had exhausted the subject and satisfied himself. His imagination was always churning, constantly spinning out ideas, and the last, the freshest, always seemed the most exciting.

∞

When Bernini came to St. Peter's the structure was settled, but its spirit was his to shape. His first commission from Pope Urban was a Baldacchino or canopy to cover the Confessio di San Pietro. The twenty-five-year-old sculptor had never engineered a construction of any kind, and at first the pope did not give him a formal contract, perhaps waiting to see if his young protégé could meet the challenge. It was a baptism by fire. The Basilica nave was more than six hundred feet long and the height beneath the dome was more than four hundred feet. Anything less than monumental would be lost in such a huge space.

For his Baldacchino, Bernini proposed an immense four-columned canopied structure of cast bronze to contrast with the marble and travertine in the Basilica. He worked continuously for three years fashioning his ideas. He began with a small wax model; then, with his father's help, he created a series of larger prototypes in plaster and wood; finally, he erected a rough full-size model. Bernini trusted his eye more than any geometric measure, and he studied the perspective from various points in the nave and transept, altering and experimenting with each aspect of the design until he was satisfied.

He had two inspirations for his Baldacchino: the cloth canopy that protected the Holy Father when he was carried aloft in his *sedia gestatoria* (today replaced by the pope-mobile), and a twisted column salvaged from Constantine's basilica. According to legend, the column was the very one that Jesus had leaned against in the Temple of Solomon.

Bernini's first construction became a seven-year exercise in virtuosity. He chose Francesco Borromini to assist him and to carve the marble bases for the bronze columns. Borromini incised on the pedestals seven graphic scenes of childbearing, culminating in the smiling face of a baby to emphasize that suffering is rewarded with joy.

Casting metal was a complex process. In his celebrated autobiography, the Renaissance goldsmith and braggadocio Benvenuto Cellini described the procedure. First, he built a funnel-shaped furnace by digging a pit and lining it with bricks. Next, he suspended a mold over the pit and lowered it into the furnace. A fire was built up gradually and kept burning day and night until the mold was well baked. The type of wood chosen affected the process. Pine or alder burned slowly, while young oak produced the strongest fire. A mold required several days to cool before it could be uncovered.

Bernini followed the ancient lost-wax process of casting. His molds had three components: a heat-resistant inner model, a wax coating, and a heat-resistant outer casing, perforated and sealed. He cast each column in five pieces: the base, the shaft in three sections, and the capital. As each mold heated, the wax melted and drained. Once the wax was "lost," molten bronze was poured in to fill the space left. When the mold cooled, the casing was broken and the core removed. The pieces were then assembled with shims and the details added. Bernini made his own wax models, not only of the columns but also of the detailed ornamentation—every leaf, bee, and lizard. To achieve realistic effects in his wax designs, he often used actual lizards, bees, and branches, which would then be consumed in the firing. His detractors referred to it as "the lost-lizard process."

The Baldacchino was extravagantly expensive to cast, costing Urban two hundred thousand ducats, one tenth of the Church's annual income, and work did not proceed smoothly. Its extreme weight required deep foundations beneath the pavement of St. Peter's, and the digging disturbed many graves in the ancient necropolis. When

several workmen died mysteriously, rumors spread that the project was cursed. The men refused to return to work, until the pope bribed them with double wages. Once the curse was eased, Bernini faced engineering complications and a shortage of metal.

The Baldacchino required so much bronze that Bernini had to set up two foundries near the Swiss Guard barracks to melt it. Paul V had stripped the bronze covering off the ribs of the cupola to lessen the weight of the dome, and replaced it with lighter lead. The salvaged metal was melted for the Baldacchino. When Bernini needed still more bronze, Urban intervened again. With the imperiousness shown by every great builder-pope since Julius, he ordered the bronze stripped from the portico of the Pantheon.

Classical looting was nothing new, and the popes were egregious offenders. In justification, they argued that the material was going to a cause more pleasing to God than pagan temples, that there was no shortage of antiquities, and that many of the ancient ruins interfered with their plans to rebuild the city. Precedent not withstanding, plundering the Pantheon caused an outcry and prompted a famous pasquinade: *"Quod non fecerunt barbari, fecerunt Barberini"* — "What the barbarians did not do the Barberini did."

So much bronze was taken from the Pantheon that there was enough to complete the columns of the Baldacchino and make eighty pieces of artillery for the papal guards.

In 1629, while Bernini was stripping the bronze from the Pantheon, Carlo Maderno, the *magister operae* of the Vatican, died. Urban chose Bernini to replace him. The pope gave Bernini the title architect of St. Peter's and superintendent of public works in Rome. "Bernini was made for Rome," Urban said, "and Rome was made for him. He is a rare man, a sublime artist, born by Divine Disposition and for the glory of Rome to illuminate the century."

Bernini would stay on the job for fifty-one years, until his death at the age of eighty-two. Like Michelangelo's, his life was driven by

his art. In his final years, he never climbed a scaffold without an apprentice beside him for fear that he would become so absorbed in his construction that he might lose his footing and fall. At the end, paralysis stopped him. Bernini must have been exhausted because instead of raging, he accepted his fate philosophically, saying that a hand that had worked so hard in life should rest a little before death. If he added up the days in his life that he did not work, he calculated, they would amount to less than a month.

Bernini dominated the century and the city more completely than any artist before or since. In the caprices and spectacle of his Baroque, in his rhapsodies in travertine, Rome found its ideal expression. He made the city his workshop and filled it with his creations—palaces, piazzas, fountains, churches, and sculptures. He gave Rome Piazza di Spagna with the Barcaccia fountain, Piazza Barberini with the Triton and Bees fountains, Piazza Navona with the Fountain of the Four Rivers, Piazza della Minerva with his whimsical Elephant and Obelisk, and the remodeled Ponte Sant'Angelo lined with stone angels. His monopoly was so secure, his talent so huge, and his capacity for work so prodigious that Francesco Borromini, his closest rival and a gifted artist, despaired of ever surpassing him.*

No one man could produce such a huge oeuvre alone, and Bernini operated a large, efficient workshop staffed by highly skilled artisans. Among his assistants were his father, Pietro; his younger brother, Luigi; his son, Paolo; Carlo Fontana, who would later chronicle the Basilica story; and Borromini. As the need arose, he also employed scores of marble cutters, goldsmiths, coppersmiths, carpenters, gilders, and woodworkers. While many aspiring artists

*Borromini, a lifelong rival, claimed that the Baldacchino was actually a Maderno design ordered by Paul V. He wrote: "It was the idea of Paul V to cover the high altar of St. Peter's with a baldachin with ornament proportional to the opening made for the Confessio and tomb of Peter." He also claimed that the design of a fountain representing the four rivers was his and was *aggiustata*—"adapted"—by Bernini in Piazza Navona.

who apprenticed under Bernini remained in his employ for years, he had just as many detractors.

Impulsive, ebullient, and worldly, he was described as "a merciless dragon," quick to act and quick to anger. He once slapped the bursar of St. Peter's across the face. Another time he chased his brother Luigi through the streets of Rome into the Basilica of Santa Maria Maggiore, flourishing a sword and threatening to run him through for flirting with a mistress. Bernini, who had many mistresses, may have suffered what was called the *morbo gallico*. When he finally settled down at the age of forty, he married Caterina Tezio, the prettiest girl in Rome, and gave her eleven children.

There is the echo of Leonardo and Michelangelo in Bernini's rule of thumb: "*Chi non esce talvolta dalla regola, non la passa mai*"—"He who doesn't break the rules, achieves nothing." Sometimes what he achieved was questionable—he cut niches in Bramante's piers that, critics argue, weakened the structure and damaged the stability of the dome—and his Baldacchino has the unnerving ability to evoke extreme visceral responses.

Any two people will disagree about it: Is the Baldacchino architecture or sculpture, awesome or overwrought? You love it or loathe it, but it does not allow for neutrality. The workmen who forged it called the structure *la macchina*, and by any standards, it is extraordinary. Eight stories high, it is ninety-three tons of cast bronze formed by four spiraling columns entwined with laurel branches where tiny *putti*, lizards, and the bees of the Barberini coat of arms appear to have alighted. An angel tops each column and together they hold up a canopy, also cast of bronze. Crowning the whole are a gold orb and cross.

No one, with the possible exception of Shakespeare, has ever had a more intuitive understanding of theater than Bernini. He is a master of the scenic art, and his Baldacchino is the ultimate prop. It has no function except to set the Basilica stage.

Without the Baldacchino, St. Peter's would be a fantasia of soaring space, mosaics, gilt, colored stone, columns, niches, statues, chapels, and sepulchres. Amid the sensory overload, the papal altar— the single element that gives meaning to the vast undertaking— would be lost.

The altar is the point where God and man are joined in communion. In striking contrast to the rest of the Basilica and to the Baldacchino itself, the papal altar is a simple table, a surface of ancient, unadorned marble, the true *petra serena*. It is one more brilliant stroke of Giacomo della Porta. Alone, in the immense, gaudy display of the Basilica, the altar would be too pure in line and substance to be noticed. But with the huge bronze canopy to frame it, the eye is drawn away from the kaleidoscopic whirl of colors and shapes to center stage.

The Baldacchino frames the altar and forms a vertical axis with the dome above and the tomb of Peter below.

∞

Once the Baldacchino was finished, Bernini began work on the first of two campanili. Maderno had planned twin bell towers above the arched openings at either end of the façade. Because the ground was marshy, he designed the towers with open arches and as little solid brickwork as possible. Bernini decided to redesign them, adding three stories to each bell tower—two rectangular sections and the third a pyramid.

Bernini presented a wooden model of his campanili to Urban. His bell towers were much heavier than Maderno's, and the estimated cost was considerably heftier as well—more than twice Maderno's projected price. Boats piled with travertine began arriving from Tivoli. In all, 192 loads, amounting to almost one thousand stone pieces, would reach the Vatican.

Bernini started with the southern campanile, to the left of the

main entrance, because that site was the more open and accessible. Although his reasoning was sound, his actions were ill-considered. The heavy campanile structure that he designed required a much firmer foundation than the location provided. Because the area had been a valley once, the land was low-lying, the soil was marshy, and a sewer emptied there.

Like Bramante, Bernini was as rash as he was talented, and with the success of the Baldacchino and the boundless favor of the pope, he was turning into a prima donna, conceited and overconfident. His own mother told him that he was becoming insufferable, strutting around as if he were "lord of the world."

Bernini began building the southern campanile in 1638 without bothering to check the site carefully. The first two stories took six years to construct, and almost immediately cracks began appearing not only in the tower but, more alarmingly, in the Basilica façade. Years later, Bernini would insist that the cracking had occurred earlier, during Paul V's pontificate. But at the time, he was humiliated—and unprotected.

Urban VIII had died while the campanile was under construction, and Bernini did not enjoy the same close relationship with the new pope, Innocent X. Although a committee of Fabbrica officials met five times and proposed various solutions to repair the collapsing tower, Innocent worried that Bernini's precarious structure would bring the whole Basilica tumbling down. He ordered the top-heavy campanile demolished, and deepening Bernini's embarrassment, he threatened to seize the architect's assets to pay for the demolition. Persona non grata in the Vatican and publicly humiliated, Bernini seemed finished at the age of forty-six.

❧

Innocent X was much different in temperament from his urbane predecessor. Urban had been an ardent patron of art and science.

The three bees of the Barberini coat of arms are a ubiquitous visual signature on the fountains and piazzas of Rome, on Castel Gandolfo, the lovely summer villa of the popes, and most conspicuously on Palazzo Barberini at the foot of Via Veneto. Considered the finest Baroque palace in the city, it had several art galleries; a beautiful library; a theater with seating for three thousand; and gardens that formed an exotic parkland planted with rare flowers and stocked with ostriches, camels, and assorted strange creatures not typically found in a Roman backyard.

With his wealth and scholarship, Urban had been an influential voice in the intellectual circles that were beginning to challenge the verities of the Church. He was a friend and enthusiastic supporter of the scientist Galileo Galilei, who was reviving interest in the arcane theories of Copernicus. Was the earth the center of the universe as the Church taught or did it revolve around the sun as Copernicus had posited? As a monsignor, Urban had dedicated his poem "Dangerous Adulation" to Galileo and had urged the scientist to present his findings. As pope, he continued a spirited dialogue, welcoming Galileo to the Vatican for audiences that lasted for hours.

Palazzo Barberini became a center of inquiry and provocative thought, known as the Roman Academy. Poets and scholars came from all over Europe to study and debate, among them the author of *Paradise Lost*, John Milton.

Although the Council of Trent had successfully rooted out most of the glaring abuses of the Renaissance Church, nepotism persisted. Urban was a prime offender. On the third day of his pontificate, he named his nephew Francesco a cardinal, and he continued to promote his family to positions of power and wealth as long as he was pope. With each venal position and each benefice he conferred, the Barberini family wealth increased, Urban advanced

his own with a sense of humor as well as entitlement. He liked to say that he had four relatives: one was a saint who performed no miracles; one was a friar who lacked patience. one was an orator who could not speak; and one was a general who did not know how to wield a sword.

Over the course of his long pontificate, Urban had time to examine his conscience. He twice appointed a committee of theologians to judge the state of his soul and the legality of his appointments. If he were guilty of nepotism, a practice forbidden by the Council of Trent, his nephews would have to relinquish their possessions and appointments. Both committees found the pope pure of heart and proclaimed his soul lily white. If the theologians thought better of finding the pope guilty of serious sin, their consciences were assuaged by the fact that the Barberini nephews enjoyed but never exploited their positions.

In stark contrast to Urban, Innocent X belonged to the breed of stern Counter-Reformation popes who deplored the decadence of the Renaissance papacy. An extraordinarily realistic portrait by Velázquez depicts a singularly ugly man with bulbous nose and bulging eyes. When he saw his likeness, Innocent reportedly murmured, "*Troppo vero*"—"Too true."

Although he gave up his efforts to seize Bernini's assets, Innocent wanted no more work from the architect of the collapsing campanile. He was adamant on the subject, until his sister-in-law intervened. Donna Olimpia Maidalchini was the majordomo in the papal household, and she had a soft spot for the rakish artist. When Innocent announced a contest to sculpt a fountain in Piazza Navona, Bernini fashioned a prototype in silver and sent it to her as a present. Donna Olimpia displayed the gift where the pope was bound to notice it. Her gambit worked. Seeing the sterling model of the Fountain of the Four Rivers, Innocent reversed himself.

"We must indeed employ Bernini," he said. "The only way to resist executing his works is not to see them."

❧

Innocent died so unloved and unmourned that his body was left in a woodshed for three days. History remembers him as the prudish pope who added fig leaves to nude statues and the inspired patron who commissioned the flamboyant fountain in Piazza Navona. Years later, when Bernini was riding through the piazza in a carriage, he closed the curtain so that he wouldn't have to see his creation. "How ashamed I am to have done so poorly," he said.

History is no kinder to Urban VIII. He is not remembered as the humanist scholar who consecrated St. Peter's Basilica, gave Bernini to Rome, or encouraged Galileo. Instead, he is dismissed as the narrow, closed-minded pope who censored the scientist. In the annals of history, a very human story of friends turning against each other has been retold as the quintessential clash of faith and reason, religion and science.

Whatever his role in the Galileo imbroglio, Urban VIII brought imagination and a glorious extravagance to the embellishment of St. Peter's. However complex his friendship with Galileo, his relationship with the brilliant artist of the Baroque was true. Bernini would enjoy an equally close relationship with the last of the great Baroque builders, Alexander VII.

FULL CIRCLE

❧

W ith the election of Alexander VII to the papacy, the Basilica story comes full circle. Born Fabio Chigi, he was the grandnephew of Agostino il Magnifico—in his heyday the wealthiest of all Romans, the banker who secured the papacy for Julius II and performed even more crucial, lifesaving tasks for the Medici popes, bankrolling their excesses and paying the enormous ransom that kept their papacies solvent for another day.

Although Agostino Chigi became the Croesus of the Church, he had desired more than money. The salon was more alluring than the countinghouse, and once he had lucre, he yearned for luster. In 1655, his descendants reaped the ultimate reward. With the family fortune greasing the way to his election, Fabio Chigi was consecrated Pope Alexander VII.

Beyond his personal fortune, there was nothing of the countinghouse about Alexander. He was a poet who published under the pen name Philomathus; a scholar who set aside time each day for stimulating discussions of literature, art, and history; a *Romano di Roma*—a true Roman—who continued to make the city one of the great capitals of the world. It was said that Alexander kept two reminders in his bedroom: a wooden model of Rome to keep him focused on his goal and a wooden coffin to keep him humble.

On the day of his election, Alexander summoned Bernini to an audience, and to the end of his pontificate, they worked together to complete the Basilica. Alexander was a patron-collaborator, as involved as Julius had been. Every detail interested him, from the technical to the artistic, and he frequently offered suggestions. He commissioned Bernini to build the Scala Regia, the broad staircase leading from the piazza to the papal palace; one of the two fountains in the square (Maderno designed the other), and the Cathedra Petri.

Rescued from Constantine's basilica, the Cathedra, or Chair, of Peter was made of oak and embellished with a carved ivory frieze and precious metals. It was revered for centuries as the actual throne on which Peter sat. The legend was off by several hundred years. The chair had been a gift from Charlemagne's grandson, Charles the Bald, to Pope John VIII in the ninth century, but it continued to be revered.

The preliminary models that Bernini made for the setting for the Cathedra are on display in Room Seventeen of the Pinacoteca in the Vatican Museums. The models are a mixture of clay and straw applied over an iron frame.

Bernini placed the Cathedra on a grandiose bronze throne, gilded and burnished with six different patinas and surrounded by angels. The chair is held up by the four Doctors of the Church and surmounted by a dove, representing the Holy Ghost. The whole is set in a glorious burst of light and clouds. Bernini located the Cathedra in front of the altar, so that as you enter the Basilica, it appears to be a picture framed by the Baldacchino. Although the Cathedra was a dazzling conjuring act, Bernini's most brilliant illusion was his last—the colonnades and piazza of St. Peter's.

In the summer of 1656, while Bernini was creating the Cathedra, Pope Alexander asked for preliminary studies of a structure that in

his words would be "the theater of the porticoes." Although the concept of a grand entry to the new Basilica had been bandied about the Vatican for years, Alexander devoted the second year of his papacy to realizing it. From his meticulous daily diaries we know that he discussed various plans with Bernini.

Alexander imagined a colonnade open at the sides, with parallel columns and statues on top, enclosing a piazza. The colonnade would serve several purposes.

It had to introduce and welcome visitors and frame and exalt the Basilica. It also had to conceal the fact that the obelisk was not perfectly aligned with the Basilica nave and the tomb of Peter, overcome the difficulties of a vast, irregular space hemmed in by numerous small buildings, and correct the feeling of disproportionate width created by the façade.

Bernini believed that "an architect proves his skill by turning the defects of a site into advantages." Initially ignoring the Fabbrica's recommendation for a rectangular construction, he submitted a number of proposals. From a trapezoid, influenced by Michelangelo's Campidoglio, his design evolved into a rectangle and then an oval. One model followed another as the pope and architect debated the best solution. Their goal was an arena with clear sight lines, so that a pilgrim standing anywhere in the piazza could see the Benediction Balcony and receive the pope's blessing, *urbs et orbis.*

When Alexander proposed the colonnade, St. Peter's was the center of a crowded neighborhood. The Swiss Guard barracks, a clock tower built by Paul V, the old church of Santa Caterina, and dozens of low houses and shops had to go to make room for the colonnade. A fountain added by Maderno east-northeast of the Basilica added a further complication. Bernini would resolve it by moving Maderno's fountain so that it was aligned with the obelisk

and sculpting a complementary fountain on the other side of the obelisk for visual balance. Diverting the water for Maderno's fountain to the new location proved more of a headache.

Through the fall and winter of 1656, while Bernini was defining his ideas, the Fabbrica began to clear the site, buying then razing the houses and shops around St. Peter's. As Alexander's diaries attest, pope and architect considered a host of variants—for double or triple porticoes, for extending and vaulting the arms, for the circumference and order of the columns.

Finally, on May 20, 1657, Alexander wrote in his diary: "Cavaliere Bernini showed the plans and elevation of the porch of St. Peter's and we shall finish it like this." Three months later, on August 28, he laid the first stone. But just as the Basilica itself had remained a work in flux, subject to change throughout its construction, the stones of the colonnade were not set. The columns in this "final" plan were probably Corinthian, repeating the colossal order of the Basilica. That would change as Alexander and his architect continued refining the design.

If the details were variable, the essence was fixed. Earlier artists had imagined an impressive avenue leading to the new Basilica.* Bernini created an embrace. His solution was an ellipse, reaching out from the sides of the Basilica and designed "to receive maternally with open arms the Catholics and confirm them in their belief, to reunite heretics to the Church, and to illuminate the infidels to the true faith." His plan called for three colonnades—one on either side of the Basilica that we see today, and a third smaller one, parallel to the façade, that was never built.

Like the atrium of Constantine's basilica, the colonnades would form a *paradisus*—a kind of open-air entryway where pilgrims prepared themselves spiritually to enter the sanctuary. Just as the

* Centuries later, Mussolini built such an avenue, Via della Conciliazione.

Baldacchino creates the interior setting for the altar and dome, the colonnades create the external setting for the Basilica. "The piazza and the gradual slope upward to the mighty Temple," George Eliot wrote, "gave me always the sense of having entered some millennial Jerusalem where all small or shabby things were unknown."

Bernini enclosed a space the size of the Colosseum with an ellipse formed by symmetrical, covered colonnades. The piazza is 1,115 feet long, the distance of three average city blocks. Like the imperial amphitheater, it is an open oval that can contain huge crowds. In each colonnade, four rows of Doric columns create three passageways. The central passage is 61 feet, wide enough for two carriages or cars to pass, and inscribed with a verse from Isaiah: "A tabernacle from the heat, and a security and cover from the whirlwind and from the rain." On top of the colonnades, Bernini placed giant statues of popes and saints, twice as large as life, creating what he called "a cloud of witnesses."

Because the obelisk is misaligned by 2 degrees from the Basilica nave, Bernini didn't use it as the locus of the ellipse. Each colonnade has its own center, so that the rows of columns seem to shift and change, appearing as one or many as you approach the Basilica.* To correct the proportions of the façade, he kept the colonnades only sixty-four feet high, lending the illusion of greater height and lesser width to Maderno's creation. Bernini described the relation of the colonnades to the Basilica as similar to the relation of the arms to the head.

The labor involved in building the colonnades was intensive. Simply excavating the site was a massive undertaking, displacing tons of earth, which then had to be removed from the site to make way for the quarried stone as it arrived from Tivoli. Construction

* A marble disk on the side of each fountain indicates the focus of the ellipse. If you stand on either disk, the colonnades appear to be one row of columns, not four.

required much of the engineering and sculptural talent in Rome. To handle the logistics of raising 284 columns and 88 pillars, each one 52 feet tall, Bernini created a veritable assembly-line force, with one group of artisans assigned to bases, another to shafts, another to capitals. Both to minimize transportation costs and to keep the work site uncluttered, he also employed teams of stonecutters in the quarries to hew the columns from the blocks of travertine. The roughed-out columns were then transported to a work area in the Vatican known as San Maria, where they were raised by winches. Teams of sculptors worked on them, then the finished columns were lowered onto rolling flatbeds, dragged to the piazza, and lifted into position. By the end of September 1658, the first twenty-four columns were in place.

A similarly work-intensive process was employed for the "cloud of witnesses" atop the porticoes. There are 140 twelve-foot statues.* Creating each one took about two months, required many hands, and involved five basic steps: building a full-size wooden model, chiseling a rough likeness in stone, hoisting the unfinished statue onto the portico for precise positioning, taking it down again to be finished, then raising and mounting it.

While Alexander was preoccupied with the Basilica projects, France threatened to invade the Papal States. The pope's most potent offensive weapon was his architect. For years the egocentric French king Louis XIV and his minister Jean-Baptiste Colbert had been hounding the pope to share the divine talent of Bernini. A letter from Colbert tactfully pleads for "a few hours of those you employ with such glory in the beautification of the first city of the world." Alexander had resisted the Sun King's imputations, but

* Ninety statues are from Bernini's workshop. In 1703, more than twenty years after Bernini's death, Pope Clement XI ordered fifty more statues.

with the French spurred and booted, he capitulated. The pope agreed to loan his architect to the French for three months.

On April 29, 1665, Bernini reluctantly relinquished what he termed "the two most important works in the world." Leaving his brother Luigi and Carlo Fontana to continue the Cathedra and the colonnades, Bernini embarked for Paris to build the Louvre. Accompanying him were three servants, the head of his household, and his three favorite assistants: his second son, Paolo, the sculptor Giulio Catari, and the architect Mattia de Rossi, who had been eighteen when he began apprenticing in Bernini's workshop.

Although King Louis assured the pope that "upon entering my kingdom, Cavaliere Bernini should begin to receive proofs of the consideration I have for his merit in the manner in which he will be treated," the visit was a disaster from the first day. Bernini was in bed taking a siesta when Colbert arrived to greet him, and relations deteriorated from there. The Italian was contemptuous of the petit bourgeois mentality of the Frenchman and dismissed his practical questions about time and cost as fit for a quartermaster, not for the world's premier artist. "Do not speak to me of anything small," he warned Colbert. Instead of building the Louvre, Bernini returned to Rome and the Basilica of St. Peter.

When Alexander VII died on May 22, 1667, ten years almost to the day after accepting Bernini's design, the two long colonnade arms were nearing completion. Bernini never began the third colonnade, and it would take another century before the last figure in his "cloud of witnesses" was sculpted and mounted.

∞

Bernini enveloped the Basilica of St. Peter in mystique. The experience begins at the river crossing. Bernini's angels on the bridge at Castel Sant'Angelo lead the way across the Tiber to the Vatican. Through the spray from his fountain, iridescent in the sunlight, the

Basilica comes into view. To the right is the Scala Regia, his majestic stairway to the Vatican palace, a statue of Constantine at his moment of conversion poised on the landing. To the left, no trace remains of Bernini's ill-conceived and long-forgotten campanile.

Within the embrace of his colonnades, you cross the piazza, mount the steps, and encounter the Basilica—the immense, glittering, breathtaking culmination of two centuries of art and architecture. As you enter the nave, directly ahead, his Baldacchino draws the eye to center stage, framing the moment and the eternal mystery of an incarnate God. From so much disparity, the grand illusionist conjured unity. It was Bernini's supreme achievement.

EPILOGUE

I f not the greatest story ever told,* the creation of the Basilica
of St. Peter is its epilogue. The narrative is written in the stones
of the Basilica and in the landmarks of the city. Bramante's
piers set heroic dimensions, but they are the outline, not the essence.

Call it the power of an idea or divine inspiration. From what
could have been a Tower of Babel, the artists, popes, and knaves
who built St. Peter's incised a symbol of the transcendent Christ
against the landscape of a city that embodied paganism. As the
Basilica rose stone upon stone, the city of Rome grew with it. From
the dust of empire and the neglect of the Middle Ages, it became
what Byron called "the city of the soul."

Few buildings have less of Alberti's *concinnitas* than the Basilica
of St. Peter. Through the years, architects and pontiffs followed
one another in rapid and sometimes wanton succession. At times,
the construction site seemed more like the set of a French farce,
doors opening and closing and characters crisscrossing the stage
in dizzying numbers, than the site of the architectural endeavor of
the epoch. There were numerous builders, many contradictory

*The life of Christ is often called "the greatest story ever told."

plans, and disharmonious junctures. Yet entering St. Peter's, the visitor experiences unity as solid as dogma. There is no suggestion that the Basilica was a work in progress for more than two centuries. From a confusion of sacred and secular, from a clash of genius and a stew of ironies, an extraordinary feat of architecture and engineering emerged.

Time and again, construction collided with history and stalled. Emperors and kings, alliances and battles, heads that rolled actually and figuratively, egos that chafed, recede before the immutable presence of the Basilica. In its ability to inspire awe—to make the heart stop and the soul soar—art triumphs over politics.

The sacrifice was huge. The Renaissance popes hocked the family jewels in the name of art, begged, borrowed, and splintered the Christian Church to build the Basilica. The details changed, but the ideal remained constant—to construct a metaphor in stone for the leap of faith that is at the heart of the gospel of Christ.

Although the fact that it took so long was a matter of money and politics more than a lack of vision, the delays seem serendipitous. The perfectly proportioned Renaissance architecture, each part in exact geometric ratio to the other and to the whole, seems too tidy for such a sprawling, messy, overreaching institution as the Church of Rome. The Baroque is its truer reflection.

When it was finally completed, the Basilica was truly catholic, incorporating in one supreme construction the conviction of numerous popes and the genius of many architects—the power of Bramante, the grace of Raphael, the clarity of Michelangelo, and the theater of Bernini. In its imposing size and majesty, the brilliance of the Renaissance and the drama of the Baroque converge. Two million tons of stone transformed into spirit create what Rome's preeminent historian, Edward Gibbon, called "the most

glorious structure that ever has been applied to the use of religion."

San Pietro in Vaticano lifted Rome from the rubble of its lost grandeur and made it the Eternal City. Gothic cathedrals reach up to heaven. St. Peter's—muscular, sublime, irrevocable—brings heaven to earth.

THE POPES

FROM NICHOLAS V TO ALEXANDER VII

Nicholas V	1447–55	Paul IV	1555–59
Calixtus III	1455–58	Pius IV	1559–65
Pius II	1458–64	Pius V	1566–72
Paul II	1464–71	Gregory XIII	1572–85
Sixtus IV	1471–84	Sixtus V	1585–90
Innocent VIII	1484–92	Urban VII	1590
Alexander VI	1492–1503	Gregory XIV	1590–91
Pius III	1503	Innocent IX	1591
Julius II	1503–13	Clement VIII	1592–1605
Leo X	1513–21	Leo XI	1605
Adrian VI	1522–23	Paul V	1605–21
Clement VII	1523–34	Gregory XV	1621–23
Paul III	1534–49	Urban VIII	1623–44
Julius III	1550–55	Innocent X	1644–55
Marcellus II	1555	Alexander VII	1655–67

STATISTICS

∞

- St. Peter's covers a total area of 227,070 square feet, more than five acres. The floor area is 3.7 acres.
- The façade is 375 feet wide by 167 feet high.
- The interior of the Basilica is 451 feet wide by 613 feet long—almost one eighth of a mile.
- The columns and pilasters are more than 90 feet high.
- The circumference of the central piers is 240 feet.
- The nave and transept are 151.5 feet high.
- The nave is 613 feet long by 84 feet wide.
- The length of the transept is 451 feet.
- The height of the dome, from the pavement to the tip of the cross, is 452 feet.
- The diameter of the dome is 137.7 feet. (The dome of the Pantheon exceeds it by 4.9 feet, but St. Peter's dome is three times higher.)
- The drum is 630 feet in circumference and 65.6 feet high, or 240 feet from the ground.
- The lantern is 63 feet high.
- The ball and cross are 8 and 16 feet high, respectively.
- The Baldacchino is about 100 feet high.

- St. Peter's Square is 1,115 feet long by 650 feet wide.
- Each arm of the colonnade is 306 feet long and 64 feet high.
- The colonnades have 284 columns, 88 pilasters, and 140 statues.
- The obelisk is 83.6 feet (with base and cross, 132 feet) high and weighs 320 tons.

WALKS IN PAPAL ROME

The modern city of Rome is the patrimony of the popes who built St. Peter's. They commissioned the fountains, gardens, palaces, churches, piazzas, and avenues that make the Eternal City a place like no other. While it would be daunting to include every commission, these walks suggest how profoundly the popes and architects of St. Peter's shaped the city. Be warned, though, these are substantial tours, and what elevates the soul can exhaust the soles.

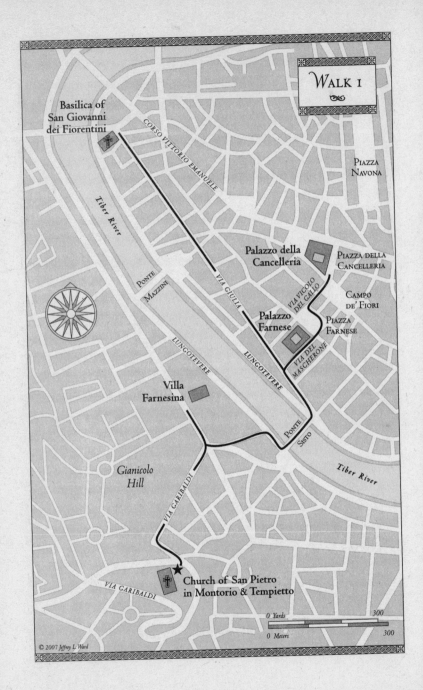

WALK I

Basilica of San Giovanni dei Fiorentini

CORSO VITTORIO EMANUELE

PIAZZA NAVONA

Tiber River

PONTE MAZZINI

VIA GIULIA

Palazzo della Cancelleria

PIAZZA DELLA CANCELLERIA

VIA VICOLO DEL GALLO

CAMPO DE' FIORI

Palazzo Farnese

PIAZZA FARNESE

LUNGOTEVERE

LUNGOTEVERE

VIA DEL MASCHERONE

Villa Farnesina

PONTE SISTO

Tiber River

Gianicolo Hill

VIA GARIBALDI

VIA GARIBALDI

Church of San Pietro in Montorio & Tempietto

0 Yards 300

0 Meters 300

© 2007 Jeffrey L. Ward

WALK I
Starting Point: The Janiculum

1. Begin at Donato Bramante's **Tempietto**, the "little temple" that inspired the monumental Basilica of St. Peter. Located on the **Janiculum** hill in the shadow of the **Church of San Pietro in Montorio**, the **Tempietto** is a flawless miniature—the Renaissance ideal in microcosm—and its perfection moved Pope Julius II to bring the architect to the Vatican. In October 1505, Julius chose Bramante to build a new Basilica.

2. From the **Tempietto**, follow **Via Garibaldi to Villa Farnesina**, once the riverside estate of Agostino "il Magnifico" Chigi, Julius II's favorite banker and confidant. Baldassare Peruzzi was the architect. Raphael frescoed the interior and designed the elegant stables where Chigi entertained Julius's successor, the Medici Pope Leo X. The celebrated stable dinner party was an ostentatious display that ended with Chigi ordering his servants to toss his solid gold dinner plates into the Tiber.

3. Crossing the river at **Ponte Sisto**, picture the tumult of gold dishes cascading into the water. The bridge is named for Julius II's

wily papal uncle Sixtus IV, who also built the Sistine Chapel. Turn left to **Palazzo Farnese**, the immodest home that Cardinal Alessandro Farnese was building when he was elected Pope Paul III. It is now the French Embassy. Three successive architects of St. Peter's also followed each other as architects of the Farnese palace. Antonio da Sangallo designed the first floor, Michelangelo changed the façade and designed the second storey, and Giacomo della Porta completed the building.

4. At the northern end of **Piazza Farnese**, follow **Via Vivolo del Gallo** past **Campo de' Fiori**, Rome's boisterous open-air market, to **Palazzo della Cancelleria**. This massive palace was built by Julius II's cousin, Cardinal Raffaele Riario, the Vatican's chief financial officer, with money he won from another cardinal in an evening of gambling. After Julius died, the fortunes of his cardinal cousin turned. Leo X arrested Riario, charged him with conspiring in a papal assassination attempt, and confiscated his palace. The oak tree of the della Rovere-Riario coat of arms that once adorned the front of the **Cancelleria** was replaced with the three balls of the Medici.

5. In **Piazza della Cancelleria**, stop for lunch at Ditirambo— the pasta and salads are excellent—or try Caffe Farnese in **Piazza Farnese**, good for either a full meal or a light pick-me-up.

6. Return to **Palazzo Farnese**, noting the single arch in front of the palace. This is one span of an unfinished bridge that Michelangelo began for Paul III to link **Palazzo Farnese** with **Villa Farnesina** across the river. By the time of Paul's papacy, the Farneses had bought Chigi's estate and renamed it.

7. From **Palazzo Farnese**, walk up **Via Giulia**, which runs parallel to the river. Bramante laid out the street for Pope Julius to create

a direct route from the heart of Rome to the new St. Peter's. Although **Via Giulia** was never completed, it became the best address in town in the sixteenth century. Both Raphael and Antonio da Sangallo, who became wealthy men as chief architects of St. Peter's, bought land there. **Raphael's House** (so named even though it was built after his death) is No. 85. Sangallo's, now called **Palazzo Sacchetti**, is No. 66. Almost five centuries later, **Via Giulia** remains one of the choice neighborhoods in Rome.

8. As you stroll along the avenue, note on the right the **Church of Santa Caterina di Siena** built by Baldassare Peruzzi, and across the street, the **Church of Sant' Eligio** by Raphael. Also on the left are the **Sofas of Via Giulia**, the beginnings of a never-completed courtyard designed by Bramante for Pope Julius.

9. **Via Giulia** ends with the **Basilica of San Giovanni dei Fiorentini**, built by Leo X for his fellow Florentines. Leo rejected the plans of both Raphael and Michelangelo. Instead, the architects Jacopo Sansovino, Antonio da Sangallo and Carlo Maderno all worked on the church. If you require sustenance again, there is an attractive terrace restaurant called Coccodrillo at 14 Via Giulia.

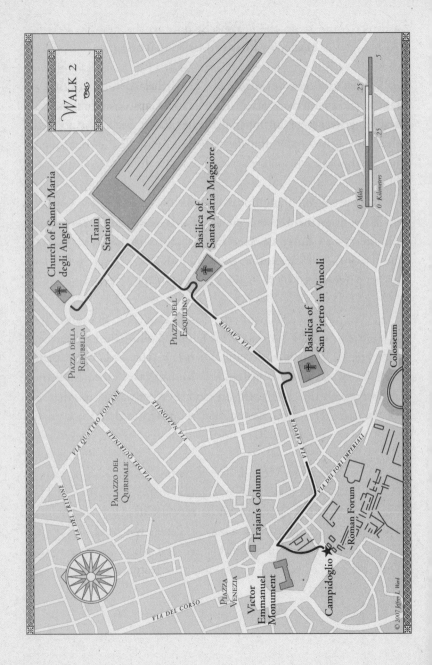

WALK 2

Church of Santa Maria
degli Angeli

Train
Station

Basilica of
Santa Maria Maggiore

PIAZZA DELLA
REPUBBLICA

PIAZZA DELL'
ESQUILINO

VIA CAVOUR

Basilica of
San Pietro in Vincoli

Colosseum

0 Miles

0 Kilometers

.25

.25

.5

.5

VIA DEL TRITONE

VIA QUATTRO FONTANE

VIA DEL QUIRINALE

VIA NAZIONALE

PALAZZO DEL
QUIRINALE

VIA CAVOUR

VIA DEI FORI IMPERIALI

Roman Forum

Trajan's Column

PIAZZA
VENEZIA

Victor
Emmanuel
Monument

Campidoglio

VIA DEL CORSO

© 2007 Jeffrey L. Ward

WALK 2
Starting Point: The Capitoline

1. This tour follows in the steps of Michelangelo, who came so late to the architecture of St. Peter's. The **Capitoline** hill was the seat of government in imperial Rome, and it became a political showcase again under the Farnese Pope Paul III, who brought Michelangelo back to the Vatican and gave him carte blanche to build the Basilica. Paul commissioned Michelangelo to design a new **Campidoglio** to impress the Emperor Charles V, who was paying his first visit since the Sack of Rome. Michelangelo created a central oval space and new fronts for **Palazzo dei Conservatori** and **Palazzo del Senatore**. Like many of Michelangelo's Roman projects, including the dome of St. Peter's, the **Campidoglio** was finished by Giacomo della Porta.

2. At the ancient statues of Castor and Pollux, descend the elegant stairway and walk to the right of the **Victor Emmanuel Monument** that Romans dismiss as "the wedding cake." Ahead, you will see **Trajan's Column**. Michelangelo had a studio in **Macel de' Corvi** in the shadow of the column. To your right, running along the **Forum**, is **Via dei Fori Imperiali**. Follow it to **Via Cavour**. Along **Via Cavour** on the right, a flight of steps leads to the **Basilica of San Pietro in Vincoli**, where the final, scaled-down version of Michelangelo's tomb for Pope Julius finally came to rest. The "agony of the tomb" plagued Michelangelo's life. He had imagined a sculpture so grandiose that a new St. Peter's was needed to house it. But Bramante's Basilica quickly eclipsed Michelangelo's tomb. Only the mighty horned Moses, with the features of Julius, suggests what might have been.

3. From **San Pietro in Vincoli**, go back down the steps to **Via Cavour**. Valentino at 293 is an inexpensive sidewalk caffe serving real Roman dishes.

4. Continue along **Via Cavour** to the **Basilica of Santa Maria Maggiore**, one of the seven major basilicas of Rome that Christian pilgrims were obliged to visit. (The other six basilicas are St. Peter's, San Giovanni in Laterano, San Paolo fuori le Mura, San Lorenzo fuori le Mura, San Sebastiano, and Santa Croce in Gerusalemme. Each merits a visit.) Michelangelo's friend Giuliano da Sangallo coffered the ceiling of **Santa Maria Maggiore** with the first gold from the New World. Other fingerprints of the Basilica architects and popes are in evidence here. After his stunning success with the obelisk in St. Peter's square, Pope Sixtus V had Domenico Fontana moving Egyptian monoliths all around the city. Fontana positioned an obelisk in front of **Santa Maria Maggiore** and designed the **Cappella Sistina** in one of the cupolas to be the pope's tomb. In the other cupola, the Borghese Pope Paul V commissioned the **Cappella Paolina**, and, following Michelangelo's drawings, Giacomo della Porta completed the **Cappella Sforza**.

5. From the **Basilica of Santa Maria Maggiore**, continue up **Via Cavour** to the train station. Turn left and walk to **Piazza della Repubblica**. After relaxing at the lively sidewalk caffe, long a popular tourist spot, cross the square to the **Church of Santa Maria degli Angeli**. This church, carved out of the **Ancient Roman Baths of Diocletian**, was Michelangelo's final commission.

WALK 3
Starting Point: Galleria Borghese

1. The **Borghese Gardens** is Rome's Central Park, and, if time permits, spend a day discovering its many pleasures. This walk begins on the eastern end of the park at **Galleria Borghese**, originally the family estate of the Borghese Pope Paul V, who completed St. Peter's and has been deplored by purists ever since for altering Michelangelo's Basilica plan. Now a museum filled with wonderful Bernini sculptures, the **Galleria** and the surrounding **Gardens** stand as a testament to Paul V's unbridled nepotism.

2. Leave the **Borghese Gardens** at **Porta Pinciana** and stroll down **Via Veneto**, the avenue of *La Dolce Vita*. Treat yourself to an espresso or *aperitivo* at one of the elegant Via Veneto caffes— Harry's Bar, Café de Paris, or Doney's. Continue down **Via Veneto**, past the American Embassy in the bend of the avenue, to **Piazza Barberini**. Bernini designed both the central **Triton Fountain** and the smaller **Fountain of the Bees** for Paul V's successor, the Barberini Pope Urban VIII, who championed the Baroque genius and silenced Galileo. The bee is the Barberini family symbol.

3. Cross to the far side of **Piazza Barberini**, being attentive to street signs because many major avenues converge here, and turn onto **Via Quattro Fontane**. The imposing palace on your left is **Palazzo Barberini**. Like his Borghese predecessor, Pope Urban was notorious for his nepotism. Begun by Carlo Maderno and Francesco Borromini and completed by Bernini, the Barberini palace is now a museum. Among its treasures are Raphael's *Fornarina*, which, until very recently, was believed to be a portrait of his mistress, a baker's daughter. Raphael once hid with *la fornarina* in Agostino Chigi's riverside residence to avoid his fiancée, a cardinal's niece.

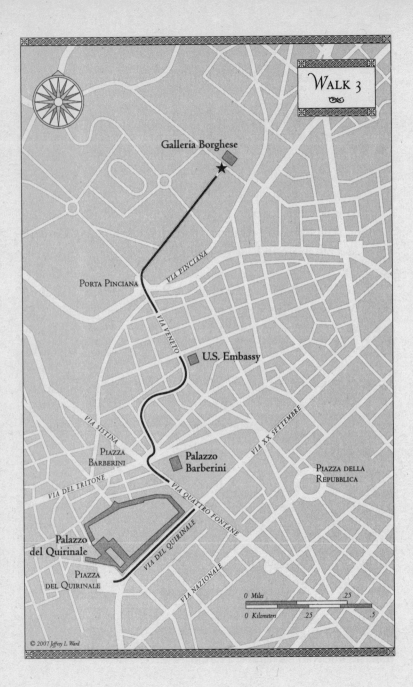

Galleria Borghese

PORTA PINCIANA

VIA PINCIANA

VIA VENETO

U.S. Embassy

VIA SISTINA

VIA XX SETTEMBRE

PIAZZA
BARBERINI

Palazzo
Barberini

PIAZZA DELLA
REPUBBLICA

VIA DEL TRITONE

VIA QUATTRO FONTANE

Palazzo
del Quirinale

VIA DEL QUIRINALE

PIAZZA
DEL QUIRINALE

VIA NAZIONALE

0 Miles .25

0 Kilometers .25 .5

© 2007 Jeffrey L. Ward

4. Continue along **Via Quattro Fontane** to **Via del Quirinale**. At the intersection are the four fountains that give **Via Quattro Fontane** its name. As part of Pope Sixtus V's ambitious urbanization plans, Domenico Fontana laid out the avenue and marked each corner of the intersection with a fountain.

5. Turn onto **Via del Quirinale**, and to the right are the **Gardens and Palazzo of the Quirinale**. Commissioned by Pope Gregory XIII, the palace was built over the course of several papacies by a number of Basilica architects, including Maderno and Fontana. Bernini contributed the impressive wing that stretches one-sixth of a mile. Romans call it *la manica lunga*, "the long sleeve." Constructed on high ground, removed from the mosquito-infested riverbanks, the **Quirinale**'s history mirrors the city's. It was the summer home of the popes when the Church was the governing power and a royal palace when Italy was a monarchy. Today, it is the home of the President of the Republic.

6. The intense rivalry between the Baroque masters, Bernini and Borromini, plays out notably on **Via del Quirinale**: No. 29 is Bernini's **Church of Sant' Andrea al Quirinale**, No. 23 is Borromini's **Church of San Carlo alle Quattro Fontane**.

7. Via del Quirinale ends in a lovely piazza. The **Quirinale** is the highest of the seven hills of Rome, and the view of the city with the dome of St. Peter's gleaming in the distance is so glorious, you'll forget your tired feet.

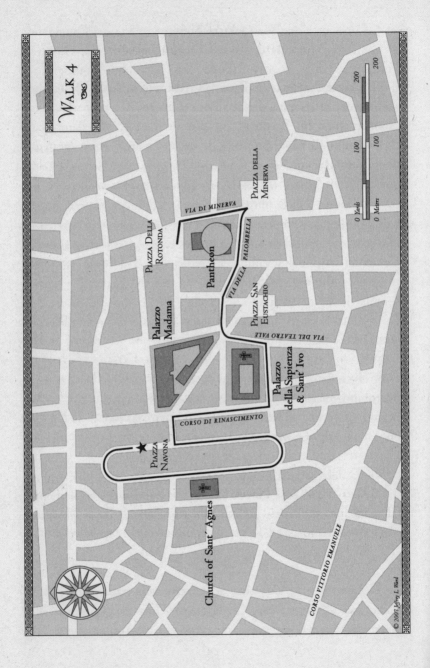

WALK 4

VIA DI MINERVA

PIAZZA DELLA ROTONDA

Pantheon

PIAZZA DELLA MINERVA

VIA DELLA PALOMBELLA

PIAZZA SAN EUSTACHIO

Palazzo Madama

VIA DEL TEATRO VALE

Palazzo della Sapienza & Sant' Ivo

CORSO DI RINASCIMENTO

PIAZZA NAVONA

Church of Sant' Agnes

CORSO VITTORIO EMANUELE

0 Yards 100 200

0 Meters 100 200

© 2001 Jeffrey L. Ward

WALK 4
Starting Point: Piazza Navona

I. Piazza Navona was Bernini's redemption. After the Basilica belltower contretemps, the new Pope Innocent X, a more dour personality than his Barberini predecessor, banned the flamboyant artist from all papal projects. To regain favor, Bernini created a **Fountain of Four Rivers** for **Piazza Navona**. Represented by dramatic stone figures, the rivers symbolize the four corners of the world ripe for conversion in the Counter-Reformation—the Nile (Africa), the Ganges (Asia), the Danube (Europe), and the Rio de la Plata (the Americas). Pope Innocent was captivated, and, restored to his position as chief Vatican architect, Bernini continued to make Rome his workshop.

2. Piazza Navona offers abundant Baroque pleasures. At the south end is a second Bernini fountain—the **Fountain of the Moor**. On the west side are the **Church of Sant' Agnes** designed by Borromini, and **Palazzo Pamphilj**, Pope Innocent's family palace. The best spot to savor **Piazza Navona**'s myriad pleasures is an outdoor table at Tre Scalini. The restaurant may be touristy and pricey, but the location is unmatched and the gelato is irresistible. If your budget is tight, order dessert at the takeout window.

3. Leaving **Piazza Navona** from the east side, you will walk directly into the **Corso di Rinascimento** and **Palazzo Madama**, now the Italian Senate. The sculpted lions on the façade symbolize the original palace owners, the House of Medici.

4. Next door to the south is **Palazzo della Sapienza**, built by Giacomo della Porta in 1575 to house the University of Rome. It is now the National Archives and contained within its interior court-

yard lies a delightful surprise: the **Church of Sant' Ivo**. Borromini designed this flight of fancy for Pope Urban VIII in the shape of the Barberini bee.

5. Continue walking east and you will soon come to **Piazza della Minerva** and another Bernini whimsy, the **Elephant and the Obelisk**. Bernini created the jaunty marble elephant that supports the obelisk to honor his last great papal patron, the Chigi Pope Alexander VII, who commissioned the **Colonnades and Piazza of St. Peter**. The elephant symbolized wisdom, and Alexander was a poet and intellectual.

6. Before leaving **Piazza della Minerva**, visit its lovely medieval church. **Santa Maria sopra Minerva** contains artworks by Michelangelo, Bernini, Perugino, Duccio, and Fra Lippo Lippi. Both Fra Angelico and Saint Catherine of Siena are buried there.

7. Piazza della Minerva lies behind the most astonishing construction of ancient Rome, the **Pantheon**. A circular temple to the multiple pagan gods, the **Pantheon** is an architectural wonder erected by the Emperor Hadrian in A.D. 125 and rededicated to the Virgin Mary and all the Christian martyrs by Pope Boniface IV in 608. Walk around to the front, past the fountain designed by Giacomo della Porta, who raised the Basilica dome, and enter. The immense saucer dome of the **Pantheon** is a 141-foot hemisphere, equal in diameter and height, and lit by a single 27-foot-wide oculus.

The **Pantheon** is the final stop in these papal walks, and it brings you full circle, both literally and figuratively. It is the model that Donato Bramante was striving to surpass with his design for a vast, domed St. Peter's, the place that Raphael chose for his tomb, and the mother lode for much of the bronze in Bernini's Baldacchino.

❦

Papal and pagan Rome are two parts of the same story. This historic marriage of the sacred and the profane dates to Constantine, the pagan emperor who accepted the spiritual authority of the popes, then tacitly ceded temporal power to them when he abandoned Rome for Byzantium.

Constantine and Christianity converge at three major sites in Rome. Each is a tour in itself. The first is **Ponte Milvio**, the bridge over the Tiber River where Constantine saw the cross in the sky and received the message: "By this sign, you will conquer." The second is the **Basilica of San Giovanni in Laterano**. The first Christian church that Constantine built and still the official church of Rome, it was the original seat of the papacy. Destroyed over time, the **Lateran** complex was rebuilt by the indefatigable Pope Sixtus V.

And then there is the third site—the **Vatican**, *ager vaticanus* of imperial Rome. Here, on the exact spot where they believed the first apostle and first pope had been crucified, the Emperor Constantine and the Christian Julius built their splendid basilicas of St. Peter.

NOTES

These bold-faced phrases are not necessarily self-contained. In most cases they highlight an area of thought suggested or supported by the cited sources.

CHAPTER ONE: THE FIRST STONE, APRIL 1506

3 **a lavender cloak:** Vasari, Giorgio, *The Lives of the Painters, Sculptors and Architects*, trans. Gaston du C. de Vere (London: Everyman Library, 1927).

7 **Named for the *vati*:** Hersey, George, *High Renaissance Art in St. Peter's and the Vatican* (Chicago: The University of Chicago Press, 1993).

CHAPTER TWO: THE FIRST ST. PETER'S

13 **Romans blamed him:** Hibbert, Christopher, *Rome: The Biography of a City* (New York: W. W. Norton & Co., 1985).

18 **Monte Caprino:** Ibid.

18 **extorting what they could and decapitating whom they dared:** Ibid.

CHAPTER THREE: IL TERRIBILIS

23 **He enters history in a fresco by Melozzo da Forlì:** Klaszko, Julian, *Rome and the Renaissance: The Pontificate of Julius II* (New York: G. P. Putnam's Sons, 1903).

CHAPTER FIVE: A SURPRISE WINNER

41 **The brothers "from Sangallo":** Heydenreich, Ludwig H., and Lotz, Wolfgang, *Architecture in Italy, 1400–1600*, trans. Mary Hottinger (New York: Penguin Books, 1974).

43 **Bramante was an outsider:** Bruschi, Arnaldo, *Bramante* (London: Thames and Hudson, 1977).

45 **earning five ducats a month:** Ibid.

46 **his drawings of centrally planned churches:** Heydenreich and Lotz, *Architecture in Italy, 1400–1600*.

CHAPTER SEVEN: VAULTING AMBITION

57 **Space and volume:** Ackerman, James S., *The Architecture of Michelangelo* (London: Zwemmer, 1961 [Pelican, 1971]).

59 *in albis:* Zander, Pietro, *Creating St. Peter's: Architectural Treasures of the Vatican* (New Haven, Conn: Knights of Columbus Museum in Association with the Fabbrica di San Pietro, 2004).

62 **artists became independent contractors:** Barzun, Jacques, *From Dawn to Decadence: 1500 to the Present* (New York: HarperCollins, 2000).

CHAPTER EIGHT: ONWARD CHRISTIAN SOLDIERS

70 **As many as fifty banking houses had offices in Rome:** Gilbert, Felix, *The Pope, His Banker, and Venice* (Cambridge, Mass.: Harvard University Press, 1980).

CHAPTER NINE: A CHRISTIAN IMPERIUM

77 **the Menicantonio Sketchbook:** Millon, Henry A., and Lampugnani, Vittorio M., eds., *The Renaissance from Brunelleschi to Michelangelo* (New York: Rizzoli, 1994).

80 **a laborer worked for 15 to 20 ducats a year:** Partridge, Loren W., *The Renaissance in Rome, 1400–1600* (London: Weidenfeld & Nicolson, 1996). Rowland, Ingrid Drake, *The Culture of the High Renaissance: Ancients and Moderns in Sixteenth-Century Rome* (New York: Cambridge University Press, 1998).

84 **Rome replaced Florence:** Cook, Olive, *The Wonders of Italy* (Viking Press, New York, 1965).

CHAPTER TEN: A VIPER'S NEST

97 **Bramante reciting Dante to him like an actor on a stage:** Bruschi, *Bramante*.

CHAPTER TWELVE: THE FIRST MEDICI PRINCE

116 **Florentines flocked south:** Hibbert, *Rome*.

CHAPTER FOURTEEN: A ROMAN CANDLE

135 **architectural renderings:** Heydenreich and Lotz, *Architecture in Italy, 1400–1600*.

CHAPTER FIFTEEN: THE REVENGE OF THE SANGALLOS

138 **Antonio built the centering:** Heydenreich and Lotz, *Architecture in Italy, 1400–1600*.

139 **more than one thousand of his drawings:** Ibid.

141 **Twenty thousand men:** Gilbert, *The Pope, His Banker, and Venice*.

CHAPTER SIXTEEN: SALVATION FOR SALE

145 **only confession and contrition:** *New Catholic Encyclopedia*, (Washington, D.C.: Thomson/Gale Group, 2003) in association with the Catholic University of America.

CHAPTER SEVENTEEN: SWEET REVENGE

152 **one press in 1465:** Burke, Peter, *The Italian Renaissance: Culture and Society in Italy* (Cambridge, UK: Polity Press, 1999).

152 **the power of the printing press:** Barzun, *From Dawn to Decadence*.

CHAPTER EIGHTEEN: A BRIEF MOMENT OF TRUTH

155 "How many of the clergy": Burke, *The Italian Renaissance*.
156 "agony of Catholicism": Laffont, Robert, ed., *A History of Rome and the Romans: From Romulus to John XXIII* (Crown Publishers, Inc., New York, 1962).

CHAPTER NINETEEN: MEDICI REDUX

160 Charles V ruled an empire: Barzun, *From Dawn to Decadence*.
162 German and Austrian troops marched south: Hibbert, *Rome*; Cook, *The Wonders of Italy*; Laffont, *A History of Rome and the Romans*; Stinger, Charles L., *The Renaissance in Rome* (Bloomington: Indiana University Press, 1985).

CHAPTER TWENTY: A VIOLENT AWAKENING

173 Familiar habits were forbidden: Partridge, *The Renaissance in Rome*.

CHAPTER TWENTY-ONE: JULIUS'S FOLLY

187 money to finance it: Heydenreich and Lotz, *Architecture in Italy, 1400–1600*.

CHAPTER TWENTY-TWO: MOTU PROPRIO

193 the Fabbrica assumed that construction would continue: Heydenreich and Lotz, *Architecture in Italy, 1400–1600*.
200 Michelangelo's method of building: Ackerman, *The Architecture of Michelangelo*.

CHAPTER TWENTY-SIX: A NEW CENTURY

229 the Fabbrica now established offices in many cities: *The Reverenda Fabbrica di San Pietro dell'Urbe in Malta*, http://melitalhistorica.250free .com.
229 Known as the Sampietrini: Zander, *Creating St. Peter's*.

CHAPTER TWENTY-NINE: THE ROMANCE OF THE BAROQUE

245 **The young Bernini remained thoughtful:** Bernini, Domenico *Vita del cavalier Gio. Lorenzo Bernino* (Roma: A spese di R. Bernabò, 1713).

246 **An English diarist, visiting Rome in 1664:** Hibbert, *Rome.*

247 **cinematic special effects:** Cook, *The Wonders of Italy.*

249 **He began with a small wax model:** Borsi, *Franco, Bernini Architetto* (New York: Rizzoli, 1984).

250 **one tenth of the Church's annual income:** Vicchi, Roberta, *The Major Basilicas of Rome* (Florence: Scala, 1999).

CHAPTER THIRTY: FULL CIRCLE

265 **The experience begins at the river crossing:** Clark, Kenneth, *Civilisation: A Personal View* (London: British Broadcasting Corporation, 1969).

SELECTED BIBLIOGRAPHY

Ackerman, James S. *The Architecture of Michelangelo*. London: Zwemmer, 1961 (Pelican, 1971).

Alberti, Leon Battista. *De re aedificatoria*, trans. Joseph Rykwert, Neil Leach, and Robert Tavernor. Cambridge, Mass.: MIT Press, 1988.

Barzun, Jacques. *From Dawn to Decadence: 1500 to the Present*. New York: HarperCollins, 2000.

Bergere, Thea, and Richard Bergere. *The Story of St. Peter's*. New York: Dodd, Mead and Company, 1966.

Blouin, Francis X., Jr., ed. *Vatican Archives*. New York: Oxford University Press, 1998.

Borsi, Franco. *Bernini Architetto*, trans. Robert Erich Wolf. New York: Rizzoli, 1984.

Briggs, Martin Shaw. *The Architect in History*. New York: Da Capo Press, 1974.

Bruschi, Arnaldo. *Bramante*. London: Thames and Hudson, 1977.

Buonarroti, Michelangelo. *Complete Poems and Selected Letters*, trans. Creighton Gilbert. New York: Random House, 1963.

Burckhardt, Jacob. *The Civilization of the Renaissance in Italy*. New York: Barnes & Noble Books, 1999.

Burke, Peter. *The Italian Renaissance: Culture and Society in Italy*. Cambridge, UK: Polity Press, 1999.

Chambers, David S., ed. and trans. *Patrons and Artists in the Italian Renaissance*. London: Macmillan, 1970.

Clark, Kenneth. *Civilisation: A Personal View*. London: British Broadcasting Corporation, 1969.

Condivi, Ascanio. *The Life of Michelangelo*, trans. Alice Sedgwick Wohl. Baton Rouge: Louisiana State University Press, 1976.

Contardi, Bruno. *St. Peter's*. Milan: Federico Motta Editore, 1998.

D'Amico, John R. *Renaissance Humanism in Papal Rome*. Baltimore: Johns Hopkins University Press, 1983.

Erasmus, Desiderius. *The Julius Exclusus of Erasmus*, trans. Paul Pascal. Bloomington: Indiana University Press, 1968.

Fontana, Carlo. *Il Tempio Vaticano 1634–1714*. Milan: Electa, 2003.

Francia, Ennio. *Storia della Construzione del Nuovo San Pietro*. Vatican City: De Luca Edizioni d'Arte, 1987.

Galluzzi, Paolo. *Renaissance Engineers: from Brunelleschi to Leonardo da Vinci*. Florence: Instituto e Museo di Storia della Scienza, 1966.

Gilbert, Felix. *The Pope, His Banker, and Venice*. Cambridge, Mass.: Harvard University Press, 1980.

Gille, Bertrand. *Engineers of the Renaissance*. Cambridge, Mass.: MIT Press, 1966.

Goldscheider, Ludwig. *Michelangelo: Paintings, Sculpture, Architecture: Complete Edition*. London: Phaidon Press, Ltd., 1953.

Gould, Cecil Hilton Monk. *Raphael's Portrait of Pope Julius II*. London: National Gallery, 1970.

Guest, George Martin. *A Brief History of Engineering*. London: Harrap, 1974.

Guicciardini, Francesco. *Riccordi*, trans. Ninian Hill Thomson. New York: S. F. Vanni, 1949.

————. *The History of Italy*, trans. Sidney Alexander. New York: The Macmillan Company, 1969.

Haskell, Francis. *Patrons and Painters*. New Haven, Conn.: Yale University Press, 1980.

Hersey, George H. *High Renaissance Art in St. Peter's and the Vatican*. Chicago: The University of Chicago Press, 1993.

Heydenreich, Ludwig H., and Wolfgang Lotz. *Architecture in Italy, 1400–1600*, trans. Mary Hottinger. New York: Penguin Books, 1974.

Hibbard, Howard. *Carlo Maderno and Roman Architecture*. University Park: Penn State University Press, 1971.

Hibbert, Christopher. *Rome: The Biography of a City*. New York: W. W. Norton & Co., 1985.

Hollis, Christopher, ed. *The Papacy: An Illustrated History from St. Peter to Paul VI*. New York: The Macmillan Company, 1964.

Horizon Magazine, eds. *The Horizon Book of the Renaissance*. New York: American Heritage Publishing Co., Inc., 1961.

Kitao, Timothy K. *Circle and Oval in the Square of Saint Peter's.* New York: New York University Press, 1974.

Klaszko, Julian. *Rome and the Renaissance: The Pontificate of Julius II.* New York: G. P. Putnam's Sons, 1903.

Laffond, Robert, ed. *A History of Rome and the Romans from Romulus to John XXIII.* New York: Crown Publishers, Inc., 1962.

Lanciani, Rodolfo. *Golden Days of the Renaissance in Rome.* Boston: Houghton Mifflin & Co., 1906.

Lavin, Irving. *Bernini and the Crossing of St. Peter's.* New York: New York University Press, 1968.

Lees-Milne, James. *The Story of St. Peter's Basilica in Rome.* London: Hamish Hamilton, 1967.

Letarouilly, Paul. *Le Vatican et La Basilique de Saint-Pierre de Rome, Vol. I.* Paris: Veuve A. Morel et Cie, 1882.

Lotz, Wolfgang, ed. *Studies in Italian Renaissance Architecture.* Cambridge, Mass.: MIT Press, 1977.

Lytle, Guy Fitch, and Stephen Orgel, eds. *Patronage in the Renaissance.* Princeton, N.J.: Princeton University Press, 1981.

Mainstone, Rowland J. *Developments in Structural Form.* London: Allen Lane, 1975.

McNally, Augustin. *St. Peter's on the Vatican: The First Complete Account in Our English Tongue of Its Origins and Reconstruction.* New York: Strand Press, 1939.

Menen, Aubrey. *Upon This Rock.* New York: Saturday Review Press, 1972.

Millon, Henry A., and Vittorio M. Lampugnani, eds. *The Renaissance from Brunelleschi to Michelangelo.* New York: Rizzoli, 1994.

Millon, Henry A., and Craig Hugh Smyth. *Michelangelo, Architect: The Facade of San Lorenzo and the Drum and Dome of St. Peter's.* Milan: Olivetti, 1988.

Murray, Peter. *The Architecture of the Italian Renaissance.* New York: Schocken Books, 1920.

Nicholson, Peter. *Encyclopedia of Architecture.* New York: Martin and Johnson, circa 1852.

Palladio, Andrea. *The Four Books of Architecture.* New York: Dover Publications, 1965.

Parsons, William Barclay. *Engineers and Engineering in the Renaissance.* Baltimore: The Williams & Wilkins Co., 1939.

Partner, Peter. *The Pope's Men: The Papal Civil Service in the Renaissance.* New York: Oxford University Press, 1990.

———. *Renaissance Rome, 1500–1559: A Portrait of a Society.* Berkeley: University of California Press, 1976.

Partridge, Loren W. *The Renaissance in Rome, 1400–1600.* London: Weidenfeld & Nicolson, 1996.

Pastor von Camperfelden, Ludwig Friedrich August. *The History of the Popes.* St. Louis: B. Herder, 1912–14.

Portoghesi, Paolo. *Rome of the Renaissance,* trans. Pearl Sanders. London: Phaidon, 1972.

Richardson, A. E., and Corfiato, Hector O. *The Art of Architecture.* Westport, Conn.: Greenwood Press, 1972.

Rivoira, Giovanni Teresio. *Roman Architecture,* trans. by G. McN. Rushforth. New York: Hacker Art Books, 1972.

Rowland, Ingrid Drake. *The Culture of the High Renaissance: Ancients and Moderns in Sixteenth-Century Rome.* New York: Cambridge University Press, 1998.

Serlio, Sebastiano. *The Book of Architecture.* London: 1611 (New York, B. Blom, 1970).

Smith, James, and Barnes, Arthur S. *St. Peter's in Rome.* Rome: Editalia, 1975.

Stinger, Charles L. *The Renaissance in Rome.* Bloomington: Indiana University Press, 1985.

Vasari, Giorgio. *The Lives of the Painters, Sculptors and Architects,* trans. Gaston du C. de Vere. London: Everyman Library, 1927.

Vicchi, Roberta. *The Major Basilicas of Rome.* Florence: Scala, 1999.

Wittkower, Rudolf. *Idea and Image: Studies in the Italian Renaissance.* New York: Thames and Hudson, 1978.

———. *Gian Lorenzo Bernini: The Sculptor of the Roman Baroque.* Ithaca, N.Y.: Cornell University Press, 1981.

ACKNOWLEDGMENTS

Many hands and minds contributed to the building of the Basilica of St. Peter, and many have contributed to telling its story. My thanks to F. Joseph Spieler, Wendy Wolf, Hilary Redmon, Douglas Steel, Dom Julian Stead, O.S.B., Rita Dwyer Scotti, Evans Chigounis, and Francesca Chigounis. Thank you also, to Dr. B. J. Cook, Curator of Medieval and Early Modern Coinage at the British Museum, the Frederick Allen Lewis Room of the New York Public Library, Pina Pasquantonio of the American Academy of Rome, and to the scholars, historians, and art historians whom I consulted. If any is slighted, it is unintentional.

INDEX

❧

Page numbers in *italics* refer to illustrations.

ILLLUSTRATION CREDITS

❧